"I can thoroughly recommend it for both students and those with a less academic enthusiasm for medieval history, who will be whisked back to those 'days of olde' from the comfort of their armchair. Most enjoyable and educational!"

—**Toni Mount**, MA, BA (Hons), Dip Creative Writing and Literature, Dip European Humanities, Cert Ed, internationally bestselling author

"In this book, *The Secret Lives of Single Medieval Women*, Rosalie once again brings to us remarkable insights into the little-known and often challenging world of single women in the Middle Ages. The depth of her research is noteworthy and her ability to bring it all together with clarity and the additional sprinkling of humorous insights makes this book highly engaging, educational, and entertaining."

—**Edith Cuffe**, OAM, Abbey Museum of Art and Archaeology

"Scholarly but not stuffy. If you are looking for an informative but fun book on Mediaeval women, you will find it between these pages. This well-written book guides one with a gentle hand through all the classes of unmarried women throughout the Mediaeval era. A must-read for all those modern women who wish to understand the role of our unmarried ancestors in the Middle Ages. Essential reading for the novice reenactor and student of early history alike. And good fun to read."

—**Susanna Newstead**, authoress of historical murder/mystery fiction series *The Savernake Novels*

"This book sheds light on the reality of single medieval women, not just the two-dimensional depictions in movies. Ms. Gilbert not only has researched her subject thoroughly, but her engaging style brings these women to life with examples of actual medieval women."

—**Susan Thatcher**, The Grand Duchy of Medieval Merriment

The Secret
Lives of
SINGLE MEDIEVAL WOMEN

The Secret Lives of
SINGLE MEDIEVAL WOMEN

True Stories of Nuns, Maidens, and
Not-So-Merry Widows Who Made Their
Own Way in the Medieval World

Rosalie Gilbert

MIAMI

Copyright © 2025 by Rosalie Gilbert.
Published by Mango Publishing, a division of Mango Publishing Group, Inc.

Cover Design: Rosalie Gilbert
Cover Photo/Illustration: Portrait of a Young Man; (reverse) Girl Making a Garland Hans Süss von Kulmbach German ca. 1508 metmuseum.org/art/collection/search/436834
Author Photo: Rosalie Gilbert
Layout & Design: Elina Diaz

Mango is an active supporter of authors' rights to free speech and artistic expression in their books. The purpose of copyright is to encourage authors to produce exceptional works that enrich our culture and our open society.

Uploading or distributing photos, scans or any content from this book without prior permission is theft of the author's intellectual property. Please honor the author's work as you would your own. Thank you in advance for respecting our author's rights.

For permission requests, please contact the publisher at:
Mango Publishing Group
5966 South Dixie Highway, Suite 300
Miami, FL 33143
info@mango.bz

For special orders, quantity sales, course adoptions and corporate sales, please email the publisher at sales@mango.bz. For trade and wholesale sales, please contact Ingram Publisher Services at customer.service@ingramcontent.com or +1.800.509.4887.

The Secret Lives of Single Medieval Women: True Stories of Nuns, Maidens, and Not-So-Merry Widows Who Made Their Own Way in the Medieval World

Library of Congress Cataloging-in-Publication number: 2025933798
ISBN: (print) 978-1-68481-822-8, (ebook) 978-1-68481-823-5
BISAC category code: HIS058000 HISTORY / Women

Lovingly dedicated to my biggest fan, Ryan.
May I grow up to be the person he already thinks I am.

"You haven't advanced an argument,
so far as I can see,
that would weaken my opinion
or properly compel me to assent to your desire."

—Andreas Capellanus

Table of Contents

Foreword	11
Introduction	13
Chapter 1: Who *Were* the Single Ladies?	15
Chapter 2: There's No Place like Home	38
Chapter 3: Dressing for Success	52
Chapter 4: Etiquette for the Solo Woman	80
Chapter 5: Learning, Education, and Skill-Sharing	117
Chapter 6: Unpaid Labour, Jobs, and Business Opportunities	130
Chapter 7: Leisurely Pursuits	161
Chapter 8: Animal Companions	195
Chapter 9: In Sickness and in Health	213
Chapter 10: Death, Funerals, and Beyond	245
Conclusion	273
Selected Bibliography	274
Source Notes	287
Heartfelt Thanks	288
About the Author	289

Foreword

I first "met" Rosalie Gilbert online when, as a historical reenactor and interpreter, I had queries concerning women's headgear in the thirteenth century and how I should wear it. Rosalie is an expert on medieval costume and soon put me right and, as a reenactor herself, she understands the problems we, in the twenty-first century, experience in coping with veils, wimples, fillets, etc. As the author of a number of factual history books myself, specializing in the lives of everyday medieval folk, I can attest to the incredible amount of in-depth research which Rosalie carries out, into both the practicalities of creating historically authentic costumes and the daily lives of those who wore them in past centuries.

Although Rosalie lives in Queensland, Australia, her Gilbert roots are firmly planted in medieval England—the family even owned a castle and have a coat of arms—so her own history qualifies her to enact the role of a real lady. She admits to being "passionate about historical reenactment and women in the Middle Ages, particularly in England" and I heartily agree with her that, "as much as we learn, there always seems to be more to learn and something new to discover."

In this new book, *The Secret Lives of Single Medieval Women*, Rosalie Gilbert's exploration of the lives of single women in the Middle Ages is a revelation. If you thought—as I did—it was marriage or the nunnery and little prospect of anything else for medieval women, the thorough research and beautifully accessible writing will give you plenty of reasons to think again. A surprising number of women lived single lives; some by choice, others due

to widowhood, and many succeeded in running business ventures without a husband. Female empowerment isn't only a recent phenomenon, with *femmes soles* being independent, making money in their own right, and representing themselves in court cases, suing for debt.

Other myth-busting chapters deal with hygiene, health, and death. Teeth were cleaned regularly and hand- and face-washing were done throughout the day, morning and night and before meals or after a journey. Women were told that they should smell clean and sweet and have clear skin, being advised on the herbal concoctions that would achieve this pleasant state. Some instructions for correct feminine behaviour went so far as to specify that, when mourning the dead, there was a "proper" way to weep. The similarities between the lives and loves of women then and now are revealed in that they kept pets for companionship, sometimes against the house rules in convents, and treated small dogs, cats, and squirrels better than humans on occasion—much to the disgust of churchmen.

I was delighted and honoured when Rosalie asked me to read the pre-edited version of her text and write a foreword for the book. I can thoroughly recommend it both for students—with a detailed list of source material—and for those with a less academic enthusiasm for medieval history, who will be whisked back to those "days of olde" from the comfort of their armchair. Most enjoyable and educational!

—Toni Mount
Kent, England
November 2024

Introduction

Single women. They existed in the Middle Ages, though you'd be forgiven for thinking that their lives were small and insignificant. Many scholarly books have talked at great length about the medieval housewife, or the life of noble ladies, queens, and their daughters. For many, medieval womanhood was defined by who a person *was* in relation to her father, husband, or monarch, but alongside them lived a number of single women about whose lives a smaller amount has been written.

An outstanding few have become well-known to us, like the nun Hildegard von Bingen and the writer Christine de Pizan, but none more so than Joan of Arc, who has continued to inspire single women to follow their passions ever since. You might think that, if a female was single in the medieval world, she was a complete nonentity, property to be passed from one guardian to another, and to a certain extent, that is true.

It was not, however, the entire story.

They were there, these medieval women and girls. We find them in court rolls, mentioned as property or belonging to some male figure, and only sometimes acting in their own stead. They *were* there. Single women were a part of society in the Middle Ages, just as they are today, but you may have been led to believe that they were a small part, since they were often included as appendages.

Single women could be young, unmarried girls under the age of twelve and in the care of their families.

Single women could be of marriageable age but not yet wed. Adults working at home or in service or in the fields for the lords, or daughters of knights, rich and eligible, enjoying all the things that high society had to offer without the burden of running a household or motherhood.

Single women could be separated or divorced or widowed, perhaps working at a trade and enjoying a certain amount of freedom and autonomy, desperately trying to avoid unwanted further matrimony, or struggling to survive without a reliable means of support. Depending on their age and rank, these women had many options, or not.

Single women could be women of religion—nuns or other single women living within the cloisters as a stopgap until marriage, an educational opportunity, or an escape from the outside world. Some embraced the religious life, while others did not.

Let's dip our toes in and meet some.

Chapter 1
Who *Were* the Single Ladies?

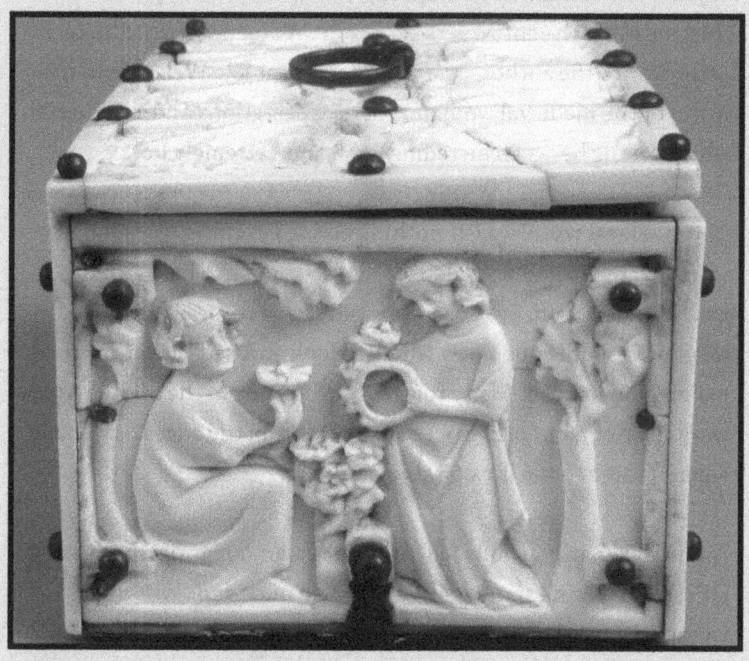

Figure 1. A young man passes a flower while a maiden makes a chaplet of flowers. Box with Courting Couples. Fourteenth century. French. Elephant ivory. Met Museum of Art. Open Access. Accession Number: 17.190.163.

> "Of All Creatures, Women be Best.
> Cuius contrarium verum est
> In every place you may well see
> That women are true as turtle on tree,
> Not free in their language, but speaking secretly,
> And great joy among them it is for to be."
>
> —Anon. English poet.

So begins a song extolling the virtues of women,[1] except, as the second-line disclaimer in Latin says, the truth is the opposite of this, meaning the entire verses are a lie. Women were not, in fact, according to the author, best, true, or a great joy. Welcome to the world of the medieval woman, where expectations and a woman's worth swung between incredibly high and extremely low.

The medieval world was, if nothing else, an exciting place for women. Sometimes in a good way, sometimes in a bad way. It can be understood, by those who study it, as surprisingly full of loopholes, if only one knew where to look and had the means to make them happen. Many roles for the fair sex in the Middle Ages were clear-cut, but others were blurry around the edges, especially when it came to the life of a single woman.

A single woman generally fell into one of four categories: unmarried girls; maidens and spinsters; widows; and nuns and cloistered women. Within the group of maidens and spinsters lived beggars, fringe-dwellers, and prostitutes, and these, although a subset, had their own set of expectations from those who dealt with them.

These were the spaces occupied by girls and women who were not married. Marriage, of course, was the state to which many women aspired. It was also the church-approved path to procreation and

sexual activity. Wedded bliss was not, however, the endgame for all women. Some did not wish to marry at all and strived to keep their single status and continue to live their best lives according to the options open to them. Many succeeded.

A woman could stay single, if she wanted to, and if only she knew *how*.

Let's take a look at our single subsets: the young and yet to wed, the older and not wed, the widows of men who had passed away before them, and those unmarried to mortal man. Those who lived alone on the fringes of society fell into one or two of these categories, but not always neatly.

A great deal of the fortune of a medieval woman rested on her rank in society and her marital status. Everything from her clothes, diet, work, social and legal opportunities, and dental care to familial expectations depended on her financial and social position at the time of her birth, or at the time of her marriage. A woman's responsibilities and obligations to society varied according to her individual life journey.

According to legal historian Frederic Maitland, at certain times throughout the Middle Ages, a woman:

> "...can hold land, even by military tenure, can own chattels, make a will, sue and be sued. A married woman will sometimes appear as her husband's attorney. A widow will often be the guardian of her own children; a lady will often be the guardian of the children of her tenants."[2]

None of this was cut and dried, as we shall see.

Young Girls

> *"Destined by Nature to be my daughter,*
> *A day which so very suddenly dawned as my relative.*
> *Grow then, little girl, the future support of your father*
> *In his querulous old age, when his eyes will dim;*
> *As the diligent servant of my mind,*
> *You will do more than a son."*[3]
>
> —Walter of Châtillon

These are the closing lines to a twelfth-century French poem about the reaction of a father to the birth of his baby daughter. He spoke of how others rejoiced in their fruit, yet he himself was unfortunate. It was only in the last few lines that the poet acknowledged that a girl child had some future benefit to him, as a carer when he grew to be an old man. Thus, we have an example of the gender preference of many medieval fathers, even if it was couched in prose.

The young, single girl was in a life space which included her infancy, childhood, and early teenage years. A girl was considered an infant until seven years of age, a child until fourteen, when she became of age to be married, a youth until twenty-eight, and finally, an adult. Generally, a girl resided with her mother until seven years of age, unless she was an orphaned heiress, where she may have been removed from her mother and put into more "suitable" care. In many cases, a mother was able to apply for guardianship of her own child, but such an appeal may or may not have been successful depending on the enormity of the child's holdings when she matured and the social position of the mother herself.

As a baby, a young girl would be born according to the mother's station, at home with midwives and other female attendants present and, at the appropriate time, baptised in a church. Once at the church, the separation of male and female started, with the baptism of girls taking place on the priest's left-hand side, compared to that of a boy, who was placed on the right.[4]

From the twelfth century onwards, it was usual for a child to have three godparents, two of the same sex and one of the opposite.[5] Godparents served an extra function which we today may find unusual: the naming of the infant. This was done with great solemnity, with the godparents very often selecting their own name.[6] In the case of a girl, one of the female godparents would do so, and it was noted that not all godparents were of equal social stature to the mother herself and may have been chosen with the desired name in mind.

Popular choices for girls' names might also be saints' names, such as Mary, Margaret, or Catherine. At Lambeth, the members of a church council concerned themselves with the naming of girl children when they enjoined priests not to permit baptisms with names that they considered salacious-sounding.

Noble girls were always at risk of being prematurely engaged, and in the case of Eleanor, who would grow up to be the Countess of Leicester and her younger sister, Joanna, the betrothals were at the very tender ages of nine and four, respectively.[7] Being the daughters of Isabella of Angoulême and King John of England, both girls were considered very valuable commodities and were married to secure political alliances. At such young ages, neither child would have been consulted about the matter. Fortunately for most girls, marriage came well after puberty.

An anonymous song from the British Library hints at the unease some youthful women must have felt when informed of a future marriage. "The Bride's Song" doesn't mention specifically how old the singer is, only that she considers herself to be very young, as seen in these two verses:

> "The maidens came when I was in my mother's bower;
> I had all that I would.
> The bailey beareth the bell away;
> The lily, the rose, the rose I lay.
> And through the glass window shines the sun.
> How should I love, and I so young?
> The bailey beareth the bell away;
> The lily, the rose, the rose I lay."[8]
>
> —"The Bride's Song." Anon. Medieval.

Most medieval girls and young women were destined to fill the traditional roles of wives and mothers, and at the age of twelve, Polish girl Hedwig was agreed to be an appropriate bride for the Duke Henry of Silesia, a fully grown man with a beard. *The Marriage of Hedwig and Heinrich* is illustrated in a manuscript illuminated at the court workshop of Duke Ludwig I of Liegnitz and Brieg in Poland in 1353. Her father is shown giving her away to him as she stands next to the priest and before her husband-to-be. He is indicating his approval at such a good and socially advantageous match.

A good marriage, even a humble one between people of the same class, might be socially and financially advantageous. It gave a recognised place in society and in the family structure, and had clearly defined expectations and responsibilities. Until that time came, a girl was single, although not entirely her own person.

She was, for the bulk of the medieval period, the property of her father and under the control of her mother to a lesser extent. Her days were filled with preparation for adulthood, when she would no longer be single. Learning domestic chores if she was working-class, or under the guidance of tutors in the finer arts of genteel pastimes if she were of noble birth and hoped to marry well, filled her days.

Single girls can often be seen named expressly in county polls. Female names can be written with no relation or further clue to their role or occupation in society, but in other listings, relationships are indicated. In rather insulting 1377 poll tax records for Carlisle, the wives and daughters of men are merely listed namelessly as "and wife" or "his daughter," whereas the female servants are recorded by their own names. An excerpt follows as such:

> "William de Karlton, senior, and his wife
> His daughter
> William his servant
> William Sadiller and his wife
> Robert de Strayte and his wife
> Thomas his servant
> Widow Sundirland
> Mariota de Esyngwald
> Margaret Allerdale
> Agnes de Burgh
> John Kyrkby and his wife
> Henry,
> Isabel, his servants
> Mariota Mawer
> Alice with her in the house
> William Dobson and his wife
> Christiana his servant..."[9]

The idea that a man's wife was nameless, but independent servants who were female (and therefore not the property of anyone just yet) were named is, to most modern eyes, appalling. The list seems to indicate several unmarried women who were not widows, as the widowed woman is listed as such. The status of Alice who is with Mariota but not a servant or child is unclear. She might be a blood relation or servant or visitor in the household when the poll was taken.

A little later on, poll tax records named wives and daughters individually underneath their fathers.

Unmarried Maidens, Damsels and Spinsters

> *"It's a very hard thing to conquer human nature,*
> *To look upon a maiden and still be pure in spirit.*
> *Boys like us just can't obey so difficult a ruling*
> *And take no note whatever of pretty girlish figures."*[10]
>
> —Anon. Medieval German song.

A twelfth-century German verse, sung by young men who were single and looking to mingle, extolled the joys of feminine company. Some maidens may have welcomed them, but one gets the feeling from the lyrics that the intentions of the men weren't exactly pure, and songs like these were not exactly a precursor to wedded bliss, but more an indication of their biological urges.

Maidens were often in danger of encountering amorous attentions against their will from men such as these. This can be seen in *The*

Art of Courtly Love, where the author gives imagined conversations between persons of different rank and age, and whether he feels love should be reciprocated, or not. In his first dialogue of two middle-class persons, a lady of tender years rejects the advances of an older man.

> "You may deserve praise for your great excellence,
> But I am rather young,
> And I shudder at the thought
> Of receiving solaces from old men."[11]
>
> —Andreas Capellanus

A young girl often looked forward to her future role of wife and mistress of her own house, and occupied her time learning the skills she would need to fulfil this. In the meantime, being a dutiful daughter, keeping her good name and hoping for a good match were all things of great importance to her. She often attended functions with her family so that she might meet suitable young men who were potential husbands—men who could provide for her and her future children, provide a nice place for them to live, and treat her well.

These unmarried women would, in the future, become householders, key-holders, and hirers of staff, and have social statuses as wives. Maidens were in a sort of holding pattern, waiting for their lives to begin, but were shown carved into objects such as ivory boxes or painted onto other wooden caskets in scenes of courtly love.

Not all single girls trod the path to matrimony, or wanted to. Some failed to marry entirely and became the women we today call *spinsters*. In the Middle Ages, a spinster was a person who

earned a living by spinning wool or linen, regardless of marital status, but we shall use the term in its modern sense, meaning a woman who is older than a child of twelve and unmarried. These women generally continued to live in the family home and might fill the role of unpaid worker for their parents or housekeepers for unmarried brothers who were then charged with their care. A woman might be single, but for all intents and purposes, she needed to be seen as having the guidance of a male head of the house. Other single, older women might also be employed in other households as long as they remained unmarried, either as chaperones, companions, or housekeepers. This sometimes put them in awkward situations which endangered their virtue.

Some worked at paid jobs; others, working for family, may or may not have been paid wages, but had a roof over their heads and food on the table. Money and other items were often left to a single woman by other women in wills and bequests, assisting them financially or with gifts of personal items or objects they might use about the house.

A merchant's wife from York, Emma Preston, made a bequest to a single woman, Alice. A monetary incentive was given to the young woman as long as she stayed chaste until married. There is no indication of the relationship between the two women, but as their surnames differ and no familial bond is noted, it is possible that Alice is a young servant in Emma's household and not a blood relative.

> "Also I leave to Alice Stede if she will stay and remain an honest virgin and of good repute until she shall have a husband, that then she shall have five marks to her marriage, but in the event that ignorantly or heedlessly she shall commit fornication or adultery, that she shall have only two marks and 6s 8d..."[12]

This seems to indicate a payment toward a dowry, and offers a substantial bonus for Alice keeping herself chaste to be a more attractive marriage candidate. A kitchen servant might expect to earn between two and four shillings a year at that time, so five marks equating to sixty-five shillings and twenty pence was no little amount.[13]

Unwed Single Mothers

Today, choosing to parent a child or children alone carries little or no stigma in many countries of the world, but in the Middle Ages, this was not a preferred or actively embraced lifestyle choice.

Many of these situations were created unwillingly on the part of the woman; in countless cases, unplanned parenthood was the result of love trysts or rape. Sometimes, marriage was promised in order to gain intimate favours and then not upheld afterwards, and other times as a result of being a mistress or a live-in servant. One woman, who was brought to court at Rochester in Kent, carried her baby full term but did not wish to care for it; rather, she wanted the father to take care of it. The court record reflects this:

> "And the woman placed the child on the ground in front of the judge, saying that she no longer wished to care for it, but that it should be taken by the father, who she asserted was the said Rowland. To which the man replied, denying it… Then the judge warned the woman to receive the child at her breast to nourish it with due sustenance under pain of excommunication until the question of paternity was discussed."[14]

Such women were talked about and treated in the worst ways. Not only was a girl's good reputation destroyed, her chances of a good marriage in the future were essentially ruined, and worst of all, her child was under no guarantee to receive an inheritance which would, in turn, provide for her food and shelter in her own old age.

A poem written about an unmarried mother-to-be from around 1200 shows what unhappiness awaits those who are careless with their chastity.

> "The Maid Forlorn.
> Blossom time is here,
> The birdsong grows,
> The earth gives solace,
> But woe!
> Such are the joys of love!
> Here I am, wretched me,
> I had hidden the thing well,
> And loved secretly.
> At last the wrongdoer suffered,
> Her womb grew fuller
> And the pregnant one's birth was upon her.
> From here my mother called me
> From there my father blamed me
> Both dealt with me roughly;
> Now I sit at home alone
> I don't dare to go out
> Nor to play in public.
> When I do go outside
> I am stared at
> As if I were some monster.
> When they see this belly
> One nudges another,

> *And they hush whilst I pass.*
> *They nudge with their elbows*
> *And point at me with their fingers*
> *As if I had done something astonishing.*
> *With nods they point me out,*
> *They judge me worthy of the grave*
> *Who only sinned once.*
> *What shall I go through as a single woman?*
> *I am in the stories and mouths of everyone;*
> *My pain piles up*
> *Because my lover is in exile*
> *On account of that tiny trifle.*
> *Because of my father's fury*
> *he fled to the furthest parts of France.*
> *I suffer from his force,*
> *Now I will die of grief*
> *And am always in tears."*[15]

—Anon

The simplest remedy to this situation was to arrange a hasty wedding, but it seemed that the father in the poem had no plans along that line. He'd made a run for it, leaving her alone and with child.

Unwed mothers-to-be were fortunate in one respect. Assistance at the time of her birthing might be forthcoming at the charity of hospitals, which are recorded as early as the end of the eleventh century in England. By the time the early fifteenth century arrived, statutes of Parliament listed poor women who were about to give birth among the groups which ought to be aided, at least on a temporary basis. *The Statutes of St Paul* at Norwich, dated between 1200 and the mid-century, also stated that poor women who were

bearing a child should stay, at least until they were recovered enough to leave.[16] Many a poor woman may not have had anywhere to leave to, but at least she had been tended to during her birth and had immediate post-natal care at hand in case of bleeding or sickness.

In the preacher's handbook, the *Fasciculus Morum*, we learn that some brash young women, when asked about their pregnancies, were bold enough to simply say that pregnancy was preordained for them, as everything was God's will, and if that should be His plan, who were they to argue? The script also quotes a friar who addresses a harlot speaking about her body as a set of clothes. Of her unplanned pregnancy, he says:

> "Truly, my daughter, he who made that bag, your belly, this way was a terrible tailor, for it pokes out shamefully!"[17]

—*Fasciculus Morum*

Shame and scorn were the lot of the unmarried mother in the Middle Ages.

Widows

Upon the death of the male head of the house, a woman stopped being a dependent and became the head of the house herself, even if only temporarily. This was a dramatic shift in how she was seen by the rest of the world. No longer described as "and wife" in tax polls, she became a named individual with assets. All she needed now was to take stock of her life and see what her options were. Had she the means and desire to stay alone, or was it imperative to find another provider for her household as soon as possible?

Being single after marriage took two forms: those recently widowed who wished to remarry (or would be forced to remarry), and those who were widowed and planned to stay solo. Staying solitary after the death of a husband was a double-edged sword. If a lady was young, attractive, or had married well and had valuable assets, she was seen as a prize to be acquired. If she was past childbearing age, she was less likely to be married off quickly, although having assets still made her a target. If her husband was a worker and lowly born, a woman's home and belongings might be taken from her, leaving her with very little in her old age. If, on the other hand, she was a townswoman or artisan trained in her husband's trade and was capable of running it, she might choose to take over his business and work there until her age or health prevented her.

There were, in some opinions, three reasons a widow might not wish to remarry. Firstly, a man might not want to marry her for herself, but only for the gain of her possessions, and she would be trapped in a loveless or affectionless situation. Secondly, her genuine attachment to her deceased husband might be so great that she might never feel the need for another in his place. Thirdly, if her new husband were good, she would fear losing him to unscrupulous women, and if he were bad, she would be unfortunate to have such a terrible husband after her previous one.[18]

In cases where a husband had particularly specified so in his will, a widow was unable to remarry or her husband's possessions would be forfeited and pass to someone else. We see this expressly stipulated in a will dated 1465 from Lincoln, where Richard Welby of Moulton leaves these instructions for his wife's future:

> "...Also, I will that, if my wife can find sufficient surety to my executors that she shall never have a husband after my decease, that then she be my chief executrix, but otherwise not to be, nor to have any more of her jointure and one half of my household goods..."[19]

If a widow remained single and kept herself chaste, she might have the option to remain in her home and run her husband's business in his stead. In such instances, a woman might live solo, work solo, hire and train apprentices solo, and run a business solo, all without a husband, and *still* remain a respected member of the community.

A high-born widow with wealth and of sufficient social standing naturally attracted the attention of noblemen hoping to utilise her assets to improve their own position. A widow of means, with a large inheritance or with strategic land holdings, might be put under the king's "protection," although *protection* was absolutely not the right word to describe the situation. Manipulation and forced matrimonial decisions made on behalf of a woman whose life he controlled for financial and strategic gain is hardly protection. *Pawn* is a more accurate word to describe the situation of any woman who found herself in it.

The *Register of Rich Widows and Orphaned Heirs and Heiresses* of 1185 shows that many unfortunate women were married "in the king's gift." Essentially, this meant that the king was within his right to grant a rich widow in marriage to whomsoever he pleased. Taken into consideration were whether she had children already, the ages and sexes of her offspring, and most importantly, the location, value, and annual income of her holdings and assets.[20] The first example we see in written records of this in England is dated 1130, on the *Exchequer Pipe Roll*.

It *was* possible for a widow to avert a match she wished to avoid by buying her way out of such an agreement, even as a temporary reprieve. Unfortunately, the price to do so was extremely high, and would cost the widow what money she possessed and the means to support herself afterwards, thus making it impossible for her to free herself. In many cases, it left her with little choice but to comply. Countess Lucy, whose third husband died in 1129, pledged a whopping five hundred marks so that she could remain single, but was only granted a five-year grace period. After three husbands, she probably really had had enough of it for a bit.

Another widow, finding herself bereft of a husband and not wishing to be told who to marry, was Sibyl. In 1277, the Manor Court records from Wellington, Somerset, show that Sibyl was in a position to take control of her own future marriage prospects, thanks to her benefactor Walter de Whitheie. It reads much like a legal document we might find today.

> "Sibyl, who was the wife of John in the Alre, gives to the Lord £6 13s 4d that she be able to marry herself within the manor whenever she pleases... And it is granted by the aforesaid Sibyl, that, because Walter de Whitheie shall pay the aforesaid fine, when the aforesaid Sibyl shall have married herself, the same Walter shall be able to hold the aforesaid tenement until he shall have levied the aforesaid ten marks."[21]

Even though she would be able to choose her future husband, there were strings quite firmly attached.

Beggars and Fringe-Dwellers

In the bottom rungs of society, financially destitute women lived alone, unable to provide for themselves and reliant on handouts and charitable donations from churches and the goodwill of private citizens for survival. Many of these met unfortunate deaths, from starvation or exposure to the elements. Assistance was available through churches and benefits from others, but these could not be relied upon to provide a proper livelihood.

The Archpriest of Talavera summed it up in the fifteenth century, repeating the well-known platitude:

> "Whilst thou art rich, oh, how many friends thou hast!
> But, when the weather changes and the sky is overcast,
> alas, how alone thou be!"[22]

—Alfonso Martínez de Toledo

The expression "fair-weather friends" that we use today meant exactly the same in the Middle Ages. Whilst she had money, lived a life of prosperity, and needed nothing, a medieval woman's friends were plentiful; but once she faced misfortune, most of her friends vanished. Only her truest were there for her, or none at all.

Itinerant female musicians and dancers also fell into the category of women who didn't have permanent homes or reliable incomes. Often, they travelled with their troupe from town to town as part of a performing company, seeking food and employment where they could in exchange for entertainment.

Another subset of fringe-dwellers in medieval society were women who made their living by selling themselves for sexual favours. Their lives varied from the poorest, to those living in brothels, to others working within the Guild of Prostitutes with set working hours and wages. We know from sumptuary law ordinances that this could provide enough money to pay for fine clothing, but for many, the working conditions were poor, and the clientele not of the highest calibre.

One Bavarian woman who left the industry, found religion, and turned over a completely new leaf was Afra of Augsburg, who was canonised and became a saint known as Saint Afra the Penitent. She died in 304 CE, when she refused to renounce her Christian faith and was burned.[23]

Many prostitutes came to the profession as widows, after the deaths of their husbands, having no job skills or ability to support themselves by other means. One set of verses by Villon in mid-fifteenth-century Paris, describes the feelings of the woman who is aging badly and does not even have her previous beauty to console herself. One verse, in particular, tells her misfortune, while the next four are devoted to describing her physical attributes and how much they have changed.

> "Well, he is dead, gone thirty years and more
> And I am left, old, white-haired.
> When I think back, sad wretch, to the good times,
> When I gaze at my naked self
> (What I was once, what I've become)
> And I see myself so very changed,
> Poor, dried-up, skinny, shrunken,
> I'm almost driven out of my mind."[24]
>
> —François Villon

Nuns and Cloistered Women

A single woman might embrace the holy life, or have it thrust unwillingly upon her. Convent living, with or without a real vocation, offered an opportunity for a reasonably full life without being attached to a husband or father. Single women could give up their worldly life and family, take the ring and the mantle of the religious life, and accept the three vows of poverty, chastity, and obedience.

Not everyone willingly made the choice to take this road. A young girl might be given whilst still a child to be brought up as a nun. This was known as an *oblate*. A *postulant* was a woman voluntarily looking to join, and a *novice* was a nun undergoing training who had not yet taken her final vows. There was no special name given to the women forcibly dumped by their fathers or guardians in cloisters for safekeeping until marriage. Unhappy. Angry. Betrayed, perhaps.

There were a number of branches of nunneries and priories during the Middle Ages. They split from other houses or founded their own based on differences in doctrine or ministry. These are, in chronological order of foundation:

> 630 CE Benedictine nuns
> 1130 Gilbertine nuns
> Twelfth century Carmelite sisters
> 1206 Dominican nuns
> 1212 Franciscan nuns
> 1212 Poor Clares
> 1535 Ursuline nuns
> 1235–41 Augustine nuns
> 1633 Daughters of Charity of St. Vincent de Paul

Essentially, these women were married to God in the theological world, but single in the real world.

A number of single women who became nuns had a genuine wish for this life and prospered in the environment. It was quiet and ordered, and it had the fellowship of other women and offered the opportunity to learn new skills. One such woman was Hildegard von Bingen, who was born in 1098 in Bermersheim, Germany, and became a nun at the tender age of sixteen. Hildegard rose to the rank of Benedictine abbess in 1136 at Disibodenberg. She died in 1181, but not before learning to be literate; composing music; writing treatises and books on numerous subjects, including the properties of all things;[25] and becoming a saint.

Hildegard's most famous work was *Physica, Liber Simplicis Medicinae*, or the *Book of Composed Medicine*, where she explained the nature of plants, stones, animals, and the elements, and described their uses, benefits, and drawbacks. *Physica* continued to be circulated for many centuries after her death. It was a compendium worth exploring, with observations on the natural world and a large dose of folklore and remedies mixed in.

Some of her extrapolations on the benefits of certain things and her recipes for the use of certain ingredients seem, to modern eyes, hilariously off the mark, but some of her other advice is grounded in science and, even today, is comparatively sensible. Her thought that wild lettuce, for example, when boiled, bathed in, and applied to the thighs of a man, would have a lust-reducing effect seems a bit far-fetched, but on closer examination, we know today that wild lettuce contains chemicals which have mild soporific and analgesic effects, so her conclusion that it would help quell flames of desire are actually not completely ungrounded.

Hildegard's writings include:

> *Aphorisma*
> (her personal notebook)
>
> *Causae et Curau, Part II, Liber Compositae Medicinae*
> (Book of Healing Methods)
>
> *Liber Divinorum Operum*
> (Book of Divine Works)
>
> *Liber Vitae Meritorum*
> (Book of Life's Merits)
>
> *Lingua Ignota*
> (her own unknown language not decoded)
>
> *Physica, Liber Simplicis Medicinae*
> (Book of Composed Medicine)
>
> *Scivias*
> (Book of Faith or Know the Ways)
>
> *Symphonia Harmonia Coelestium Revolutionum*
> (The harmonic symphony of cosmic revolutions)

Whilst there is no doubt that some women took to a spiritual life with a genuine religious vocation, others were sent to nunneries as younger girls as a stopgap whilst awaiting a suitable marriage, or to prevent them from marrying or remarrying at all. This meant that any lands, holdings, or inheritance specifically willed to her remained under the control of male siblings or other family members. It was a convenient way to seize control of her assets whilst she was still alive.

On a positive note, there were educational opportunities which might be offered. Literacy might be taught at some level, and other skills could be acquired. Older, wealthy women might see

the benefit of an all-female-led life and enter willingly to escape the outside world, but without any real interest in holy matters; these ladies were often disruptive to the peace and tranquillity of the cloisters, and we find them bitterly complained about in the ledgers of visiting diocese.

One nun at Greenfield Priory in 1525 was singled out for special mention with a short, despairing entry in the ledger, noting:

> "Agnes Kettill does not seem suitable to be a nun."[26]

Perhaps the hapless Agnes was deposited there for safekeeping by her family, as was often the case with marriageable daughters who weren't behaving themselves, and was having a hard time adjusting to her newly imposed lifestyle. Should a young maiden enter the cloister or nunnery willingly at first but change her mind and wish to leave in order to marry later, she could do so, but not without penalty. The *Poenitentiale Hubertense*, dated at ca. 850, set down what was to happen.

> "If any maiden vows herself to the service of God and changes to a secular habit, she shall be deprived of communion and separated from her husband; she shall do penance and not be joined to her husband thereafter."[27]

St. Hubert's words indicated that even after marriage, the woman in question should not *be joined* to her husband, which made her marriage pointless. He also mandated that those who committed fornication with such women be treated exactly the same as those who had sex with the wife or betrothed of another man.

Chapter 2
There's No Place like Home

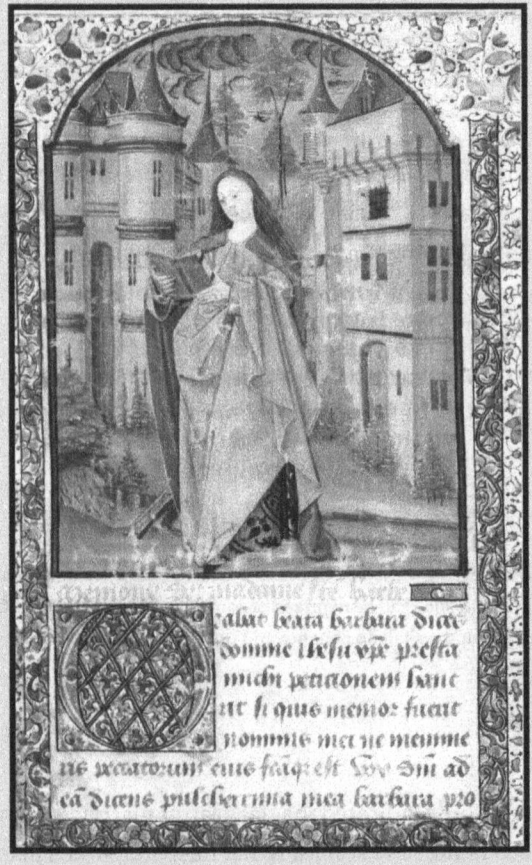

Figure 2. Saint Barbara stands in front of homes of the wealthy. The miniature from the volume's suffrages (short prayers or memorials to particular saints) is dedicated to St. Barbara. Master of Jacques de Luxembourg, 1460. Cleveland Art Gallery 2011.63. Creative Commons Zero, Public Domain.

A place to call home is a basic life necessity, and finding a home in the Middle Ages was no different than at any other time in history. A single girl needed somewhere to stay, a place to come home to, or a place to call her own, even if it wasn't actually owned by her. Whether a wealthy merchant or a peasant indentured on an estate, individual circumstances offered limited options and many times, those options were decided on her behalf and without her consultation by her father or guardian.

Young Girls

In her early childhood, it was commonly agreed that a single girl child should live with her mother or blood-related female family members, who would teach her all the things that she should know and prepare her for her future life. Having said that, it must be noted that mothers did not automatically have custody of their own children, and in the cases of well-off families, mothers might need to apply for wardship of their own daughters. Only in some court cases was the mother awarded custody.[1] If, however, a young girl was an orphan from a wealthy family, she might quickly be made a ward of the king, who would find a suitable place for her upbringing until she reached marriageable age. At that juncture, a suitable husband would be found. Suitable to the wishes and political conveniences of the king, that is.

This status was called being "in the king's gift" and could apply to wealthy widows as well. In cases where the child was a part of a feudal household, guardianship of a child after the death of its father passed automatically to the lord until the child came of age. A mother might apply for guardianship, but sentiment was often overlooked in the interests of the child's future as seen from the lord's perspective.[2]

Susan Broune, whose exact age we don't know, must have been young when her guardianship was left by her father to another family. This included her share of goods and land, which was also passed to the couple who took her. The will of John Broune, dated 1493, states his wishes quite clearly so there would be no doubt on the matter.

> "Also I leave my daughter Susan to Robert Preston with her portion and I leave to Janet his wife for to be a good mother to her, 6s 8d."[3]

It is of interest to note that Susan was not given to the care of Robert's wife Janet directly, although it is without question that she would be the primary caregiver of the child. Susan was passed from the guardianship of John Broune to Robert Preston, one male person to another.

Some young girls were given to religious houses as foundlings or orphans for charitable care, but in the 1408 bishops' register in Salisbury, we meet Katherine Brombelegh, who was not just being given as a child ward to raise in lieu of a suitable parent, but being offered as a potential nun for religious training.

> "Letter to the abbess and convent of Shaftesbury nominating as nun, Katherine, daughter of John Brombelegh of Sherborne, a young girl, in accordance with the bishop of Salisbury's customary right of appointment. She will be sent by the bishop and is to be received and put into the company of Agnes Poney, who is to instruct her in the regular disciplines."[4]

Whether Agnes had any say in the matter of becoming a responsible substitute mother for a young girl or not isn't mentioned, but it is hoped that this was a task to which she was well-suited. Katherine, of course, had no say in the matter whatsoever. Where her parents were and why they could no longer be her guardians is not mentioned. They may have died or may have wanted a religious sister in the family to pray for them in the future, since the weight of a nun's prayers carried more influence with God than a regular person's, which would be particularly helpful to erase the deeds of a sinful life.

Young girls who were born out of wedlock might be given to an orphanage straight from one of the charitable hospitals which helped unwed mothers. Others maintained the children until seven years of age, before other arrangements were made.

The hospital of St. Leonard in York was given special concessions for its work with infants, and by 1287 it housed eighteen children of both sexes, a housewife in charge, and one or two cows, which provided milk. By 1364, forty-seven loaves of bread were set aside weekly for feeding the children, along with milk, still provided by two cows.[5]

Unmarried Maidens and Spinsters

An older, unmarried woman had a few options for accommodation. Firstly, she could live with her own parents at the familial home and earn her keep cooking, cleaning, doing laundry, and working in the fields, or hiring herself out as a labourer for seasonal farmwork

in her local area. Unmarried daughters remained dependants and were not seen as proper individuals.

For many a rich, unmarried single lady, time was spent preparing for the life ahead, as the supervisor of a house herself, employing other single women to work beneath her. She lived comfortably at home in the manor house she grew up in and was entirely dependent on her parents to provide her with the necessities of daily food and clothing.

While single women were unable to purchase their own homes for the bulk of the medieval period, some inherited them from family or leased them in their own right, and there are a few records of women buying land for themselves.[6] This indicates that they must have had the means to do so independently, but they aren't common.

Some peasant women were included in land bequests. Rolls from the Manor of Brigstock, Northamptonshire, show that a quarter of the lands given to children by their parents were passed to unmarried daughters. It was noted that it might be years before the girls married and was not especially for dowry. It may be expected that some of these lands would be returned to her father upon marriage, as her new husband would provide the home and land on which she worked.[7]

The second option for accommodation included situations like living as a housekeeper for a priest or a male, adult sibling who had his own home but was not yet married. She might work as a servant or companion and be a full-time, live-in employee with a small wage but a rent-free place to reside.

The Goodman of Paris advised his wife that her chamber maids who lived with them, being young and single, would need watching, and told her to approach the situation with a firm hand. Their sleeping arrangements should definitely be carefully monitored, ideally in a room without windows overlooking the street, lest they become distracted by boys.

> *"...if you have girls or chambermaids of fifteen to twenty years, since they be foolish at that age and naught have seen of the world, ...cause them to sleep near you, in a closet or chamber, where there is no dormer window or low window looking onto the road..."*[8]

—Goodman of Paris

This indicated that both young women who were employed as her personal maids lived in the household itself on a permanent basis. Ladies like these can be seen in numerous images from art like the Gradual illumination leaf of *the Birth of the Virgin in an Initial G*, by Don Silvestro de Gherarducci, working in Florence, 1375. It shows five female attendants or servants, and two sainted women. These may have lived in the household, but certainly would have been young women of spotless repute.

A term or terms of paid service in another household might be rewarded with not only a salary and a place to stay, but either money or goods which, added to her own household goods, helped set up a young woman for her future life. Women were often the beneficiaries of wills, in return for years of loyal service.

The will of William Nunhouse, a fishmonger from York, leaves his servant, Margaret, a number of goods and some monetary endowments to his other two servants:

> "Also I leave my servant Margaret, a Prussian chest, a brass pot of my wife's choosing, a coverlet, a blanket with a pair of sheets so that the aforesaid Margaret does not leave or depart from my wife Joan's service during the term of her hire and contract made between me and her.
>
> I also leave Cecily my servant 2s.
>
> Also I leave Agnes my servant 12d."[9]

These goods and monies were bequeathed to the girls specifically and became their own property.

Widows

Those previously married, but now widowed, might continue to live in their extant homes, either for a short while or permanently. These homes ranged from modest country houses to brick-and-mortar multi-level homes in a city, which are shown in manuscripts in cut-away form to reveal the interiors. These houses, much like our own, had stairs, windows, tile or timber floors, and soft furnishings which echo our own. Cushions, tablecloths, ornately carved furniture, and pretty tableware were part of the medieval woman's world.

Widows might live, temporarily or permanently, in homes willed to them by their husbands, which were to be handed over to their sons upon marriage. Lands and housing could be willed to the sons in name only, so that, should the widow remarry, the property did not pass to her new husband instead of her children. These properties came with conditions, which might stipulate where the mother was to live, for how long she should reside there, and what extras, if any, she could expect on a yearly basis until the end of

her life, or remarriage. Inclusions of clothing, food, and firewood were mentioned, providing the widow with some of her basic life necessities for the foreseeable future.

These wills with special considerations might have initially started congenially, but court cases indicate that unfair evictions and contracts not met caused issues within families. We see that this was anticipated in the case of one Joan Hardy of Lyddington. Her husband, Robert, makes his wishes very clear on the matter.

> "...Also I will that Joan my wife will have the profit and governance of the house and lands for the term of her life, and if any of my children be obstinate and cause trouble toward their mother against my will, he that so troubles is to have nothing other than at his mother's will..."[10]

Robert ensures that his children do not oust their mother for any reason whatsoever, under penalty that they would absolutely lose their inheritance altogether.

Other widows remained in the family home and held the husband's land and goods until a minor child came of age and became the new owner of his father's property. It was not unusual that, under the terms of this agreement, the widow was required to remain single and of good character for the duration of this transitional period. In the case of Alice Ederych of Tottenham, her young son was just six years old when her husband died, meaning she could reasonably look forward to many years of living in her own home without the expectation of remarriage. The court rolls of 1395 show this expressly:

> "To this court has come Alice, late wife of Thoman Ederych and receives of the lord the tenure of five acres and three roods of land to hold to herself until the legal age of John, the youngest son of the aforesaid Thomas, who, according to the custom of the manor, will inherit the land in bondage, and the aforesaid Alice is to keep the said John, who is now six years of age, in food and clothing well and competently until his legal age, and she gives the lord fine for entry...
>
> And after the full age of the said heir, if she shall have kept herself sole and in good repute without a husband, then she shall have the tenements and land for her whole life, and if she shall not, then it is to be taken into the lord's hands according to the custom of the manor."[11]

In this way, a widow could remain single and retain the life she had been living in the home she already had, minus a husband, for a number of years.

Beggars, Single Mothers and Fringe-Dwellers

Beggars, unmarried mothers, poor women, and performers often lived an itinerant life, moving from town to town in an effort to make ends meet and avoid starvation, or in the case of musicians and seasonal workers, seeking new audiences or following trade fairs and markets. Very often they were moved on from the towns and cities to beyond their walls, where they ceased to be people of any concern to the authorities at all.

Single women like these are mentioned little in stories and books, except as dire warnings as to what might happen if the many rules and regulations of polite society were not met. She should fall on

"hard times," dress in rags, be starving and pitied by one and all. Borough courts do mention these women, but overwhelmingly to fine them for misbehaviour or to report their deaths from exposure while begging on the streets.

While temporary accommodation could be sought in hospices run by the religious houses, it couldn't be relied on as any kind of permanent home. The *Visitations in the Diocese of Lincoln* from 1530 named a certain widow who was assisting unwed mothers in her Oxford home and was brought to court for it. The brief record reads:

> "Widow [uxor] Colls receives pregnant women in her home in which they are cared for."[12]

One might think that this act of charity should be rewarded as meritorious, not singled out as a neighbourhood disturbance, but evidently her neighbours thought otherwise.

Those unfortunates, with child and without husbands, often found themselves estranged from their own family homes for bringing disgrace to themselves, and therefore their fathers. Fortunately, hospitals took the burden of housing them, even if just for their confinement or late confinement, delivery, and post-natal recovery, until the time of the mother's churching, which was a period of six weeks. There were a limited number of places available, so this option could not be guaranteed.

At least three major hospitals in medieval England offered this kind of assistance to pregnant women. St. Mary's in Bishopsgate is recorded as having tax exemptions as a concession for its

charitable work of this nature in both 1341 and 1344. Southwark, famed for its brothels and bathhouses and therefore an area more likely to have unwanted pregnancies, claimed St. Thomas as a place of refuge for the time of delivery. St. Bartholomew's, also in London, is likewise named as assisting poor, unwed mothers until the weeks after they were fit to be reintroduced into society for their churching.

Nuns and Cloistered Women

By the end of the medieval period, and into the early Tudor period of the 1530s, there were around 840 religious institutions in England, 150 of which provided housing and sanctuary from the outside world for the sisters and cloistered women who lived within their walls. Although there were eight branches of religious houses for women to choose from, two were more dominant, the Benedictines and the Augustines. Nunneries were encouraged to be self-supporting, with all that was needed inside the walls. Bathing facilities, water, a garden for both herbs and vegetables and fruits, a bakehouse with an oven, and a mill for processing grain[13] were standard. A large majority of these religious houses were known as priories, ruled over by a prioress.

Daily life in the priory or nunnery was divided into three parts, each considered as important as the others: manual labour, devotionals, and singing in each of the eight services daily.[14] These were:

Matins: the very early hours of the morning for night office.

Lauds: a little later in the early morning.

Prime: around sunrise.

Terce: mid-morning.

Sext: midday.

None: mid-afternoon.

Vespers: around sunset or early evening.

Compline: late evening before bed.

The advised daily routine for an institution such as this was given in the twelfth century with clear and concise instructions, so that it might easily be understood what was expected.

"They must rise at midnight for the Night Office. After the Office they should return to the dormitory until the hour is struck for morning Lauds. The morning hour should be celebrated as soon as the day dawns, and if it can be arranged, the bell should be rung at sunrise. When it is ended the sisters should return to their dormitory...and we are willing for them to sleep a little before Prime, until they are waked by the bell.

On coming out of the dormitory they must wash and then take books and sit in the cloister reading or chanting until Prime is rung.

After Prime they should go to Chapter, and when all are seated there, a lesson from the Martyrology should be read... After this, there should be some edifying words or some of the Rule should be read out and expounded...

On coming out from Chapter, the sisters should apply themselves to suitable tasks, reading or chanting or handiwork until Terce. After Terce the Mass shall be said...

> After Mass they should return again to their work until Sext and not waste any idleness; everyone must do what she can and what is right for her.
>
> After Sext they should have lunch, unless it is a fast-day, when they must wait until None, and in Lent, even until Vespers.
>
> In summer they should rest in their dormitory after lunch until None, and after None return to work until Vespers. Immediately after Vespers, they should eat and drink, and then, according to the custom of the season, they should go to Collation...
>
> After Collation they are to come at once to Compline, and then retire to sleep."[15]

Daily meals were a communal affair, with the abbess joining the rest of the women, although complaints about dining alone, or in a chamber with special guests, are noted in church records.

For those cloisters which observed strict rules of complete silence, hand signals much like our sign language today were used. This can be seen pictorially in the detail from *The Life of Blessed Saint Humility* by Pietro Lorenzetti, dated at 1341. The nuns eat while a bible reading is taking place from a window above their heads. At the table, communication is done by pointing and gestures.

Sleeping arrangements were one nun to a bed, although several complaints from visiting bishops show that this was not strictly adhered to. Other women, and sometimes children, shared the nuns' sleeping spaces, and complaints about guests, both male and female, staying overnight were also disapprovingly recorded from time to time.

The Bishop of Lincoln was unimpressed with the state of affairs at Burnham Abbey in 1521 and made note of it in his report.

> "The abbess ought by the monastic rule to sleep in the dormitory and eat in the refectory with the nuns. The present abbess, however, does not do this, but sleeps in her chamber and has another nun in her bed with her and she eats in her chamber.
>
> The bishop commanded the abbess that she eat at all times in the refectory and that she never have anyone in her bed with her..."[16]

That these observations were made repeatedly at differing cloisters show that this was a widespread issue, at least for the bishops and the nuns who weren't included.

Chapter 3
Dressing for Success

Figure 3. A fashionably dressed young women with buttons to her elbows with long, hanging lappets on her sleeves and fur-trimmed fichets in her surcote. English *Book of Hours*, between 1300 and 1400. Walters Art Gallery. W105 obverse detail.

Clothing and dress accessories were a minefield for the unattached medieval girl. One might wish to dress in a fetching manner to catch the attention of a future husband, but one also needed to be careful not to become a laughingstock in the town or to be seen as gaudy, vulgar, or available for the taking. There were enough criticisms of the clothing standards of the wives of nobles and the upwardly mobile aspirations of the affluent merchant class without single women drawing attention to themselves in an unseemly manner.

The preacher's handbook, *Fasciculus Morum*, cautions men that the manner of clothing worn by some vain women was an incitement to lechery, which they should both be aware of and avoid. Instead of advocating that the issue could be solved by covering up the women, in this instance, he thought men should just not look at them and the matter would be resolved.

> *"To Interpret morally...*
> *women who are dressed up and decked out to provoke lust;*
> *if you plan to overcome and extinguish their evil flames,*
> *turn away your eyes that they may not see vanity..."*[1]
>
> —*Fasciculus Morum*

Sumptuary laws attempted to define the types of fabrics and dress accessories each class could wear. These were seen as helpful suggestions, at best, by those who could afford to dress above their station, and were widely disregarded by many, causing the laws to be updated and reissued every few years. Ingenious ways to circumnavigate the rules were adopted. When questioned by authorities about the length of the tippet on her hood, one lady demonstrated that it was merely pinned on, and therefore not a part of her hood at all.

Jewellery should be functional—brooches to close the front of a dress, or a simple ring. Belts should not be ostentatious displays of wealth, but practical places to hang a purse. In spite of this, belts were festooned with metal mounts of various shapes, brooches were set with precious and semi-precious gemstones, and jewellery continued to be an opportunity for display for those who could afford it.

For those who couldn't afford gold brooches, brass ones were an acceptable alternative, with glass-paste stones duplicating gemstones. In this manner, a young lady could emulate high-end jewellery at a very affordable price. Existing archaeological finds occasionally have the stones and pins still in place, giving us insights into not only their construction, but their size and composition.

Respectability and modesty were the keys to the single lady's wardrobe, according to absolutely everyone who was in charge of single women. And priests. Priests also had a good deal to say on what *they* felt was appropriate clothing for women to wear.

Thomas Aquinas put a lot of thought into women's fashion for a man of the cloth, and in 1340 he put his opinions to paper. He advised married women to dress attractively so their husbands wouldn't be tempted into adultery by straying from them, but in the same breath he pointed out that, if they were too attractively dressed, they might lead some *other* woman's husband to adultery. He surprisingly and reluctantly felt that a woman might be permitted to dress as a man in order to flee an enemy or…if they had absolutely nothing else to put on."[2]

Young Girls

A young, unmarried girl's clothing was the responsibility of her mother or guardian. She wore whatever was provided and had no choice in the matter.

Single girls wore the fashions and styles of their mothers, usually modest kirtles which reached to the ankle and had long sleeves. The notable exception, when it came to creating an acceptable appearance, was that a small child or young maiden's hair could be left loose, not braided or hidden under the veils and wimples which were popular in the thirteenth and fourteenth centuries. In medieval art, we do sometimes see young girls with their hair hidden, sporting the hairstyles of their older sisters and mothers, but this seems to be in cases of the very wealthy, who are promoting themselves as a well-bred family line for future generations to see.

It was important, and this was largely agreed, that a young girl dress modestly. Advice to girls and older, single maidens was repeated by Christine de Pizan, a fifteenth-century French writer who had much to say to other women via her books, and who had three children herself. Erring on the side of caution was her position.

> *"Protect yourself from blame and ill-repute because of appearance, cost, or style of your clothing."*[3]
>
> —Christine de Pizan

Less wealthy girls often had to be content with hand-me-down clothes, passed down for the same economic reason as families

today. Should a developing child outgrow an item of clothing, it would hardly be thrown out if there were a younger sibling to dress; it would be passed down to the next smallest child in the house, especially in households of lower financial standing. These might be remade to suit the body shape of the new wearer, so the fabric wasn't wasted and the clothing fitted nicely.

On the whole, a young girl's clothing echoed that of her mother in cut, cost, style, and fabric, as can be seen in the image of a young fifteenth-century girl purchasing dress accessories with her mother in the lower margin of *Hours of Duke Adolph of Cleves*. Both wear the tall, conical hennin and Burgundian-style gown with wide fur cuffs at the wrists and wide fabric belt worn just under the bust. They are shopping for jewellery and pointing to a large, trefoil brooch pinned to the wall.

Maidens and Spinsters

An older, unmarried woman, one who was able to choose her own attire and manner of dress accessories, was generally careful to dress in a modest and socially appropriate manner. Being single, a woman did not want to attract the wrong kind of attention from lecherous men or slanderous women. Even though she was her own woman in one sense, any scandalous behaviour, including the way she spoke, acted, and dressed, reflected badly on her male head of house. Bringing disrepute on one's father might negatively affect his business, and attracting the attention of gossipy townspeople ruined reputations and potential good matches or employment opportunities.

Men were warned about the dangers of women who were too beautifully dressed and were likened to certain flowers which, while beautiful to look at, were dangerous.

> *"The hawthorn has many beautiful blossoms in open view,*
> *yet underneath it carried very sharp thorns.*
> *Women are just like that:*
> *the more decked out and beautiful they are,*
> *the more sharply they sting."*[4]
>
> —*Fasciculus Morum*

The lesson here was clear. Women who spent significant time and effort on making themselves eye-catching were most likely not wholesome underneath. A woman should not be as eye-catching as a plant with many gorgeous blossoms when her underlying character was not soft and mild. Maidens who dressed immodestly were not to be applauded. Less exterior showiness and more underlying character was what was needed, he felt.

She might not be expensively dressed, but respectability was the goal.

That said, many young women who were not yet burdened with running a household of their own—and who were rich enough to have the leisure time to do so—spent more time and effort on items of clothing designed to get them noticed by the opposite sex than their working counterparts did.

One German preacher in the thirteenth century, Berthold of Regensburg, commented with annoyance. Women, he believed, were spending far too much time and energy on decorating their clothes instead of engaging in other employments of their time.

> *"...you busy yourselves with naught by vanity.*
> *You busy yourselves with your veils...*
> *you gild them here and there with gold thread,*
> *and spend thereon all your time and trouble.*
> *You will spend a good six months' work*
> *on a single veil which is sinful great travail*
> *and all that men may praise thy dress."*[5]

—Berthold of Regensburg

Complaints like these reverberated through many countries as men attempted to tell women what *they* thought they should or shouldn't be wearing. Complaints from the pulpit over several hundred years were many, and it appears the thought that women might just like to wear pretty things for themselves, not as mantraps or incitement to lust, did not seem to have occurred to them.

While the names of various items of a medieval woman's wardrobe varied throughout the period, most of the common garments remained the same. For example, a *cote*, *kirtle*, *gowne*, or *cotehardie* may vary with subtle differences, but it was essentially almost the same garment: the dress, which was worn over the linen undergarment and, where needed, under a second surcote.

Fabrics for the upper classes included silks and stiff brocades woven with gold metal thread, but the overwhelming choice for medieval clothing was wool. It had excellent wellness properties, according to health handbooks, and was easy to acquire. Both rich and poor people wore wool, and at no time was it considered a fabric suitable only for the poor. Only the quality differed.

It must be remembered that, although textile production may have been done at home in rural areas, the quality of the finished cloth

and clothing was higher than movies imagine today. Medieval women could spin and sew, and home-made clothing neither was of poor quality nor had chunky, large stitches. Cloth made from hand-spun fibres was not rough, full of chunky knobs and inclusions. By the time a woman was old enough to be making clothing, she had had many years of spinning and weaving practice under the tutelage of her mother and was skilled. The clothing of the working class needed to be sturdy, well-made, and durable. It might be worn and patched and repatched, but this still didn't mean it was poorly made in the first place.

The first layer of clothing for any female, the chemise or smock of white linen, was worn next to the skin like a full or three-quarter slip petticoat, along with any undergarments. It might have long sleeves or be sleeveless. The bath house attendants in the Bohemian *Wenceslas Bible* from the late fourteenth century are shown wearing filmy, semi-transparent chemises with thin straps over the shoulder and no sleeves, whereas other manuscripts show opaque, long-sleeved garments.

A further style option of a bra or shaped chemise with two distinct round cups for breasts, worn as a foundation garment, is seen in fifteenth-century Germany, where we see these represented in artworks and in a singular extant archaeological find. The shaped chemise with two cups was also laced at the side, giving a firm foundation garment which would, indeed give noticeable raised bust support or alternatively help to contain a larger bosom. Reconstructions of the one found at Lengburg Castle, studied by Beatrix Nutz, confirm this.

An unknown text from the medieval period speaks of these bra-type foundation garments:

> "Many a woman makes two breast bags, with them she roams the streets, so that all the young men that look at her can see her beautiful breasts; but whose breasts are too large, makes tight pouches, so there is no gossip in the city about her big breasts."[6]

English manuscripts show merely an A-line shift, usually with long sleeves, without the benefit of breast bags.

The cote, kirtle, or gown was the second layer, worn over the linen chemise or smock. Before the 1350s, this garment was a looser, A-line garment made from rectangular fabric sections with triangular gores set into the seams giving fullness at the bottom of the hem. These were without rows of buttons or lacings at the front, and pulled on over the head. It was usual for these to have a small slit down the front to allow the high neckline to pass over the head and be secured with a brooch. There might be several small buttons at the wrist. This style of kirtle persisted into the latter half of the century for the lower working classes, who found the later fitted fashions impractical for active jobs.

Around 1350, fashions changed for the wealthy and buttons became more popular, which caused a dramatic fashion shift. The mid-fourteenth century saw kirtles becoming more tailored to the wearer's body, buttoned or laced and having sleeves with many smaller buttons up to or past the elbow to the upper arm. As the fifteenth century drew nearer, some kirtles adopted a waist and had the skirt gathered onto it.

Working women had more practical versions of these, with hems not quite reaching the ground and sleeves not so tight that they couldn't work comfortably. These had fewer buttons and required less effort to put on unassisted. The elite favoured very tight

kirtles, with closely buttoned sleeves and long trains, which let onlookers know that here was a woman of means who could afford voluminous quantities of expensive fabric and was unconcerned about ruining her hems, or cleaning them.

The third layer of a medieval woman's clothing was a surcote of some kind. Styles varied from essentially a second sleeved or sleeveless overdress to one with wide sleeves and a high neck, like the houppelande, or sideless surcotes with large, showy buttons or metalwork plaques down the front. Many of these were fur-lined for warmth. We know that some of these were bag-lined—sewn together in one piece as an entire lining—because in wills, like one of a widow in Oxford, the outer garment is gifted to one person and the fur lining is gifted to another.[7] This would not be possible if the garment was made with the fur lining sewn to the individual pattern pieces before being assembled.

Many surcotes were almost identical to the kirtles worn underneath them, and we see them as surcotes when the outer layer is lifted, as shown in the image of a female saint from the book of hours by the Master of Zweder van Culemborg. The woman's green surcoat reveals a printed or brocaded kirtle underneath.

Sideless surcotes, which were so called for their distinctive style of not having sides, could be entirely lined or bordered with expensive furs, or partially furred at the top with wide fur hems. These were particularly favoured by the wealthy. This style of garment was cut away at the sides in sweeping curves and worn by women who could afford to do so as a fashion statement. The cutouts allowed the expensive, possibly brocaded garment underneath, the tight-fitting kirtle, and the figure of the person wearing it, all to be seen.

For travelling, another less fashionable and more voluminous surcote might be added, as well as a cloak and hood with a cowl.⁸ This style of surcote was designed to protect the wearer from the elements and had wider sleeves which covered the arms without buttons. It was, altogether, a very practical garment.

On her lower legs, a medieval woman wore high woollen, over-the-knee socks called hose, which were held up with garters. These might be made of tablet woven bands, leather or wool. Those who could afford them had the option of buckles, but one extant one in the Museum of London, with decorative *daggues*, is merely tied.

Leather shoes were worn by both upper and lower classes alike. A very common style of plain medieval shoe, worn by both men and women, looks very similar to our Mary Janes of today! Workers in the fields are shown in art wearing ankle boots, which would have been far more practical for field work than the more lightweight footwear suited to noble ladies and indoor staff. The shoes of the more wealthy were stamped in decorative patterns or had fancy cutwork designs. Remnants of these can be seen in museums today.

The well-bred lady wore a veil or hood, or some kind of hairnet and covering, in public for most of the Middle Ages. It was fashionable for the hood to have a long dangling tail, called a *tippet* or *liripipe*, which might be quite lengthy. There was no practical purpose for liripipes, and while the term correctly described the specific part of the hood which dangled, after a while the entire hood was known as a liripipe.

For the bulk of the medieval period, it was not polite for a grown woman to display her hair undressed. Hair was sexy and alluring, and undressed, it was eye-catching. For a great deal of the time, to

go out with a bare, undressed head, when not a child, could have a woman marked as a prostitute or a woman of dubious morals.

Fourteenth-century English women wore their hair fashionably plaited above the temples, or in two folded plaits framing the sides of the face. In the fifteenth century, it became the fashion to wear them on the top of the head, resembling small cow horns, which, as you'd imagine, caused a great deal of angst with the churchmen of the day who had a lot to say about it.

Countries like Spain and Italy favoured elaborately braided hairstyles with transparent veils. Countless paintings of the Virgin Mary show her wearing beautifully embroidered, gauzy veils, and women in Italian art can be seen sporting multiple braids and beading which might also utilise a small strip of transparent veil around the ears, seemingly as a token afterthought.

In Italy, veils might have stripes woven into them, whilst in artwork from England and other parts of Europe, we see more opaque linen veils, with two iconic braids peeking out from the sides of a woman's face under her headwear. The wimple, barbette, and gorget were also widely worn by women of good breeding, and it was only later in the fifteenth century that they were dropped as daily wear by the general populace and retained by nuns and older women.

Veils could be made from a variety of fabrics, ranging from fine opaque linens to gauzy barely-there silks. For the poorer woman, thick linen or wool was both a practical and a warm option to provide protection from the elements. Fine Flemish linens could have thread counts of between sixty and two hundred per inch and could cost thirty times as much as finely woven wools, indicating the good quality and desirability of the fabric.

The *goffered* veil or *nebule* was a frilled affair which consisted of an intricate lattice or honeycomb effect from ruffles which formed a frame around the face. It was mostly popular during the period of 1350 to 1380, although there are a few examples of this style of veil both earlier and later. This fashion was not a style for those who worked outdoors or in manual labour.

Not content with providing a practical way to ward off the elements whilst being a necessary fashion item, *De Ornatu Mulierum*, from the eleventh century, advised that a veil could be made to smell nice too, with this tip:

> "Also the veil with which the head is tied should be put on with cloves and musk, nutmeg and other sweet-smelling substances."[9]

As fabric was handmade and very expensive, clothing was seen as a status indicator—the richer the wearer, the better quality and more costly the fabric, and the more voluminous the garments. Wealthier persons wore more layers, often lined with expensive furs in winter, while those with a more moderate income wore fewer layers, which were often unlined.

Sumptuary laws concerned themselves with expensive dress and attempted to limit the fabrics and furs which were permitted to each class of person. The laws of 1363 condemned *"outrageous and excessive apparel of diverse people, contrary to their estate and degree"* and were exceedingly specific as to what fabrics and furs were permitted to whom. The trouble with the newly affluent merchant class, who lived and worked in cities, was that many of these single women could afford finer fabrics than their social superiors, and it became a sore point for the nobility, who wanted their own clothes

to stand out. What joy was there in having showy clothes if even the daughter of a banker or jeweller could wear them?

Clothing was made by hand without the benefit of a sewing machine, whether by the lady of the house herself, by her in-house seamstress, or bought off the rack from a mercer's store. Ready-made clothing was available to the townswoman, but some women may have still preferred to buy the fabric and have their in-house servants make their own. By sewing her clothing herself, the townswoman was able to have a well-fitting garment without the expense of hiring a professional tailor to make it.

Many, of course, did get their clothes tailor-made or buy off-the-rack, pre-made garments.

Upwardly mobile daughters of the newly wealthy merchant classes dressed in the latest fashions hoping to gain the attention and future marriage to their social superiors. Stamped leather belts, or woven silk belts with metal mounts, shoes in bright red with decorated punchwork, and long tippets streaming from the upper arm were all designed to be noticed. Affluent city women were very well-off and strove to emulate their noblewoman icons in dress. In the case of royal households, a tailor might be employed full-time, along with laundresses and other clothing specialists to dress the young ladies and single women of the house and staff.

In the late fourteenth century, the *Menagier de Paris* wrote instructions for his very young bride on what he regarded as respectable and suitable clothing for her. These ideals also would have applied to single women of that time.

> *"I will here speak a little of dress...*
> *See that you are honestly clad,*
> *without new devices and too much frippery or too little.*
> *And before you leave your chamber or house,*
> *see you first that the collar of your shift, and your blanchet,*
> *your robe or your surcote, straggle not forth one upon the other,*
> *as befalleth with certain drunken, foolish or ignorant women,*
> *who have no regard for their honour,*
> *nor for the honesty of their estate or of their husbands...*
> *their hair straying out of their wimples*
> *and their collars of their shifts and robes one upon the other...*
> *Beware then, fair sister,*
> *that your hair, your wimple, your kerchief and your hood*
> *and the rest of your attire be full neatly and simply ordered*
> *so that none who see you can laugh nor mock you..."*[10]
>
> —Goodman of Paris

Twice he brings up the issue of seeing the under layers poking out. A careless attitude toward clothes and person was seen as a careless attitude toward all other things in life, it was thought. It was extremely important that a woman's chemise not show, as it was essentially her underwear. A good general rule of thumb for clothing was that the under layer was covered by the next: the chemise was covered by the kirtle, the kirtle by the surcote. One would not expect to find a visible smock or kirtle neckline under a surcote.

Unless one was a washerwoman or engaged in manual labour, arms were never bare. If a gown with wide sleeves was worn, then a kirtle with closely fitted sleeves was worn under it. Chemise sleeves were never seen in public.

The exception were farm workers or those engaged in washing or cooking with short-sleeved kirtles on a hot summer's day, as seen in various images from the *Très Riches Heures du Duc de Berry*, a book of hours from the very early fifteenth century, and the Month of July in Bening's *Book of Hours*, also from the fifteenth century. Other times, long sleeves were simply unbuttoned and rolled up. Bare arms were covered after the task was completed.

Sleeves which could be removed for work and pinned on back on afterwards were worn with the short-sleeved kirtles. A woman never left the house or would receive company without first replacing them if they had been removed. This fashion wasn't restricted to the lowest economic sector, but can be seen in paintings of women wearing costlier clothes. This fashion permitted fancier sleeves made from better fabrics, brocades, and the like. This used a fraction of the fabric required for an entire kirtle and lifted a plain outfit.

The idea that a woman's chemise shouldn't be seen changed dramatically when the Renaissance and Italian fashions became widespread in the late fifteenth century and it became fashionable to show off the under layers, especially the pleated chemise.

Unmarried women who worked at home had no special clothing, other than an apron to protect their day clothes. Women dressed as usual for work outdoors, with the addition of a straw hat. A detail from a border decoration from the *Romance of Alexander*, dated between 1338 and 1344, depicts a peasant woman working in the fields, wearing a kirtle short enough that her lower legs and boots are visible. She is using the same harvesting equipment that men would also have used.

An unmarried woman who worked for a well-off family in town might expect to receive a new gown as part of her yearly upkeep. Not only was this a form of charity on the part of the employer, it also ensured that the staff maintained a reasonable standard of attire and remained fit to be seen as part of their retinue. In the household accounts for the Countess of Leicestershire, Petronilla the laundress is given shoes worth twelve pence for her Easter term, indicating that she also received shoes at other times of the year.[11]

Girls and maidens who worked as servants sometimes had clothing left to them by their female employers when they died. We read in the will of Elizabeth Stafford, written in 1413, that Alice, her chambermaid is given a blue gown. She is also left twenty shillings, which is a good amount for a servant. Elizabeth Speke left her chief woman-servant, Alice Uppeton, a gown of tawny cloth *perfeled* with crimson velvet and an old bonnet of black velvet and forty shillings.[12]

Items gifted by wealthy employers were usually of a better quality than a household chambermaid or servant might normally be able to afford, and these kirtles and gowns could be cut down, trains removed, refitted, and remade into suitable clothing. At certain times, the fashion of lower-cut gowns was popular, but of course, one who wore her dress too low-cut was also marked for comment and nasty gossip. It was ascertained that a woman's neckline may be low, as low as her armpits, but no lower. What we see in manuscripts and paintings tells a different story.

Widows

As with unmarried girls and spinsters, a widow who wished to remain single had a few dress options, depending on her rank and place in society. At the time of her bereavement, she should dress modestly.

> *"...women in our society do not wear beautiful, expensive, colourful and precious clothes when their husbands have died, but rather a black and simple dress as a sign of their sadness and mourning..."*[13]
>
> —*Fasciculus Morum*

A wealthy woman who had assets and family connections in her own right might choose to continue to dress in the latest fashions, with expensive fabrics and even more expensive jewellery. An affluent lady could afford to do so if she controlled her own finances and was a woman of independent means and impeccable morals.

A working-class widow generally chose to dress more modestly. This was for several reasons. Attracting attention is something a newly single, bereaved woman may desperately wish to avoid. Remarriage was not always high on her list of priorities, and appearing sexy and enticing could incite gossip amongst others and attract prospective suitors sooner than desired. Christine de Pizan, who herself was widowed at twenty-five, warned others that dressing immoderately could lead to the wrong kind of attention from the wrong kind of men.

> "A woman's exaggerated clothes and ill-considered manners
> can lead to evil gossip and even more dangerous results.
> Evil men may think that she is trying to attract their attention,
> so they will feel free to make improper advances."[14]
>
> —Christine de Pizan

If a widow hoped to continue to work at the family business on her own, that is, a *femme sole*, she needed to appear to be all of the things associated with a successful and trustworthy business: stable, reliable, decent, hard-working, and honest. These things were maintained with an air of respectability in her presentation, and much less extravagant spending on the latest fashions when she had a business to run. Her clothing needed to be practical more than fashionable.

Wealthy widows had a great deal more clothing to find homes for when they died than their poorer working-class sisters, and included bequests of many items of their best clothing to family and friends. Widows made gifts of clothing, not only to servants, but to other women who might be of equal social standing. The will of Joan Buckland, widow of Edcock, who died in 1462, leaves:

> "...all my other gowns and kirtles, that they be given to my women servants dwelling with me at my departure. Also to the woman that is by me at the time of my departing...one gown furred with mink."[15]

Mink was an extremely expensive item, and it was a very generous enticement for a lady to stay bedside. It was quite normal for clothing to be handed down to other women, if the fabric was suitable, and remade or refitted to suit the new wearer's status or

occupation, and we learn from Joan's will that it was no shame to have expensive clothing gifted. Second-hand, in this case, did not mean cheap or unwanted cast-offs.

We see this in a second example, from an upper-class widow who left clothing and dress accessories to her female friends or members of her household. Again, these were not poor hand-me-downs, but an array of valuable items. The will of Elizabeth Speke bequeathed a number of expensive gowns and dress accessories.[16]

> Elizabeth Colshill: "a tawny gowne of cloth purfeled with black velvet."
>
> Amy Ashe: "my third best bonet and a piece of chased siver."
>
> Margaret Trowbridge: "a gowne of black chamlett perfelyd with crimsom velvet and my best bonet garnyssed and my best frontlet embrouded."
>
> Alice Gere, her sister: "a gowne of violet ingrained, furred with black bogie." Also "a gowne of violet ingreyned and furred with white leetes." Also "my second best bonet." And "a black kirtill of wolsted."

As well as the named clothing items in the list, it is likely that Elizabeth had other clothes too, less valuable or in worn condition, and these would be distributed as seen fit or donated to almshouses for the poor. There is no mention of her under things or shoes, but it is certain that they would not have been wasted.

Beggars and Fringe-Dwellers

Single women who had fallen on hard times did the best they could do with clothing. Second-hand clothes dealers, known as *fripperers*, sold clothing in a reasonable state of repair which was significantly less expensive that that bought new or tailor-made.

William Langland's fourteenth-century moral book, *Piers the Plowman*, tells how he was lured to a tavern on his way to church, where he met other people who were either itinerant or on the outer fringes of society economically, including a gaggle of old clothes dealers who offered to buy him a drink.[17]

Manuscripts often show poverty in human form wearing ragged and patched clothes. There were no special social markers required of them, unlike prostitutes, who had a variety of clothing regulations thrust upon them. At special times of the year, clothing might be given to the poor by wealthy households or by church charities as part of celebrations.[18]

Clothing might be acquired from wills or charitable alms houses. One such donation came from a widow who wished to benefit a particular poor woman who was known to her. A 1459 bequest from York by widow Joan Cotyngham shows that even underwear might be gifted.

> "Also, I leave to Joan Day a poor little woman staying in a certain maison-dieu my russet gown lined with buckskin and a chemise of linen cloth."[19]

In a further will from 1436, from a certain Thomas Bracebrigg, a merchant in York, he concerned himself with providing new, and not second-hand, footwear for poor women:

> "And I leave 10s to buy and give twenty pairs of shoes for poor women immediately after my death according to the good discretion of my executors."[20]

Workers in the sex industry were a subsection of society with their own set of rules regarding their apparel. From council records and complaints, we can learn not only what women were wearing, but what was forbidden and why. Records often note that a certain item *is* worn by good and honest women, thus telling us that it was only appropriate for the higher-born lady.

Very early in the medieval period, between 1162 and 1202, a law passed in the municipal statutes of Arles, which forbade prostitutes to cover their hair with a veil lest they should be mistaken for a woman of good virtue. The law encouraged good women to snatch the veils from the heads of women of suspected ill-repute.[21] In London, the borough records of 1351 had a lot of restrictions for prostitutes, including what clothes were suitable.

> "...no such common sort of woman...shall be so bold as to be attired either by day or night in any kind of clothing trimmed in fur, such as miniver, badger fur, close-trimmed winter squirrel, spring squirrel, 'bys' of rabbit or hare, or any other kind of noble budge, or lined with sendal, buckram, samite, or other noble lining...not yet be clothed in either coat, surcote, or hood set off with fur or lining after the feast of St. Hilary next, on pain of forfeiting the same clothes..."

> but let every common sort of woman...go openly with a hood of unlined, striped cloth, and clothes neither trimmed with fur nor yet lined with lining, and without any kind of decoration, so that everybody, natives and strangers, may know what rank they are, on pain of imprisonment etc."[22]

The fourteenth century borough ordinances of Bristol in England repeated that no prostitute should go about town without a striped hood.[23] Other sumptuary laws furiously forbade them nice clothing, and yet, in other writings they were allowed better clothing, as it was considered a tool of the trade and was needed to obtain work. In spite of this, laws in Avignon from 1372 forbade prostitutes coats, silk veils, amber rosaries, and gold rings.[24]

Cosmetics were a whole other issue. Although Thomas of Chobham, the subdean of Salisbury in the early thirteenth century, understood that women might use them to artificially enhance themselves, particularly in this line of work, he had ideas about the money prostitutes earned by wearing makeup and false artifices.

> *"For if a prostitute deceitfully adorns herself with cosmetics*
> *and acquires a false image,*
> *thereby deceiving the eyes of the onlooker,*
> *or perhaps that she should lie that she is noble,*
> *thereby inciting another to lust,*
> *then she cannot convert to her own uses*
> *what she acquired through deceit."*[25]
>
> —Thomas of Chobham

His train of thinking here was that a woman may be making her living in a manner of which he and God didn't approve, but she was earning the money for providing a service, so the income itself

was legitimate. Once she dressed better than she ought or applied makeup to make herself look better than she did, she was being dishonest and gaining payment under false pretences, which was a sin. It's a fine line to quibble over, and yet, he did.

Nuns and Cloistered Women

Dress of religious houses were different in colour and yet very similar in style. Although the sects varied, in manuscripts we usually see nuns shown dressed entirely in black, with a white veil and wimple. The shape and form of the basic garments and headwear were the much the same as any other thirteenth-century woman. A nun's attire was simple and practical. A loose robe called a *habit* was worn over a plain, linen smock and pulled in at the waist with a simple belt. Over this, a *scapula* was worn. The scapula looked very much like a tabard, only thinner. As the centuries passed, secular women adopted new fashions, but cloistered women retained their simple clothes which did not draw attention to the figures of the nuns wearing them.

On her head, a nun wore a simple white linen veil with a white linen wimple around her neck. Her hair wasn't seen, and her jewellery was limited to the ring she was given when admitted to the order, perhaps a cross around her neck, and a rosary. Covering her lower legs, like other women in the Middle Ages, she too wore hose and shoes or sandals.

The nun's crown, however, was an extremely distinct item of headwear which was adopted in Northern Germany, but not globally. These can be seen in only some orders and are curious

indeed. Although called a crown, it was not a crown, *per se*, but was constructed from several bands of white linen. One circled the head around the forehead like a typical circlet or fillet, but then had two additional bands, one running from front to back over the top of the head, and the third from ear to ear, also running over the top of the head.

This formed a white cross on the top of the nun's head. Birgitta of Sweden added five red dots, one at each join, to symbolize the wounds of the passion of the Christ.[26] The red, of course, represented his blood. These crowns were bestowed at a special ceremony.[27] The nun's crown can be seen on the effigy at the tomb of Maria de Vilalobos, housed in Lisbon Cathedral, Portugal. In photographs of her effigy, we can clearly see Maria's crown is decorated more highly than usual, with not five, but eleven large roses and trapezoid shapes set in between them. Another, less-decorative one can be found on a nun in Estonia. This style of headwear is hard to spot in manuscripts where nuns are shown face-on, as all that can be seen is the white fillet band and one white stripe running up the middle of her head.

Hair shirts rarely make an appearance when the clothing of religious women is listed, but we do know they existed from stories in secular women's writings. A hair shirt was a roughly woven undershirt deliberately including tiny pieces of matter, which made a slightly abrasive garment which was worn next to the skin to promote uncomfortableness and suffering in the particularly devout. The idea of the hair shirt was that as Jesus suffered, so too, could one become closer to him by suffering also.

In theory, cloistered women, who were not consecrated sisters of the order they resided in, dressed simply and with modesty and made no pretensions to high fashion, which was not becoming in

the environment in which they lived. In theory. Secular women who enjoyed the benefits of life in a nunnery, but with no desire to embrace their actual lifestyle, were not under any legal obligation to dress modestly. They were free to dress however they liked, which led to new styles, fashions, and dress accessories finding their way into the sacred spaces. Naturally, this led to temptation for the women living there who *had* taken vows. Nuns themselves were periodically caught wearing jewellery and belts more suited to secular women than their occupation suggested and were reprimanded for doing so.

The usual clothing sumptuary laws of the land did not apply to nuns, as they had their own dress codes, and their clothing was supplied from within the nunnery itself. There was no choosing flattering styles and consideration to what was flattering. Holy ladies weren't there to look good.

One set of stipulations exists, from the Bishop Nicolaus of Cusanus when he visited the nunnery at Sonnenburg in Germany, which listed the requirements of each nun.

> *"...each and every one is to be given a chorkutte*
> *[frock to wear in church], a frock for the day, a long fur,*
> *a kursen [fur frock or gown], two night gowns,*
> *a scapular for the day, a scapular for the night,*
> *veils and kerchiefs as they need;*
> *and if they have the female sickness*
> *they need linen shirts and linen sheets as long as the sickness lasts.*
> *They may have bedclothes*
> *according to the rules and customs of the order..."*[28]

—Nicolaus of Cusanus

The list indicates several changes of clothing depending on the time of day and the occasion, including sheets of linen to be used when they had periods.

In the twelfth century, Heloise, the abbess at Paraclete in France, wrote to her ex-lover and now priest Pierre Abelard, asking him to give instruction on the clothing and food that would be suitable for the nuns in her abbey. He replied that they were to be sensibly dressed, in underwear and a habit which hangs clear of the dust, with a full change of clothing and necessary sanitary protection, and to wear proper stockings and shoes.[29] By stockings, one assumes that he is referring to the usual women's hose, which covers just above the knee and ties with a garter, and not joined stockings as we understand them today. Joined hose can be seen on men in the fifteenth century, but are not seen on women.

Complaints about expensive dress accessories were not limited to the single lay sisters, but also pointed to the nuns themselves, who likewise wished to wear beautiful things—this in spite of their vows to a simple life, away from distractions like secular jewellery and clothing.

Hildegard von Bingen, an abbess of unquestionable holiness, drew harsh criticism in 1150 from the Magistra of the Augustinians over her choice of headwear. Nuns, he felt, should be dressed modestly and simply. Hildegard and her nuns living at Rupertsberg were seen wearing beautiful gold crowns with decorative crosses all around and the Lamb of God motif on the front. Not content with just the crowns, the women were pairing them with veils of silk, instead of plain linen.[30]

In her own defence, Hildegard explained that the crowns her nuns wore were entirely appropriate. The five crosses represented the

five wounds of Christ, and the lamb signified their holy shepherd, whom they followed. One can see how Tenxwind, the magistrate, may have felt that gold and silk weren't in keeping with the ideals of poverty or humility, however.

In spite of situations like this, nuns were directed to garb themselves modestly. Again and again, visiting bishops reminded them. Instructions on appropriate dress accessories given by the Bishop of Lincoln to the nuns at Elstow Abbey in 1421–42 included a stern reminder that:

> *"Also we enjoin and direct that no nun presume to wear silver pins on her head, or silk gowns, or numerous rings on her fingers, but only the one of her profession, under the penalty written below."*[31]
>
> —Bishop of Lincoln

Records like these show that consecrated women, who were supposed to be dressing modestly in the manner of their order, were flouting the rules, exchanging simple tunics in plain wools for silk kirtles, and the ring of Christ for flashier bling. This was a misdemeanour which reoccurred frequently throughout the entire medieval period at many places where nuns and cloistered women could be found.

Chapter 4
Etiquette for the Solo Woman

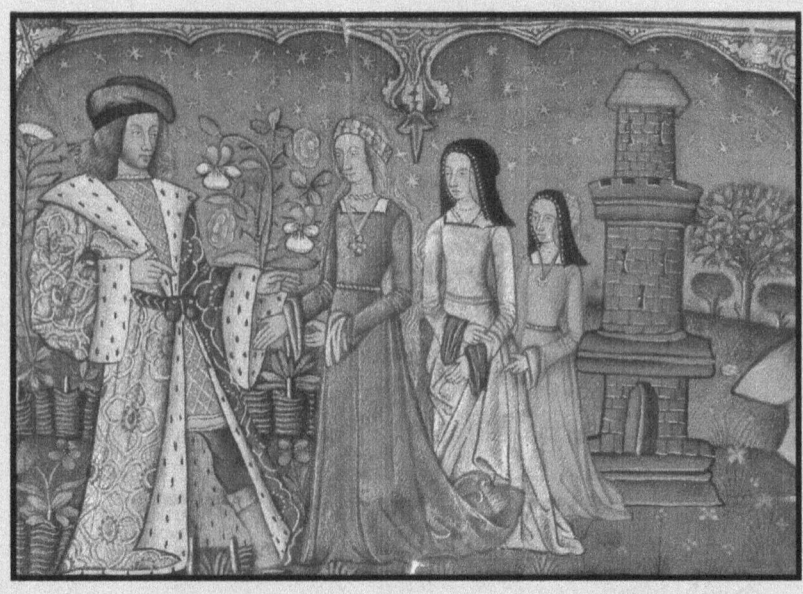

Figure 4. Geoffroi de la Tour Landry, the Knight of the Tower who is the author of the book, is teaching his daughters. Miniature from a manuscript of the *Livre pour l'enseignement de ses filles* or *The Book of the Knight of the Tower*. France, Chantilly, Musée Condé, Bibliothèque, Ms. 293 folio 003) Anonymous End of fifteenth-century French artist. 1485–1500. Public domain.

How a woman conducted herself was a topic of great interest to medieval writers of the day, mostly those who weren't actually female themselves. There were few lady authors in the medieval period who spoke of manners, but quite a large percentage of the instructions given to single women about how to behave came from men.

The actual innate goodness of women was also a challenging topic, as Eve and Mary were the two standards for feminine behaviour, and Mary was perched so loftily that it was unlikely that any mortal woman would come close. Women were constantly reminded that they were the daughters of Eve, and that it was in their nature to be sinful. Male writers of a clerical nature were quite sure of this.

The Archpriest of Talavera wrote extensively about women in his sermons. Initially, he stated his views on the feminine gender charitably, feeling that women merited a certain amount of admiration, but he spoiled it a bit at the end by adding a caveat that even good women were for the benefit of his own sex.

> *"Of good women, it is said they have no equal,*
> *nor should they be ill-spoken of...*
> *rather they should be placed like a mirror*
> *for men to look at."*[1]
>
> —Alfonso Martínez de Toledo

Saintly women, or those who adhered to a saintly code of dress and behaviour, were to be admired as the beloved Virgin Mary was. Secular women who were pious, meek, and well-behaved made ideal daughters, future wives, domestic employees, and potential

nuns. Women were constantly reminded that the Bible was full of virtuous women who should be role models for their own persons.

Fathers, mothers, knights, husbands, and priests all had plentiful thoughts on the topic of womanly manners and social interactions, and helpful guides were written so that a well-bred single girl might learn the proper way to act: how to deport herself, how to behave at the table, and the correct manner in which to walk down the street. A French village woman from Montaillou, when asked about the way a young girl should walk, offered her own brand of thoughtful advice.

> *"When you are walking,*
> *do not throw your arms and legs about carelessly,*
> *but keep your elbows well in,*
> *or you might knock over a ghost."*[2]
>
> —Arnoud Gelis

Poets and *minnesingers* were kinder when it came to describing their perfect lady. Between 1460 and 1500, Robert Henryson, a poet from Scotland, penned verses wherein he clothed his ideal maiden in his ideal womanly virtues. These were the garments of all good ladies.

> *"The Garment of Good Ladies.*
> *Would my lady love me best,*
> *And work after my will,*
> *I should a garment goodliest*
> *Gar make her body till. [cause her body to be dressed this way]*
> *Of high honour should be her hood,*
> *Upon her head to wear,*
> *Garnish'd with governance, so good*
> *no deeming her should deir.*

> Her sark [shift] should be her body next,
> Of chastity so white:
> With shame and dread together mix'd,
> The same should be perfite. [perfect]
> Her kirtle should be of clean constance
> Laced with lawful love;
> The eye-holes of continuance,
> For never to remove.
> Her gown should be of goodliness,
> Well ribbon'd with reknown;
> Purfill'd [embroidered] with pleasure in each place,
> Furred with fine fashioun.
> Her belt should be of benignity,
> About her middle meet;
> Her mantle of humility,
> T'endure both wind and wet.
> Her hat should be of fair having,
> and her tippet of truth;
> Her patelet of good pansing [thinking]
> Her neck-ribbon of ruth.
> Her sleeves should be of Esperance,
> To keep her from despair;
> Her gloves of good governance,
> To hide her fingers fair.
> Her shoes should be of sickerness [firmness]
> In sign that she not slide;
> Her hose of honesty, I guess,
> I should for her provide.
> Would she put on this garment gay,
> I durst swear by my seill [knowledge],
> That she never wore green or gray,
> That set her [suited her] half so well."³
>
> —Robert Henryson

Manners were a very important part of a medieval woman's life. The common misconception of a rough and rude society with

little polish is a widely held but mistaken belief. Like today, *some* demographics of the social order were more uncouth and rougher and ruder, but when it came to polite manners, the regular person was not the ill-mannered oaf seen in media today.

Whilst a young lady was encouraged not to gaze around when out and about in town for fear of catching the attention of a man, it was considered the height of rudeness to avert your gaze when being introduced. Honesty was judged by the directness in the eyes, and to hide one's face was interpreted as dishonesty and ill-intent. Unless one was specifically instructed that one may not look upon a personage, one should look with open sincerity.

Table manners were better than generally supposed today. Medieval people were religious by today's standards, and prayer was an integral part of the day. A prayer would certainly always be said before any meal, even when eating at home, before any of the food is brought to the tables. In many households nowadays, saying grace is still a dinnertime tradition.

In larger households, communal plates at the table were usual and meant to serve four people at once. The guests at the high table, however, only had to share with one other person. Food was usually bite-sized or served in small portions to make eating easier. Finger food was easier for a lady to manage at the table. Large roasts brought to the table would be carved into slices and not torn apart into large hunks of meat thrown onto plates. Whilst serving plates and platters were made of pewter or silver for the upper classes, the diner's plates were often made of wastrel bread, which was given to the poor after the meal.

Hands were always washed both before and after a meal. Even people with little in the way of fancy tableware were conscious of

basic hygiene and good manners. Mothers have, after all, changed very little over the course of time, and always sought to instil the best manners they could in their offspring. There is little hope of social improvement with rudeness, and should one be called upon to serve a person of higher rank, it was imperative that offense not be given, even unintentionally. A young lady's manners reflected on her family, so it was important that she be courteous at mealtimes, especially if her parents had aspirations of marrying her up the social scale.

A feast would begin with less important people washing their hands before going to the table. To fail to do so was the height of rudeness. The upper class and guests of honour would be seated by a servant, and a washing bowl would be delivered to them at the high table. Most upper-class homes had a lavar or lavabo installed—a handwashing station which the guests would have used on arrival. Handwashing was an integral part of life and was observed several times a day, not just at mealtimes. White cloth towels striped with blue were used at the table as serviettes, and paintings and manuscripts show them in abundance in other handwashing settings.

The "Roman de la Rose," a lengthy French poem from the thirteenth century, gave advice to a woman about her table manners, including what to do with her hands, what size piece of food she should take, and to make sure she didn't drip food juices or grease all over herself when she ate or drank.

> "She ought also to behave properly at table. She must be very careful not to dip her fingers in the sauce up to the knuckles, nor to smear her lips with soup or garlic or fat meat, nor to take too many pieces or too large a piece and put them in her mouth.

> She must hold the morsel with the tips of her fingers and dip it into the sauce, whether it be thick, thin, or clear, then convey the mouthful with care, so that no drop of soup or sauce or pepper falls on to her chest.
>
> When drinking, she should exercise such care that not a drop is spilled upon her, for anyone who saw that happen might think her very rude and coarse. And she must be sure never to touch her goblet when there is anything in her mouth. Let her wipe her mouth so clean that no grease is allowed to remain upon it, at least not upon her upper lip, for when grease is left on the upper lip, globules appear in the wine, which is neither pretty nor nice."[4]

Daintiness and small pieces of food were the goal.

It is true that medieval life could be violent and dangerous, but people from all walks of life were bound to adhere to a certain amount of daily courtesy. To fail to do so was social peril and could cost a person their life for an insult, whether real or perceived, against a person of higher social standing.

Young Girls

> *"If a dress is cut well in the beginning, it will fit well,*
> *but if it is cut badly, it will hardly ever get the right shape:*
> *Thus it is also with the teaching and correcting of children."*[5]
>
> —Proverbs 22

An unmarried girl's behaviour was the subject of many writers. A thirteenth-century monk, Bartholomew the Englishman, described the many moods of a young child by noting that children lived

in the present, rarely thought for their future ahead, and were gregarious creatures.

> *"Children often have bad habits,*
> *and think only of the present, ignoring the future...*
> *They cry and weep more over the loss of an apple*
> *than over the loss of an inheritance...*
> *They desire everything they see,*
> *and call and reach for it...*
> *Suddenly they laugh, suddenly they weep,*
> *and are continuously yelling, chattering, and laughing."*[6]
>
> —Bartholomew the Englishman

These words are very familiar to parents today and perfectly describe the many dispositions of a toddler or small child.

Modesty and proper manners made for a better future marriage, so parents and tutors did the best they could to instruct their young wards. This might be achieved with words or corporal punishment. Chaplain John Raven was involved in a legal case in 1381 involving the discipline of his young cousin, Isold, who was described as "of tender age." Apparently, the young girl wanted to play with boys, which wasn't the issue itself, but that the boys were not of a suitable rank to be her companions.[7]

The beating with small rods that followed was delivered for fear that she might make an emotional attachment to a person who, in the future, was not a suitable marriage prospect. Marriage for love, rather than suitability, was just not on in most cases, and although a girl might not currently be of marriageable age, correction was given with thoughts of her future.

Several of the bestselling books of their time had a lot of wisdom to impart to young girls about preserving their reputation from slander. The most famous early medieval book on courtly love, *The Art of Courtly Love*, by Andreas Capellanus, written in the twelfth century, warned that a girl's good repute might be easily tarnished by something as small as gossip. This was echoed for the next several hundred years by a number of writers, both male and female.

> *"As you know well, a maiden quickly loses her honour,*
> *and her reputation is ruined*
> *by a slight rumour and a little word."*[8]
>
> —Andreas Capellanus

To be above reproach in word and action was the target.

Another such book written in 1371–72, especially for the instruction of his daughters, was that written by the lord of la Tour-Landry, Geoffroy de la Tour (the younger), called *The Book of the Knight of La Tour Landry Compiled for the Instruction of his Daughter*. Although the title states that the book was written for his daughter, singular, he was known to have at least two, but in an illuminated miniature from the manuscript *Livre pour l'enseignement de ses filles,* Ms. 293 folio 003, housed in the Musée Condé, Bibliothèque, three.

The Book of the Knight was very lengthy and rather heavy on moralising, in order to provide many, many examples of correct behaviour for any likely situation he could think of. Everything from deportment to table manners to the kindness and charity expected to be shown to strangers was covered.[9] Not the least of these were his instructions for the correct way to behave at church.

"Afterward, in saying your prayers at mass or in another place,
be not like the crane or the tortoise;
for they are like the crane or the tortoise
that turnith her head and faces backward,
and looketh over the shoulder,
and, ever staring with the head like a vessel,
havith you look and holdeth your head firm
as a beast that is called a lymer [bloodhound];
the which looketh ever before him,
without turning her head hither and thither,
but looketh ever forth right.
And therefore be firm and looketh forth right before you plainly,
and if you lust to look aside,
turnith your body and visage together;
and so your countenance shall be most firm for sure;
for they that looketh back, and are often staring with the head,
are often scorned and mocked.
Daughters, I would you have heard
with withhold with you an example upon this matter."

—Geoffroy de la Tour (the younger)

The late medieval poem "How The Good Wife Taught Her Daughter" gives more motherly advice for general deportment in public, which was suited not only to young girls and maidens, but to the entire fair sex. A small excerpt of it specifically relates to the correct carriage of self and manner of speech.

> "And when thou goest on thy way, Go thou not too fast,
> Brandish not with thy head, Nor with thy shoulders cast,
> Have not too many words, From swearing keep aloof.
> For all such manners Come to an evil proof."[10]

—The Goodwife

Poor girls were warned to behave in a humble manner and avoid prideful mannerisms. A handbook for Franciscan preachers in England from the very early fourteenth century, the *Fasciculus Morum*, agreed with other contemporary writers on deportment and behaviour. The writer was very clear on the matter of pride and modesty, and girls staying within their own social strata.

> "...I say that one must not take pride in one's power and rank.
> He who does so is like that very poor girl who in Summertime,
> in a game amongst girls, is made their queen
> by borrowing fine clothes from her playmates.
> As she looks around in her dignity, she forgets her
> former condition...
> and thus despises her playfellows.
> But when evening comes
> and each of the girls has taken back her own clothes...
> she will remain poor and naked."[11]

—Fasciculus Morum

Girls of noble birth were also reminded that humbleness and meekness were attractive, husband-getting qualities, which should be cultivated with diligence.

Unmarried Maidens and Spinsters

Social standing and one's place in society was everything in the medieval world. One might hope to advance through material gains and advantageous marriages, but one had little hope to do so without the correct courtesy and manners. An unmarried woman was expected to be the epitome of good conduct no matter what her status in life, and the higher a woman was born, the more essential it was for her to act appropriately. Even today, the conduct of young royal women is watched and scrutinised by media at great length. What one does or doesn't do is noted with approval or scandalised commentary.

While the goal of many single women was to attract a good husband and marry well, the songs of love sung by troubadours warned that marriage took away love, that it begot ill-feeling and jealousy and eliminated the genuine affection which is evident when love is new. It was therefore better to remain single, the singers of love songs said. Guillaume Dufay, who composed lyrics and music for the Burgundian court in the early fifteenth century, covered this theme in his song *Le Belle se siet*, when he advised against the traditional expectation that a young girl should find her future with a husband.

> *"You girls of marrying age,*
> *don't you marry.*
> *For if there's any jealousy,*
> *neither you nor he will be happy."*[12]
>
> —Guillaume Dufay

Geoffroy de la Tour-Landry, our knight of the book of instructions in 1371–72 CE, warned his daughters that young ladies should only be cheerful with men of equal or higher life stations.

> *"To this I answer you, I will well and am content,*
> *that they should make good cheer to all worshipful men,*
> *And more to some than to the other, that is to wit,*
> *to them of greater name and more genteel,*
> *or else better men of their persons,*
> *And after that they bear them to worship and honour*
> *And that they sing and dance before them honourably..."*[13]

—Geoffroy de la Tour (the younger)

He accentuated his point by further emphasising the careful selection of social connections, and the importance of aiming higher, not lower, in this area.

> *"...that is to wit, that no woman unwedded*
> *shall not settle her love upon no man*
> *of lower or lesser degree than she is of.*
> *For if she took him, her parents and Friends*
> *should hold her lost and hindered.*
> *These which love such folk,*
> *done against their worship and honour."*[14]

—Geoffroy de la Tour (the younger)

In other words, don't be overly friendly with men of less stature than yourself, but be especially courteous to those young men whose friendships and connections were beneficial. Certainly, Geoffroy had in mind that his daughters should marry upwards, and that being particularly charming to suitable potentially

affluent suitors would do no harm whatsoever. Whilst an unmarried young lady might be interested in courting and flirting, she needed to be careful that she wasn't accepting advances from unbecoming suitors. By that, he meant poor.

Again, Andreas Capellanus's advice in *The Art of Courtly Love* continued, with guidance to the unwed maiden. On the subject of encouraging admirers, he spoke sternly about the character flaws inherent in seeking attention from men who were not actually available at all.

> "I want to make it very clear to the women
> that it is a great blot on a woman's character
> if she has anything more to do with a lover
> who is engaged to a new love;
> a man deserves no mercy if he forgets
> honours of this kind which he has received
> and is so lacking in gratitude
> that he is not ashamed to think of embracing some other woman."[15]
>
> —Andreas Capellanus

His warning was well needed, as many paramours who were to wed were also keen to keep a mistress, and Andreas hoped that love-struck girls wouldn't play that game. In modern terms, "don't be the side chick" is the takeaway here. He did admit that the key to attracting considerable attention could be good looks, but that the kind of man attracted to only looks may not be of the highest moral calibre, which is still a valid argument. He added further that it is a person's conduct which makes her worthy, which is also a compelling observation for today's world.

> *"A beautiful figure wins love with very little effort,*
> *especially when the lover who is sought is very simple,*
> *for a simple lover thinks that there is nothing to look for*
> *in one's beloved besides a beautiful figure*
> *and face and a body well-cared for.*
> *Character alone, then, is worthy of the crown of love."*[16]
>
> —Andreas Capellanus

A less eloquent opinion comes from the allegorical character Dame Study in *Piers Plowman*. She, like many older people, sourly complained that young ladies of those days had no manners whatsoever and that as far as she was concerned, it was crass and not becoming in the least.

> *"Getting tanked up and constant swearing*
> *are the only forms of amusement now in fashion."*[17]
>
> —William Langland

Indeed, it was indecorous that a woman curse or use foul language for any reason whatsoever. Common women might, but it wasn't good breeding. Once again, it reflected badly upon her father or husband. That said, many words which we feel are vulgar today were in common use, in particular, those associated with bodily functions. Shitting and pissing were normal words. Streets like Gropecunt Lane and Cock Lane in London were indicative of the type of unsavoury activity one might purchase there, but the names themselves weren't offensive.

In the Middle Ages, manners which were appropriate for a man were not necessarily so for a woman. The thirteenth-century poet Robert of Blois admitted that ladies needed to know how to

behave, but that it was difficult for a woman, as whether she was the shy, retiring, introverted type or the outgoing, extroverted type, someone would always criticise her. One just couldn't please everyone.

> *"If she speaks, someone says it is too much.*
> *If she is silent, she is reproached for not knowing how to*
> *greet people.*
> *If she is friendly and courteous, someone pretends it is for love.*
> *If on the other hand, she does not put on a bright face,*
> *she passes for being too proud."*[18]

—Robert of Blois

A woman who entered into conversation with a stranger might gain herself a bad reputation, and to accept a kiss from a male friend or acquaintance, or from any man who was not related by blood or marriage, even on the cheek, would have had tongues wagging and potentially ruined a woman's reputation. This can be seen clearly in advice given by the character Prudence to young wives in *The Treasury of The City of Ladies*, but it also applied to young maidens who were still single. In particular, in a world where entertaining was often conducted in a lady's solar, or private chamber, Prudence emphasises that this was not appropriate for the virtuous.

> *"Speaking with men in private is not suitable for her,*
> *whoever they may be, knights, squires or otherwise.*
> *She must not be found in their company too frequently,*
> *nor should they be around her, especially in her bedroom."*[19]

—Christine de Pizan

French writer Antoine de la Salle was still expounding the virtue of good company when he wrote in 1456. His excellent advice was rather modern in that, instead of turning the cheek and ignoring inappropriate and unwanted comments from men, he advised calling them out, before withdrawing from their company altogether. He included uncouth dialogue about *any* woman, not just those present.

> *"If you fall into company where men*
> *speak disworshipfully of any woman,*
> *show by gracious words that it pleaseth you not,*
> *and depart."*[20]

—Antoine de la Salle

While telling a woman who she should fraternise with isn't tolerable, perhaps keeping men out of your bedroom if you want to keep things casual isn't a bad idea. Men who talk badly about you or your friends are also not to be endured. This is good advice from both writers, which would not go astray even now.

Albertus Magnus took a more practical approach to preserving virtue. St. John's wort, he assured his readers in his writing *On Plants*, was an herb which preserved chastity and continence. One might use every part of the plant—leaves, roots, fruit, and juice—and he assured his readers that its powers of preservation were not diminished when the plant was simply strewn about the bed or chamber.[21]

A young woman who was no longer a child needed to learn other, important social niceties, like what to do when meeting a person of higher rank. One must never address a social superior first, especially if one was a woman, and an appropriate greeting must

be given. It was also unthinkable for a woman to turn her back on a person of superior standing. She should wait for the person to pass or remove herself from the room backward.

When introductions were being made, should there have been no man to do it for her, convention dictated that a woman must acknowledge and introduce the highest rank to the lowest, and then vice versa. This is still true for formal introductions today.

An error in the order of introduction could have been a grave insult indeed. Should a woman have found herself in the company of important people and another important one arrive, she must bow and move away to permit the newcomer the privilege of standing closer. In polite upper-level circles, when a woman entered the house or room of a person of equal standing, she ought to bow. If of higher standing, she ought to kneel on the right knee, like a small curtsey. Should she be presented to the queen, she knelt at the door, entered halfway, and knelt again. Only if she was motioned to come farther should she approach closer.

It was absolutely better to err on the side of caution in this regard, as it was better to appear overly humble and meek than forward, ill-mannered, and rude. Of course, all the etiquette advice in the world does not mean that single women everywhere were well-behaved. Courts received complaints for all manner of petty crime, slander, and minor assault. From the records of Manor Court in Halesowen, we find this grievance:

> "Amercement. The vill of Oldbury present that Alice the daughter of Philip Robines of Oldbury unjustly drew blood of Felicity the daughter of John Walter."[22]

The fact that these two are specifically mentioned as "daughters of" show that they were single and therefore still under the guardianship of their fathers.

Women were instructed to be gracious in their deporture and not wriggle their shoulders; to look straight ahead with a tranquil and measured air or focus on the road ahead, and not look curiously at every little thing. When out, a woman's hands should not be touched in a familiar fashion by a man who was not of her family. Public hand-holding was quite unfitting. Again, our late thirteenth-century poet, Robert of Blois, wrote in his work *Chastoiement des dames* (or *Enseignements des dames*) about his thoughts on deportment by comparing women to hawking falcons who eyed their prey with quick jerks of the head before they pounced. Ladies, he advised, should not do this.

> *"Ladies should walk erect, with dignity,*
> *neither trotting nor running, nor dallying either,*
> *with their eyes fixed on the ground ahead of them.*
> *They are to be particularly careful that they do not regard men*
> *as the sparrowhawk does the lark."*[23]
>
> —Robert of Blois

When travelling outside the home, it was acceptable for any woman to walk arm in arm with her female companion or a male member of her family. A woman of good breeding tried not to venture out alone if she could help it. A working woman or a mother in a small peasant household might have had cause to go out alone, but only when unavoidable.

Where possible, a young woman might seek the security of another woman's company when going to the bakehouse or to the creek

for washing. A single woman out alone was an easy target for men with less than civil intentions, and as the saying goes, there's safety in numbers.

Medieval records are filled with numerous complaints of unwanted sexual contact which women had forced upon them while they attempted to go about their daily business. It was all too simple for the perpetrator in question to defend himself in court by claiming the woman he had raped was of known easy virtue and therefore his actions were not that bad, really. In this situation, a woman's good name and character would support her, either as the victim or as a character witness on behalf of the victim.

The Art of Courtly Love reminded men that a woman should not be judged on whether she was rich or not, but rather by her character, as virtue could be found in lowly places.

> "And do not look down on worth, no matter in whom you find it, since we gather roses from the sharp thorns amid which they grow, and gold which we find in a vessel of cheap material cannot lose any of its value."[24]
>
> —Andreas Capellanus

One Joan Baron found herself in court facing false charges of fornication, but she adamantly denied the allegation and, with the help of her four female character witnesses—Elizabeth Forster, Elina Godynton, Allice Fuller, and Alice Pym, themselves women of good repute—the judge overturned the case.[25] In this situation, Joan had her name cleared by law. Had Joan been of questionable morals, or had her witnesses been, their testimony would have been discounted. Loose women, after all, were probably liars, thieves, and worse, and would say anything for a friend.

Fortunately for Joan, this was a two-way street. Respectable ladies, who themselves were beyond reproach, made excellent referees.

When it came to staying beyond reproach and keeping a good name, nothing was trickier than being single and accepting presents from men.

Acquiring tokens from suitors in the name of courtly, nonphysical love, was a minefield. A single woman might consent to accept some things without raising an eyebrow about the propriety of the gift, but not others. The Archpriest of Talavera warned single ladies about the perils of presents. He felt that when it came to gift-giving, ladies could be easily bribed, more easily yield to the desires of men, and be encouraged to pervert justice if the love offerings were welcomed.

> *"So then, be not astonished*
> *if gifts bring about the downfall of honest women*
> *and cause them to lose their honour and good name,*
> *for a gift respects neither place, station, nor wealth,*
> *but twists everything to its purpose."*[26]

—Alfonso Martínez de Toledo

The Art of Courtly Love's author, Andreas Capellanus, wrote on love tokens which he felt were suitable for single women, stating what may and may not be freely given to a lady without being improper. Further in the same book, he writes that he spoke with the Countess of Champagne about what gifts were appropriate to accept. She agreed that, as long as the gifts were taken in the right spirit, a lady might receive them. Several of these were far more expensive than those in the author's original recommended-gift-giving guide, and perhaps this was because of the nobility of the

lady he asked. Items which were mere trinkets to a countess were expensive presents for lesser girls further down in the world. This list also shows us what items of toilette a lady might have in her chamber in the twelfth century:

> "A woman who loves may freely accept these things from her lover:
> a handkerchief, a fillet for the hair, a wreath of gold or silver,
> a breastpin, a mirror, a girdle, a purse, a tassel, a comb,
> sleeves, gloves, a ring, a compact, a picture,
> a wash basin, little dishes, trays, a flag as a souvenir,
> and, to speak in general terms, a woman may accept from her lover
> any little gift which may be useful for the care of the person
> or pleasing to look at or which may call the lover to her mind,
> if it is clear that she is accepting the gift, she is free of all avarice."[27]

—Countess of Champagne

The Countess instructed that, in the matter of receiving a ring as a love token, it ought to be worn with the stone facing inwards on the little finger of her left hand. In this way, it would not be mistaken for a wedding ring.

Almost two centuries later, medieval writer Jean de Jandun visited the markets on the banks of the Seine in Paris, and made note of the beautiful objects available there, many of which were well-suited to giving as gifts:

> "Crowns, chaplets and bonnets, ivory combs for the hair,
> mirrors for looking at oneself,
> belts for the waist, purses to suspend from them,
> gloves for the hands, necklaces for the breast,
> and other things of this type which I cannot list
> as I lack the Latin terms for these objects."[28]

—Jean de Jandun

The fact that these were available at the markets shows that they were not out of the reach of regular people. The use of the word *crown* may refer more to metalwork circlets and diadems than to jewelled crowns fit for royalty.

Warnings which surrounded accepting offerings from suitors and well-wishers can even be found in fourteenth-century poetry. The character of the Old Woman in the romantic epic *Romance of the Rose* instructed young ladies not to take expensive gifts from young men. Unlike earlier writers, who felt that certain gifts might be accepted with impunity, she warned that many of those were far too expensive.

> *"Most careful should a woman be,*
> *Though she loves a man tenderly,*
> *Gifts to shun of value great:*
> *A pillow soft and delicate,*
> *A purse, a handkerchief, or hood,*
> *Not costly, though fair made and good,*
> *A silken lace, a belt to clasp*
> *his waist with inexpensive hasp.*
> *or pretty pocket-knife of steel,*
> *or ball of thread, fine and soft to feel,*
> *Such as is made by cloistered nuns..."*[29]
>
> —Guillaume de Lorris

Her feelings were that, if these gifts were accepted, the giver of the gift might feel freer to make unsavoury advances. The modern equivalent is a hopeful suitor taking his date out for a romantic dinner and then expecting her to repay him with sexual favours because he feels she "owes him." Even in the fourteenth century, this was a concern to some writers.

Christine de Pizan had strong feelings about accepting things from optimistic men and wrote bluntly on the matter.

> *"She who accepts a gift, sells herself."*[30]
>
> —Christine de Pizan

Christine felt that accepting anything of any kind was a gateway to impropriety, while other writers, as we have seen, allowed some gifts, as long as they were small, appropriate, and given in the right spirit.

For chambermaids and female domestic staff, Christine had different advice altogether on how to behave. Servants had very little leisure time and, although meals were provided, the time to sit down and eat them properly did not always present itself. They should eat when they could. While the meals were not especially fancy, servants might eat a little more regularly than the ladies of the home, who, if devout, ought to be observing religious fast days. A servant girl who worked hard could be excused from these if she needed to keep her strength up to perform her household duties.[31]

Widows

As a woman who was once married, but now was on her own, further expectations were added for a widow's behaviour. The myriad of requirements regarding deportment, clothing, and sexual continence still applied to her, but a now-single widow might have other responsibilities which required new management from her. She might have a business to run, new areas of the

household to supervise, tenants to oversee, and still an air of respectability to maintain.

Advice written for the medieval widow was especially tailored to her new situation. Widowhood consisted of a mixed demographic: some were old ladies, newly single late in life after a lengthy marriage, and others were reasonably young because they had been either married off to someone much, much older than themselves, or made single through accident or misadventure.

Some widows had children, which came with its own set of complications. In 1449, Agnes Paston tried to arrange a good marriage for her single daughter, Elizabeth, who was twenty. The intended husband was an elderly man, and when Elizabeth refused, Agnes embarked on a barrage of daily physical assault leading to head injuries and a forced isolation from her friends and the outside world. She was unsuccessful in her mission, and her daughter eventually married a man of her own choosing.[32]

For the older widow who was a landlord, John Paston said it was appropriate for a woman of a higher class to visit or take care of her tenants, especially when they were unwell or in distress. It was, he noted, something that a woman of good breeding should do, even though her tenants were of a lower situation than herself.

> *"Ye be a gentilwoman,*
> *and it is worship for you to comfort your tennants."*[33]
>
> —John Paston

A widow who was in a position to run her husband's businesses and estates after his death might appear in court to defend and protect her own property and contracts. In preparation for such an

occurrence, she needed to be well-informed about her legal options and exactly where she stood. Christine de Pizan, who was widowed herself at only twenty-five, advised self-advocacy when she wrote in *The City of Ladies*:

> *"Preparation for important matters by wise advice*
> *will permit her to speak and act to her own advantage...*
> *Without becoming agitated to the point of immoderate language,*
> *she will strongly voice her claims*
> *or have them stated publicly with notable courtesy.*
> *However, she will assert her due rights."*[34]

—Christine de Pizan

The right attitude, she felt, would produce the best outcomes. Being arrogant and argumentative was counterproductive to her own cause. Finding the right balance of dialogue and attitude was the trick.

> *"She must be knowledgeable in the mores of her locality*
> *and instructed in its usages, rights and customs.*
> *She must be a good speaker;*
> *circumspect with the scornful, surly or rebellious;*
> *and charitably gentle and humble*
> *towards her good, obedient subjects."*[35]

—Christine de Pizan

Christine felt very strongly that arming oneself with good legal counsel and advice from those wiser than herself was in the best interests of everyone, but definitely for the woman herself. It never hurt to be prepared. Being assertive at the right times was a good character trait, with generosity and charity always seen as

things a virtuous widow should embrace. Two quotes from the popular fourteenth-century writer William Langland indicated this with these words about assistance to the less fortunate.

> "Mould yourselves in the shape of Charity."[36]

> "Charity takes as much satisfaction in a single penny as in a pound of gold."[37]

> —William Langland

He advised that a widow of moderate means should still make an effort at giving what she could, and encouraged even those with a middling income or those who were fairly poor to make a small contribution to the even less fortunate, even if they had only a little themselves.

As we have seen, widows attracted a lot of attention from medieval writers because they were single and therefore in need of guidance. On the subject of sexual continence, a young widow should be chaste, according to everyone who held a quill throughout the Middle Ages. Often, it was noted with extreme disapproval, widows who had experienced carnal knowledge were likely to be lusty and, with no husband to take care of their urgings, priests feared they might accost any unwary man and lure him into temptation, if not ravage him outright.

Older widows, too, were not beyond suspicion. Beatrice, an older but still very attractive widow in the French village of Montaillou, accused a younger clerical man of bewitchment in order to gain her sexual favours. In spite of the fact that she had been a willing participant in their relationship, in a statement to the authorities, she claimed it was unnatural.

> *"I have never committed the sin of sorcery,*
> *but I think the priest Barthelemy did cast a spell on me,*
> *for I loved him too passionately;*
> *and yet when I met him I was already past the menopause."*[38]

—Beatrice de Roquefort

Widows who wished to remain free from remarriage were cautioned not to draw too much attention to themselves. Dress modestly, go to church, be honest in business dealings with others, don't get drunk down the pub or display uncouth behaviour. Above all, don't flaunt your fine belongings in public, or one was sure to catch the eye of a bachelor looking to improve his fortune and/or assets by marrying up.

Staying under the radar was the best thing a widow could do.

A widow who wished to spend her life alone and continent, and not be a nun, had the option of taking a vow of chastity, promising to keep herself chaste for the glory of God. A life of celibacy was seen as a worthy sacrifice, and praised by the church, which extolled giving up sex as a virtue. A vow of chastity could be taken whilst married, but it was a rarer occurrence.

In 1454, widow Isabel Maryone made her vow in front of the Lord Bishop of Lincoln, several Doctors of Law, two ministering priests, and others, including a notary public and one Agnes Kyrkeby, who made a deposition about it. This document gives us the wording used by a woman wishing to take this next step in her life. The correct way to take a vow of chastity is to recite the following:

> "In the name of the Father, the Son, and the Holy Ghost, I [insert name here] of your diocese, widow, promise and vow to God, Our Lady, St Mary, and to all the saints, in your presence, reverend father in Christ [name of priest], by the grace of God, Bishop of [parish], to be chaste and I determine to keep myself chaste from this time forward as long as my life lasts. In witness of this I here subscribe with me own hand."[39]

This is followed by the signing of the statement.

In theory, this was rather straightforward, but of course, it was heavily dependent on three things:

Firstly, she would need to know that this was even an option. Taking a vow of chastity was not something that every medieval woman knew about. This knowledge might come about through interaction with nuns, being housed with nuns for safekeeping until a marriageable age was reached, or through a private priest.

Women living in modest circumstances in villages and regular homes, those who grew up, married, and found themselves widowed, might know it was a possible option, but may have been advised against it very strongly. Remarriage secured her accommodation, offered stability, and gave her family a head. Those in large households, who had a chaplain or were exposed to other women who had already taken a vow, might learn of this and seek out more information. Legal accounts suggest that many household priests were not particularly chaste themselves, and many were charged with impregnating servants, so advice on how to take a vow and live without sex may not have been bandied about overmuch.

Secondly, to take a vow of chastity, the widow would need to be independently wealthy enough to support herself to afford it. Food, clothing, taxes, and other household expenses still needed to be met. If this was not possible, then it negated the desire for living alone.

Thirdly, celibacy was not suitable for everyone. A widow who hoped to remarry might be mindful that her new husband may want an heir. Only if she was certain that her days of pregnancy or child-raising were behind her might a woman consider taking the vow.

One such widow who took this step was Joanna Large. Joanna was already thrice a widow and had no further plans to remarry, so she had no qualms about swearing the oath before the Bishop of London in 1441. Robert Gilbert, the bishop, heard her promise faithfully that she would be a virtuous Bride of Christ.

> "I, Joanna, that was sometime the wife of Robert Large, make mine avow to God...to live in chastity and cleanliness of my body from this time forward as long as my life lasteth, and never to take other spouse but only Christ Jesu."[40]

Three years later, her long-time close friend, who happened to also be the executor of her late husband's will, married her, much to the dismay of everyone and the ire of the church. To break a promise of this kind to God was appalling. Joanna and her new husband John Gedney both were made to do penance, but it was a small price to pay for the benefits of merging their properties and wealth, which was reasonably substantial.

Poor Women, Beggars and Fringe-Dwellers

Poverty, although it was a terrible life, was seen by the religious as a kind of virtue-enhancer. As awful as it was to be without the trappings of a comfortable life, poor women were less likely to sin.

Underprivileged women had no opportunity to indulge in gluttony, sloth, or pride, three of the seven deadly sins. Gluttony because she couldn't afford to buy adequate food in the first place. Sloth because she had no leisure time whatsoever whilst trying to work or beg enough to keep herself alive. Pride because she had no fine clothes or fine home—these were all great sins which other noble ladies fell to. Therefore, it was a blessing to be without that kind of temptation.[41]

Of course, this then permitted envy, which was also a sin.

A poor woman's behaviour should therefore be meek, although we know from court records through the medieval period that vagrant women were not always so, and caused their share of legal infractions, from stealing (usually food) to forestalling (selling dishonestly) to prostitution, among other minor misdemeanours.

The medieval church had a complicated relationship with women who sold their bodies to survive. Many women fell into prostitution to support themselves, which, as one would expect, earned wrath from the church more than sympathy. Others took a different approach to houses of prostitution, with religious men taking an active role in the industry as both proprietors and customers. In the thirteenth century, Thomas of Chobham's

Summa confessorum devoted a number of chapters to prostitutes in all their guises, including wives who gave themselves to lust within the marriage bed, and women who made themselves publicly available to the lust of many men. Should a woman sell herself privately, it was a different matter. Chobham felt that, while prostitutes shouldn't be banned from church altogether, to have them making an offering was not acceptable.

> *"However, in no way should prostitutes be allowed to make an offering to the altar during Mass lest they carry with them the stench of the brothel to the perfume of the sacrifice."*[42]
>
> —Thomas of Chobham

Men were exhorted not to visit women of renown ill-repute, and even the Venerable Bede didn't sugar-coat his feelings on this issue.

> *"He who kisses a whore is knocking at the door of hell."*[43]
>
> —Venerable Bede

Women who worked in organised brothels had standards of behaviour expected of them both by their employers and by their clientele. Many did work willingly, as it provided an income which put a roof over her head and food on the table. Laws attempted to limit their business locations to certain areas in the city and modify their conduct. They were not to lure men into their places of work by pulling at their clothing or hoods.[44] Other unfortunate women were trapped in situations where they were forced to sell their bodies by unscrupulous employers who pocketed the money for themselves.

Nuns and Cloistered Women

As with women generally, a certain code of conduct was expected from religious women. While they might be single and free from the patriarchy for the most part, they were expected to act within a certain set of their own rules and behaviours within their own cloisters and abbeys. While this was achieved with success among women with real religious zeal, once again author Andreas Capellanus felt the need to warn unsuspecting men that not all nuns were well-behaved. In his book, *The Art of Courtly Love*, he devoted the entirety of chapter eight to *The Love of Nuns*, and how to avoid it.

> *"Be careful, therefore…*
> *about seeking lonely places with nuns*
> *or looking for opportunities to talk with them,*
> *for if one of them should think*
> *that the place was suitable for wanton dalliances,*
> *she would have no hesitation in granting you what you desire…"*[45]
>
> —Andreas Capellanus

Keeping nuns and vowesses on the straight and narrow path was nothing short of a Herculean task for the abbesses in charge when it came to single women living in nunneries without any actual religious vocation whatsoever. Two verses from a German song in 1359 hint rather broadly that this living arrangement wasn't particularly enjoyable for the unwilling nuns either.

> *"God give him a year of blight*
> *who made me to be a nun,*
> *who bade me take this tunic white*
> *and the coal-black mantle don.*
> *And must I be a nun in truth*
> *and all against me will,*
> *when I could cool a lad's hot youth*
> *and all his passion still?"*[46]

—Anon. Germany.

Advice for nuns and cloistered women was what one might expect. Novices and other young nuns should be diligently and religiously instructed. They should be humble in bearing, conversation, and devotion, and given to holy works. All the secular writings concerning deportment and manners especially applied to those living and working in religious houses. This sometimes proved a real challenge to the younger and more free-spirited inhabitants.

From around 1220, the *Ancrene Riewle* introduced codes of conduct for the sisters, vowesses, recluses, and anchoresses. A few key elements of this come as no surprise: no talking at all when attending meals; one must live on charity and give to the poor what was left over. Recluses' extra instructions stipulated that they shouldn't whip themselves with flagella of leather thongs or wear hair shirts. Zealously religious people of both sexes might do these things to increase their personal suffering to emulate the lamentations of Christ, but the new rule attempted to discontinue both practices within the walls of cloisters.

Naturally, young females might be afflicted with physical stirrings. Nuns were warned in the Archbishop of Canterbury's *Liber pontificalis*, the Penitential of Theodore, that a woman must be

ever vigilant about her sexual urgings, whether they involved other people or not.

> *"If a woman practices vice with a woman,*
> *she shall do penance for three years.*
> *If she practices solitary vice,*
> *she shall do penance for the same period.*
> *The penance for a widow or a girl is the same."*[47]
>
> —Theodore of Tarsus

This was written sometime between 668 and 690 CE and is attributed to Theodore of Tarsus, but the book was copied and used for several centuries after the initial compilation date. Giving a penance of this kind relied on the lady first admitting that she had sinned, and no mention is made of whether she was to provide the names of women she had committed her sin with.

Existing excerpts from diocese records list many infractions and indecorous goings-on within the hallowed walls reserved for prayer and devotion. Many of the single ladies living there were absolutely not living lives of quiet contemplation, much to the annoyance of the rest of the residents. In the visitations to Bardney Abbey, we see that secular visitors staying late and disrupting the cloister were becoming an issue which resulted in an edict being issued.

> "Also, we will direct, enjoin, and command under the penalties written above and below that seculars in no circumstance make their way through the cloister whereby the quiet of those studying or engaged in meditation be impeded or disturbed, and that absolutely no woman, and especially Joan Martyn and her daughter, enter the cloister or the inner places such as the refectory, dormitory, or infirmary or its hall, unless they are the mothers or sisters of monks..."[48]

No indication of what the named women had done to be singled out personally was given, but it was obvious that complaints about them had been strenuously made.

Godstow Abbey was encountering its fair share of noncompliant nuns when it was noted in the diocese visitations that the levels of rowdiness were unacceptable. Nuns were sternly cautioned in regard to visitors of either sex, especially those who stayed late and brought alcohol.

> "Also that there be no parties or drinks after compline...[and]...that no nun receive any secular for any recreation in their rooms under threat of communication. For the scholars of Oxford say that they can have whatever entertainment with the nuns they wish to desire."[49]

These edicts hinted that there was too much of a good time going on within the walls of Godstow and that it needed to stop.

Visiting clergy, like Richard, the Bishop of Lincoln who called in at Elstow Abbey, thoughtfully gave moral advice to the abbess about the type of woman she should appoint to overseeing others. In 1421, he firmly warned:

> "Also that no nun convicted, publicly defamed, or obviously suspect of the crime of incontinency be appointed to any office within the monastery, especially that of gatekeeper, until it is sufficiently established concerning the purgation of her innocence."[50]

He added particular instructions to those who were taking care of the sick.

> "Also that the nun infirmaress visit her invalid sisters twice or three times a day, or more often if need dictates, that she see that the infirm are adequately and suitably ministered to in regard those things that they need according to the monastery's resources, and that a suitable priest be provided who is to celebrate mass daily in the infirmary chapel before the infirm nun."[51]

Cloistered women were not always particularly keen on the devotional lifestyle, and one Agnes de Flixthorpe took the step of running away from her convent altogether. She travelled over three and a half miles from Stamford to Nottingham, and it was there that she was found in 1309 disguised as a man. Poor Agnes was excommunicated, chained, and forced to live in solitary confinement, but after five years, she was permitted to once again return to the greater convent with her sisters. Not one to waste a good opportunity, Agnes made another break for it, and this time eluded the search party entirely.[52]

She was never caught.

Chapter 5
Learning, Education, and Skill-Sharing

Figure 5. Saint Catherine of Alexandria, a female martyr of the Christian Church, who was renowned for her learning. Northeastern France. Miniature from a *Compendium of Saints' Lives*. Saint Catherine of Alexandria. At the start of the fourth century. Cleveland Museum of Art 1997.12.

One of the great myths surrounding women in the Middle Ages is that they could absolutely neither read nor write in any way whatsoever and were completely dependent upon others to do these for them. Nothing could be further from the truth. Whilst it is true that many could do neither, it's also true that many could do at least one or the other, to some degree.

Teaching women science and trade skills wasn't the usual educational path for girls, but fifteenth-century writer Christine de Pizan felt girls could become skilled in areas and occupations other than mundane household tasks, or the gentle arts of embroidery or textile production which every woman was expected to master.

> *"Should I also tell you whether a woman's nature is clever and quick enough to learn speculative sciences as well as to discover them, and likewise the manual arts? I assure you that women are equally well-suited and skilled to carry them out and to put them to sophisticated use once they have learned them."*[1]
>
> —Christine de Pizan

Literacy and the sciences could be achieved, she speculated, although in reality it wasn't the lack of intellect, but the lack of training opportunities which presented a problem. Not for *everyone*, but for many. Of course, numerous country women *were* illiterate, but these women lived rurally and had no real need for reading or writing. What use was literacy when her sermons were read to her on Sunday? Who would send her correspondence that she needed to read?

Women who lived in towns and cities, or who aspired to run large estates or their husband's businesses in widowhood, had more of a

need. Upper-class women also communicated with their husbands and friends via letters. These skills were taught before marriage, as part of a girl's education. In the twelfth century, the Countess of Champagne advised that women, should they exchange letters with a secret lover, must keep their correspondence surreptitious. A lady must not sign her own name nor use her personal seal.[2]

Instructing girls happened in some form for most of the medieval period. Educational opportunities for medieval women, like so many other things, depended on a woman's lot at birth. Many women could both read and write to some extent. Many could only read. The frequency which this occurred increased as the period progressed from century to century. It is interesting to note that in proper terms, any person was thought illiterate if he or she couldn't read and write *Latin*, the language of the educated.

In the fourteenth century, women increasingly became book owners and romance story readers. Some had books specially commissioned for them—beautifully illustrated Books of Hours. In order to read them, they needed to be literate. At this period, it was not wholly uncommon for a woman to be able to read well enough to adequately teach others, namely her daughters, to do likewise. St. Anne teaching the Virgin to read remained a popular icon in art over hundreds of years, even though she was teaching scripture, not reading romances or letters of communication to friends.

Young Girls

Education for the young girl could take many forms, but a great deal of it was practical if a young girl was rurally located or destined to be an average housewife of modest means.

Skills a young girl would need later in life were the most valuable. Cooking and laundry were more important than reading or writing. Peasant girls had far less opportunity or need for a formal education than their wealthy counterparts. Many received little or no education unless they lived in or near the town. For the most part, the extent of their outside learning was verbal religious instruction. Peasants and other lower-class girls were generally employed in outdoor duties, and a written record of their simple household expenses was not necessary.

The primary teachers of small girls were their own mothers, other familial females, or in the case of wealthy girls, tutors. Girls assisted their mothers at a very young age. Jobs such as preparing wool for spinning, baking, weeding in the kitchen garden, sewing, cooking, and caring for the poultry taught girls the skills they would use in later life as wives and mothers.[3]

Adolescents also learned to hand-sew clothing and make repairs, like darning, so that when a young woman became head of her own household, she would be adequately prepared to clothe her family in durable and well-made clothing, thus making the best of what economic resources were available to her.

The higher up the social ladder she was born, the more likely she was to be taught further lessons, but even so, a working knowledge of household tasks was invaluable. One could hardly oversee future staff if one had no idea what they should or should not be doing.

Some girls were fortunate enough to attend schools, as described in the poem by Jean Froissart, "L'Espinette amoureuse." Froissart, who was active in the last quarter of the fourteenth century, was better known for his chronicles of battle than his observations on

daily life, but in this short work he speaks personally. An excerpt of it reads:

> *"When I was no more than twelve...*
> *They sent me to school,*
> *Where they school the unlearned,*
> *There were little girls there*
> *who were my pastime playthings..."*[4]
>
> —Jean Froissart

While monasteries continued to provide some education to some girls, by the fourteenth century, more secular options became available. There were twenty-two school mistresses who were able to teach girls licensed in Paris alone.[5]

Young girls from upper-class families were taught to read, write, tell stories, read romances, and judge the merits of poetry. They often undertook singing lessons, were instructed in one or more musical instruments, and mastered fine embroidery. It goes without saying that a young, single girl who would one day be married to a rich husband must be well-schooled in manners and courtesy. Lack of such refinement did not encourage social advancement.

One fortunate young girl in ninth-century Saxony, Liutbirga, had the advantage of gaining an education and living single for the entirety of her life when she was rescued from a convent and taken away. A married woman, Gisla, stayed overnight at the nunnery and whilst she was there, saw Liutbirga whom she later described as "superior to her contemporaries in beauty and intelligence." After making enquiries about the girl's family, lineage, and social status, Gisla was well pleased and promised that if she came to

work for her, Liutbirga should be treated as one of her daughters and live with her forever. Luitbirga had been at the nunnery "since a young age" and was only twelve at the time, too young to take her vows, and she accepted. This offer was honoured and Liutbirga lived a long life, famed for her piety and charity. After the death of Gisla, she lived as a housekeeper for her son. She spent the last thirty years of her life as an anchoress at Wendhausen and a saint in her later life.[6] Any woman who rose to the rank of anchoress had a certain level of education, so her appointment shows that she was educated to an adequate level.

Examples of secular women teaching young daughters to read can be found in literature and art. Images of the Virgin learning to read from her mother is a popular inclusion in the many depictions of scenes of the life of the Virgin. In one miniature from England, dated around 1300 CE, the Virgin holds an alphabet book to learn her letters, and around that time the phrase *woman teacheth child on book*[7] appeared, indicating that mothers were taking an active role in the education of their children. This indicates a level of literacy amongst the mothers themselves.

It was noted that in 1463, Margaret Plumpton, daughter of a Yorkshire esquire, was almost four years of age when she had nearly learnt to read by studying a psalter.[8] Whilst this was by no means an everyday occurrence, it does demonstrate that education of some small girls was valued by their parents.

Upper-class girls would often be sent to other households to learn additional aspects of their education which would prepare them for marriage. It was not uncommon for young daughters of wealthy nobles and upper-class families to be educated in nunneries. Such a girl would also have her spiritual education tended to, as well as learning to read and write.

Unmarried Maidens and Spinsters

Educational opportunities for older women who had not married were varied and again depended on their family circumstances. While access to an academic career was denied to women for much of the medieval period, some unmarried women were taught by their fathers in subjects which were not traditionally accessible to females.

Christine de Pizan, from the fourteenth century, and Heloise, from the twelfth, are two well-known examples from the Middle Ages. Christine herself, speaking on the topic of educating women, said:

> *"Not all men share the opinion that it's wrong to educate women. But it's true that only the most stupid continue to support it, because they don't like that women know more than them."*[9]

—Christine de Pizan

Heloise, the niece of Fulbert, a Bishop of Notre Dame, had the good fortune to be better educated than most. Before her tragic entanglement with her tutor, Peter Abelard, Heloise was educated at Argenteuil, an all-female monastery, and was already widely famed for her intellect. After Abelard arrived in Paris, the young Heloise was placed in his care for independent tutorage.[10] Lessons commenced, but quickly turned to trysts of illicit lovemaking. After several months of an affair, followed by a brief period of marriage, pregnancy, and being abandoned in a convent, Heloise spent the rest of her days as a somewhat reluctant prioress. Most

of her life was spent as a single woman; less than a year was tied to a lover and husband.

Another young lady with decent literacy skills was Novella d'Andrea, the daughter of Professor Giovanni Andrea, who taught canon law. She was apparently a great beauty, and when her father was unavoidably absent from his classes, she read his lessons for him from behind a curtain so she wouldn't distract the young, male pupils. In 1321, she was ravished by a student who was beheaded for his crime.[11]

In the fifteenth century, a certain Dame Berthe de Corne studied grammar, geomancy, and medicine under her father, Renault de Corne. Berthe secretly practiced medicine and "lived pretty well" from it.[12] She was a part of a group of women who narrated their home remedies, traditions, and old wives' tales, which were transcribed by Wynkyn de Worde into a book known as the *Distaff Gospels*.

By the fourteenth century, a number of books were aimed at the female reading market, particularly maidens and ladies who were caught up in the ideals of courtly love. These included the *Romance of the Rose*, *Lancelot and Guinevere*, the *Gawain* romances, and of course, the *Canterbury Tales* by Chaucer.

Wealthy townswomen commissioned prayer books which could be read to their daughters for their spiritual education. Single women were not expected to make a living from writing, and indeed, it seems that chroniclers of the medieval period are almost entirely men. The *Book of the Courtier* by Baldesar Castiglione was written in 1528, which is slightly past the medieval period proper, but he offered some unlikely encouragement for the education of the fairer sex.

> *"There can be no doubt that being weaker in body, women are abler in mind and more capable of speculative thought than men."*[13]
>
> —Baldesar Castiglione

The detail from Guillaume de Deguileville's manuscript *Le pèlerinage de la vie humaine*, shows an audience of both men and women in attendance of a teacher. This text echoed the famous *Romance of the Rose*, where allegorical characters peopled the narrative in a morality tale. Where the *Romance of the Rose* had love and the attaining of a virgin and her conquest as its theme, the *Le pèlerinage de la vie humaine* had the finding of a religious life and the virtues which were needed to achieve it as the primary outcome.

Other more instructional books were also available to the maiden, and the recommended reading list included the *Book of the Knight* and Christine de Pizan's *City of Ladies*, both of which were morally instructional in nature. A noble woman's older daughter might also learn literacy from a nurse or tutor, someone especially employed for that purpose.

In a world where a nobleman's wife was expected to run, not only her own household, but her husband's estates in his frequent absences, it was extremely useful that she be functionally literate and have some rudimentary mathematical skills, so that she might run these with efficiency and be able to examine whether her household costings seemed reasonable, or whether her staff were siphoning off produce and consumables. She was not responsible for all expenditures of the household, or for handing the collection of the accounts, but certainly needed to know enough about

business management to see that her household was being run properly.

Wills during Chaucer's period demonstrate that many wealthier women bequeathed books to other women, excluding other family members who were not female. These books were both devotional and works of romance, showing that books were read not only for instruction, but also enjoyed for pleasure, and were treasured commodities.

One example of this is the 1390–91 will of the Countess of Devon, Margaret Courtenay. Her books included primers, a medical book, and stories of Tristram, Merlin, and Arthur. These treasures she left to her daughters and a woman friend. Her daughters also were left books from her husband, and it is interesting that no books were left to her sons.[14] She was not alone in her patronage of the book industry, as other wills testify.

Widows

A woman who had reached this stage of her life did not have opportunity to further her learning, unless she entered a nunnery. Her literacy skills would have been taught prior to her marriage whilst she was single, and as a young widow, she would have been focusing on supporting herself with the skills she had, possibly whilst juggling child-raising. Going to school or university, or learning a new trade, was unlikely.

A regular woman who was widowed might have trade skills, taught by her husband whilst working side by side with him in his workshop, but further educational opportunities were slim. Guilds

did not accept widows as new trainees. A widow might learn a new trade through her next husband, but that doesn't concern us here.

One example of a widow whose education and literacy skills were of a high standard is that of famed French writer Christine de Pizan. Christine was married as a girl of fifteen and a widowed woman by twenty-five, with a young family to support. The bulk of her education was undertaken by her father while she was a child, but after widowhood, she became a prolific writer.[15] Her books were written for an exclusive audience of female readers, and incorporated themes which were relevant to women at all levels of society. The fact that her books were written for women tells us that there were enough women educated well enough to read them to make this a worthwhile venture.

Nuns and Cloistered Women

Many of the female Christian saints were well-known for their learning and teaching, and were widely revered. Modern people often forget that these, too, were single women. One such was Catherine of Alexandria, a virgin who lived in the fourth century. She was renowned for her learning and teaching and died a martyr. In spite of her status as an unmarried woman, she can be found in illuminated manuscripts throughout the entire medieval period as an inspiring example of womanhood.

As we have seen in previous chapters, some girls had the opportunity to be educated in a nunnery, where learning to read and write was commenced under the supervision of a suitably qualified nun. Nunneries provided educational opportunities for

daughters of families of low income who were handed over for life, the daughters of better families who were to be married off at a later time, and those with genuine religious inclinations, although this last category rarely included small girls.

Reading and knowledge of prayers and other devotions, the *Pater Noster* (Our Father) and the *Ave Maria* (Hail Mary) among them, were of primary interest. Reading and writing would stand a young lady in good stead in the outside world should she have daughters of her own to teach. A better standard of literacy which included Latin would be more valuable to those nuns who illuminated and copied manuscripts.

The West Saxon Abbot Aldhelm of Almesbury visited the nuns at Barking in Essex in the seventh century and had only enthusiastic reports of their diligence and knowledge on a variety of topics—including the four gospels, grammar, spelling, and the rules of metrics—and noted that they wrote *"with a rich verbal eloquence"*[16] which was a great credit to the abbess, Hildelith.

Several hundred years later, Godstowe Abbey near Oxford fared less well. The nuns were supposed to be able to read Latin, since holy texts were largely written in it, but the good ladies of Godstowe nunnery had a substantial number of inmates amongst them who could only read English. In 1460, a concerned brother offered his services to transcribe volumes from their library from Latin to English for their benefit.

The English Register of Godstowe Nunnery records his wish thus:

> "For this reason a poor brother and well-wisher to the good abbess of Godstow, Dame Alice Henley, and all her convent, who are for the most part well versed in books in English, heartily desiring the worship,

> profit, and welfare of that devout place, that, for lack of understanding of their muniments, should not hereafter incur any damage to their livelihood...the greater part of the muniments contained in the book of their register in Latin, have purposed, with God's grace, to render... from Latin into English..."[17]

His concern that their religious educational opportunities were severely limited was quite justified. Even by the mid-fifteenth century, the bulk of religious texts were written only in Latin. Nuns who were unable to read Latin were unable to access a wealth of spiritual treasures.

Chapter 6
Unpaid Labour, Jobs, and Business Opportunities

Figure 6. Fifteenth century illustration from Giovanni Boccaccio's *De Mulieribus Claris*. Master of the Coronation of the Virgin (fl. from 1399 until 1405). In the collection of the Bibliothèque nationale de France. Accession number Fr.12420 101v. wikidata: Q23900700.

It would be impossible to provide a comprehensive description of women's employment opportunities during the medieval period in full in a single chapter. Instead, we shall delve into a brief overview of paid occupations available to single women of all ages at that time.

Jobs for single women in the Middle Ages were as wide and varied as they are today. Many jobs were regarded solely as women's work, but there are contemporary records of women who worked outside the normal conventions in occupations usually reserved for men alone.

One inaccurate image given to us by popular movies is that of the serving wench. While it's true that most brewsters were women who made and sold beer from their own residences, the serving of food was not particularly a woman's job outside of her own domicile. Women waiting on the high table at noble feasts are never shown in paintings or manuscripts. This was a job far too important to be entrusted to mere women, who were to be found in the kitchen chopping and preparing food. Serving food at a feast or to an honoured guest was highly esteemed and therefore a job which belonged to the head steward of a house—a man.

What kinds of jobs *could* a single woman obtain?

Her options were many: a servant in someone else's house, a manual labourer in the fields, tending the home for someone else, textile production, chambermaid, embroiderer, illuminator, copyist, and candlemaker were all occupations in which a woman could gain employment if she had adequate training. Employment for single women of almost any age could always be found as a servant or launderess. Tax records show one worked in leather as a saddler.

Manuscripts like the *Très Riches Heures du Duc de Berry*'s month of June, illuminated by the Limbourgh brothers, and the well-known English manuscript the *Luttrell Psalter* show women workers engaged in domestic chores—working in the fields, feeding chickens, and tending sheep. The detail from the month of April from the *da Costa Book of Hours*, illustrated in 1515 by Bening, shows a homely scene where men and women work together at a variety of menial jobs—milking the cows, tending the sheep, and churning butter.

Young Girls

Most single girls under the age of young adulthood were not employed as such, but were not idle. Whilst lower classes worked alongside parents and older siblings, they did this in order to be employed in the future. Skills they learned at home were valuable for when they were mature enough to work solo, either in their own village or in another nearby. For those who aspired to a life of domesticity, these were skills they needed to run a household. Young girls learned cooking, cleaning, and laundry from their mothers.

A young rural girl would have had the opportunity to tend her family's chickens, ducks, and geese, as well as small livestock like goats or cows for cheese and milk. The milking and husbandry of these fell solely on the shoulders of the woman of the home. She taught her daughters, who would, in turn, teach theirs.

Even a young girl could be taught how to use a spindle and how to prepare wool for spinning. By the time a young woman was in her late teens, she was already an accomplished spinner. Her threads would have been even and of a reasonably high quality. When she

was married and making clothes for her own family, the cloth she produced would have been of quite a good standard. A character in the work *Piers Plowman* agrees that this is what daughters should learn from their mothers:

> *"Some shall sew sacks to stop the wheat from spilling...*
> *Wives and widows, spin wool and flax;*
> *Make cloth, I counsel you,*
> *and teach the craft to your daughters."*[1]

—William Langland

Working for family had multiple benefits: a roof over one's head, food on the table, and less danger of being chronically overworked or sexually assaulted by one's employer.

Unfortunately, this was not the case for Alpais, a twelve-year-old peasant girl who laboured alongside her father in northern France. Alpais was the oldest of his children and, although she had younger brothers who tended the cows, she, being the senior, worked beside him in the fields. She worked with their two oxen, prodding them with a stick to keep them moving, and was responsible for the collection and distribution of manure they gave to fertilize the grounds. On Sundays, she refrained from rest and continued to work. This was not a sustainable workload for a child, and eventually she suffered a variety of bodily injuries and was unable to work, withering away.[2]

Girls might have worked for a neighbour or relative or engaged in household duties in the nearest town, though it was uncommon for girls under the age of twelve to seek employment outside of their familial home. Very poor or orphaned girls were sometimes put to work at an earlier age through economic necessity.[3] In 1427

in Florence, 280 of the 736 known servants were females between the ages of eight and seventeen.[4]

Servant as an occupation was not seen as a demeaning work choice, and occasionally, in household rolls, children are described as servants of their own parents.[5] The Court of Common pleas in England, dated 1380, named a girl, Joan, who was the natural daughter of the mother of the house, but was also working there as a servant. With only the very poorest peasant women unable to afford some domestic help, there was usually no class difference between mistress and maid at this level.

The duties of a chambermaid in a city house included sweeping out and cleaning the entrances to the house, and dusting and shaking out the cushions and cushion covers. The Goodman of Paris gave advice about hiring a young girl to this position, namely doing a background check, recording the names of her parents and kin, where she came from and where she was born, along with references. This was all to be carefully recorded in the household ledgers when the girl was hired.[6] Enquiries were made into her demeanour, behaviour, dress, and speech to ensure that she was a suitable type of employee to be added to the house. At times like this, a girl's attention to her lessons on good behaviour made the difference between employment and none.

Unmarried Maidens and Spinsters

Caring for the average home was always the domain of the wife, via her servants, but if she had passed away, through either accident or illness, this responsibility fell squarely on the shoulders of the

eldest daughter, should she be of a suitable age. Her preparation for domesticity in her formative years mattered now that she was expected to fill the role of head female of the house. This was not the case for the high-born maiden or damsels, who had female staff hired to take up the workload.

An adult woman who was not wed and was over the age of twelve might earn a living outside of her family home. There were numerous options available to her, once again depending on her station at birth. Jobs were available all year round, both domestic servitudes indoors and seasonal engagement outdoors. She might work for a lord's house as a dairymaid, chambermaid, or housekeeper, or, if she was well-bred, as a personal companion to a lady. Working in such a situation helped to teach a young lady the niceties of upper society and make valuable social connections while she was unmarried.

In 1276, the Bedfordshire Coroner's Rolls record a death by misadventure of one Emma, lady of the house, but as an incidental part of the transcript, we learn of a young woman who was hired as a maid or a mother's help.

> "Maud, daughter of Ellis Batte of Sutton was sitting in William's house keeping watch over Emma's child Rose, who was lying in a cradle."[7]

Maud was clearly not a blood relation to William, or she would have been named as such—daughter, niece, or cousin. She was named as another man's daughter, which tells us she was working in his employ and was not kin.

Peasant women were often employed in menial work outside the home as well as raising their own family, all while taking care of their own vegetable patch and any poultry they may have had. Rural women did their own cooking and cleaning, although many peasant women had domestic help. It isn't true that all peasants were extremely poor, and a young, unmarried woman could earn extra money working in another home. In her own house, she had dishes from cooking and eating to tend to, laundering of clothes and bedsheets, bedbugs and household pests to deal with, and floors to sweep. These were all jobs she could perform in someone else's home for pay.

The popular health handbook of the fourteenth century, the *Tacuinum Sanitatis*, shows illustrations of women working with men in a garden setting on page after page. Although the workers are often dressed in fine clothes, there is little doubt that the actual agriculture was performed by servants and gardeners.[8]

Rural women were also engaged in spinning and preparation of fibres for spinning and weaving—scouring flax, combing wool and hemp, and assisting with sheep shearing. In an anonymous legal manuscript from the thirteenth century known as the *Fleta*, the duties of the dairymaid, a common occupation for single women, are given.

> "It is the duty of the dairymaid to receive from the reeve, by written indenture, the utensils belonging to her office and when she leaves to return them by the same indenture, in which the date of her commencing work is stated. Further, it is her business to receive milk, against a tally, by the number of gallons, and to make cheese and butter, and to take charge of the poultry and frequently to render account and to answer to the bailiff and the reeve for the produce resulting therefrom..."[9]

Not content with that list, it continued with additional jobs for any spare time:

> "And when she can reasonably find leisure for such things, it is her business to winnow, to cover the fire and do similar odd jobs."

This showed that it was a position of a certain amount of responsibility and trust, not only making milk byproducts of cheese and butter, but keeping the accounts and tallies correct.[10] Her reward for finishing her own jobs in a timely manner? More work.

Another thirteenth-century manuscript on how to manage an estate, the *Seneschaucy*, written by Walter of Henley, also describes the work a dairymaid was responsible for.

> "She is in charge of the milking, cheese and buttermaking
> and the stocks of dairy produce;
> in addition she keeps the geese and hens,
> has to help with winnowing the corn,
> and is in charge of keeping and screening the fire."[11]
>
> —Walter of Henley

Looking at estate records, we learn that labourers could be hired by the day during peak seasons or by the year for longer terms of employment, and women as well as men are named individually. These workers were hired specifically for the work stipulated, unlike the dairymaid, who had many other jobs thrust on her if she had a spare moment.

Women's outdoor work was usually paid at a rate slightly less than men's, although women thatchers and reapers were often paid at the same rate as their male coworkers. The *Statute of Cambridge* in 1388[12] shows that the maximum wage for women labourers and dairymaids was six shillings per year, much less than the top wage of ten shillings for men. This was also demonstrated in advice given on the running of an estate at the end of the thirteenth century.

> "If there is a manor in which there is no dairy then it is always advisable to have a woman there for much less money than a man would take, to take care of the small stock and all that is kept on the manor and answer for the issues... And she ought to be responsible for half the winnowing of the corn..."[13]

In the earlier medieval period, many of these regular jobs were supplemented by owed service, where tenants were required to work unpaid for their lord for a certain number of days each week. On the estates in Wiltshire owned by the Templars, if a woman lived on five acres or more, she was obliged to milk the ewes each day and, at shearing time, wash the sheep before clipping.[14] This applied to either single or married women, on top of their own work at home.

Rolls from the manor court at Halesowen in 1300 show the amount of work the daughters of certain tenants were expected to give.

> "Day in Autumn. The daughter of William de Wylinghurst, two daughters of Nicholas le Yonge, two daughters of Thomas Colling and the daughter of Dygan to work two days for the lord in Autumn, each of them one day at the wheat."[15]

The daughters, being unmarried and therefore essentially the property of their fathers, are not individually named.

There was very little that a peasant woman might not be called to do, and many illuminations show women working in the fields alongside men.[16] They were hired to do various types of agricultural labour, including planting peas and beans, weeding, reaping, binding, thatching, haymaking, hay stacking, threshing, and winnowing.

The Peace Sessions from Lincolnshire in the fourteenth century show a number of single women who worked in the fields reaping. Some of these accounts are disputes over wages, and others arose because certain women had left their own estates and worked outside their own manors without permission. These included Emma Dagge in 1383, who was unhappy with a proposal of being paid on a daily basis rather than weekly or for the term of the season and was refusing to accept the conditions. She wasn't alone, and it was a demonstration of workers standing together to fight for more acceptable and fairer pay.

> "Also they say, Emma Dagge and others are common labourers and refuse to swear before the constable to take by the day autumn wages according to the ordinance of the Statute..."[17]

Several other women are mentioned specifically by name as working as reapers in Yorkshire.[18] In 1363, fifteen women are named, and a further four are listed as wives of certain men. It should be inferred that the other fifteen listed by name are spinsters. These women were charged with charging more for their

services reaping "than they were wont," which was set at 3d each day including a place to stay.

Washing was a woman's domain. In a town household or the house of an upper-class woman, laundry was carried out almost exclusively by female servants under the charge of a senior laundress who was herself under the charge of the noblewoman. A noble woman was expected to oversee these things but not take part in them herself. Washing clothes may have been done either inside over a fire or outdoors at a nearby stream, and was often a social occasion as well as a necessary chore. The job of a laundress was most suited to an older single woman, rather than a much younger one. The work was hard and heavy, and involved boiling and hoisting wet washing from cauldron to baskets and hanging or laying items out to dry.

Larger establishments had in-house washing facilities, but other houses used a communal washhouse. In medieval Brittany, it was noted that these were a hotbed of gossip and news exchange.

> "The washhouse is one of the principal laces of gossip in our region. Women of all ages meet there and soaping and beating their linen seems only a secondary activity, so enthusiastically do they exchange scandal, tell each other of the loves, marriages, births and other major events of the district."[19]

As with many jobs today, medieval laundresses had their superstitions about the job. The *Distaff Gospels* of the fifteenth century was a collection of advice and old wives' tales from a group of dames who were discussing the things a woman, single or otherwise, should know.[20] With regard to laundry, Dame Berthe de Corne, who was around eighty years old, warned that

one shouldn't tempt fate by speaking about how well the process was going.

> *"Each time you do the laundry*
> *and the cauldron full of washing is on the fire,*
> *and the washing is boiling because of the strength of the fire*
> *burning underneath,*
> *you must refrain from saying: 'Ha! My friend, the laundry is boiling!'*
> *but you must only say 'it laughs,'*
> *otherwise the clothes will go up in smoke."*
>
> —Berthe de Corne

While medieval people, especially the lower classes, worked extremely hard, they enjoyed almost sixty holy days a year. Servants were often not permitted to perform their usual duties on these days, and a poem dating to the mid-fifteenth century reflects this.

"The Serving Maid's Holiday"

> *"All this day I have tried,*
> *I have not wound spindle or reel;*
> *To great bliss I am brought on this high holiday.*
> *I cannot weave nor wind nor spin,*
> *For joy this is a holiday.*
> *All unswept is our floor,*
> *and our fire is unlit,*
> *Our rushes are still uncut, on this high holiday.*
> *I cannot weave nor wind nor spin,*
> *For joy this is a holiday.*
> *I must go and bring herbs in;*
> *Thread my kerchief under my chin;*

> *Dear Jack lend me a pin to thread me this holiday.*
> *I cannot weave nor wind nor spin,*
> *For joy this is a holiday.*
> *Now it draws near to noon,*
> *And all my chores are undone;*
> *I must clean my shoes a little to make them soft on this holiday.*
> *I cannot weave nor wind nor spin,*
> *For joy this is a holiday.*
> *I must milk in this pail;*
> *I should have cooked [or lined] this whole dish,*
> *The dough is still under my nails as I knead on this holiday.*
> *I cannot weave nor wind nor spin,*
> *For joy this is a holiday.*
> *Jack will entice me on my way,*
> *Desire to enjoy himself with me;*
> *I am not even afraid of my dame on a good holiday.*
> *I cannot weave nor wind nor spin,*
> *For joy this is a holiday."*[21]

Of the two work options, live-in servitude was a more secure form of employment, although the wages were slightly less than seasonal work. Many townswomen were single women who had previously lived in the country and had moved to a nearby town seeking full-time work. This was not seen as a lifetime occupation, but rather an engagement suitable for single women until marriage.[22]

In household accounts over various years, we see women being paid to perform small household duties: washing, sewing, portering goods from town, cleaning the buttery, and making candles.[23] Even working in the kitchen and tending the enclosed garden in a city or town was less back-breaking than working in the fields, and offered opportunities for the unskilled young woman

of good manners. A Flemish image from the Walters Art Gallery Manuscript W425, folio 4r, *Labours of the Month of April*, shows a town garden being planted out by a female servant under the direction of the lady of the house.

A good working environment depended heavily on what kind of boss one might have, and one was vulnerable to sexual misconduct or beatings and mistreatment if one had a poor employer. Once such record survives from early Tudor London (1552) from a chronicler known from Greyfriars. A female employee was injured cruelly when her female boss used a carding comb with iron teeth on her body as if she was wool. The woman responsible, who was noted as living at Aldersgate Street with an occupation describing her as a maker of alcoholic spirits, was sent to prison for her misdeeds.[24]

Living as an unmarried lady in waiting, or in the case of Agnes Pore as a nurse to a wealthy family, could have huge financial benefits which made well worthwhile her years of servitude. Agnes was employed as a nurse to King Edward III's daughter, Margaret, and was granted benefits for as long as she, Agnes, lived. In a letter patent dated 1352 from the London *Calendar of Patent Rolls*, 1350 to 1354, we read her grant:

> "Grant to Agnes Pore, late nurse of the King's daughter, Margaret de Wyndesore, in lieu of a grant to her for life of ten marks yearly at the Exchequer by letters patent surrendered, of ten marks yearly from Michaelmas next out of the farm of the alien priory of Hamble during the war with France. If the war end in her lifetime, she shall then take the said sum at the Exchequer according to the form of the previous letters patent."[25]

Skilled work was also available to some. Records of women who worked in towns include, but are not limited to, the following occupations: hat-making, cobbling, glove-making, girdle-making, haberdashery, saddle-making, embroidering, purse-making, cap knitting, spinning, and silk weaving. They were involved in the food industry in brewing ale, butchery, innkeeping, and selling garlic, fresh bread, flour, salt, candles, butter, cheese, fish, and poultry.

The York Chamberlain's accounts from 1486–87 named a Margaret Burton and received a fine of thirteen shillings and four pence for a transgression in her craft of barker (tanner), and received a payment from Joan Bell in the 1445–46 period for a temporary huckster's licence. Joan was given permission to sell by retail until the Feast of the Purification and was charged twenty pence for the privilege.[26] There was no mention of what goods she was licensed to sell, but that her goods were sold at retail prices hints that she had some small capital to be able to buy items cheaper and make enough of a profit to be worth her while. Joan, unlike other women in the Chamberlain's accounts, is not named as anyone's wife, widow, or daughter, and must therefore have been supporting herself and trading independently as a single woman.

The life of an upper-class lady was vastly different. In her *Le Livre des Trois Vertus*, Christine de Pizan wrote of the duties of an aristocratic wife and said that, while such a lady may not actually do the weaving in her household herself, she must be knowledgeable about every facet of the process so that she may oversee each and every stage of the process—from the selection of the fleeces to the final construction of finished garments. In this way, she might ensure the best standard of materials and workmanship, and know how much of what product should be

fashioned and what quality should be expected.²⁷ If a single girl was to aspire to be an upper-class wife in her future, she needed to be proficient at these skills before she married. She would be unable to instruct her staff on improvements in technique or skill if her own abilities were sub-standard.

While many of the professional textile arts were dominated by men, embroidery seems to have had a larger percentage of women workers than other guilds. Records from the very end of the thirteenth century show that, of the ninety-four registered embroiderers in Paris, seventy-nine were women. The *Girdler's Ordinances* of London in 1344 tried to restrict exactly who was being trained and working in their craft by limiting the involvement of unmarried women.

> "Also that no one of the said craft shall set any woman to work other than his wedded wife or his daughter."²⁸

This indicates that previously, other single women were involved. It was good news for unmarried daughters though, who could continue to work and be trained in the field by their fathers. French guild regulations by the end of the thirteenth century restricted women to some occupations, but not to others.

Tapestry weaving, for example, was too taxing for women and therefore forbidden. Women only were to be the makers of embroidered headdresses, and a six-year apprenticeship was required. The guild was strict in its working hours, because it believed that the work needed to be done in adequate lighting. It stipulated:

> "No mistress or apprentice in this craft may work in winter or summer at night, nor in the morning if it be not by daylight."[29]

It may come as a surprise to some that women were also employed in traditionally male-dominated fields, such as chandlers, ironmongers, smiths, goldsmiths, skinners, bookbinders, painters, spicers, and farriers. Possibly, these were widows who were given permission, had the desire, and were physically able to carry on their late husbands' trade.

According to P. F. P. Goldberg in *Women in England, c. 1275–1525*, the author states that women were comparatively common participants in the small metals trade, especially mailwork, which is believed to be the manufacture of chain mail. One will named Agnes, daughter of Adam Hecce, an armourer in York, as the beneficiary of all his tools pertaining to mailwork, while leaving tools for furbishing, that is, finishing weapons, to his son John.[30] It appears that he had involved both his children in aspects of his business he deemed them best suited to. Art also reflects this, although most manuscript images of women working with smithing tools are allegorical. They show Mother Nature forging babies, or a woman forging the nails used to crucify Christ.

Medieval women also worked in the field of illuminating manuscripts and as copyists for books.[31] Although a number of women are listed as working in various aspects of book production, it is unclear from the records whether they were married or single; however, it gives us examples of the kinds of trades that a woman might be involved with. Marth and Ermangarde were parchmenters in Paris, Asceline was a French ink maker. Maroie was a French copyist, Alice Drax a London bookbinder. Elisabeth

Scepens helped a widow run a bookstore in England but also produced new books on commission.[32]

Other occupations provided important livelihoods for medieval women, and these included religious devotions, certain types of health care, music, or prostitution. Fifty-nine female doctors and surgeons can be named from the medieval period before 1600, but medicine was not a common career path open to them if they were single. Magistra Hersend and Sara of Sancto Aegidio were both notable exceptions.

We know a little about the life of Magistra Hersend, who comes to our attention in 1249, when she accompanied King Louis IX of France on the Seventh Crusade as a surgeon. Her duties included the health care of Queen Marguerite and the female camp followers. For her services to the crown, she was bequeathed twelve pence a day for the rest of her life. She caught the eye of the royal apothecary, whom she eventually married.[33]

Sara of Sancto Aegidio has revealed a little of her life, but not too much. She was the daughter of a physician named Avraham, whose widow remarried. Her medical training may have come through her mother, as her stepfather does not appear to have had a medical background. Sara was Jewish, lived in Marseille, France, and was actively involved in medicine around 1326. On August 28, 1326, we find her making a contract with her student Salvetus de Burgonoro, of Salon de Provence, to take him on and train him for seven months as her apprentice. During that time, he was to give her any earnings he might make, but she would provide him with his clothing and a place to live.[34] She was only able to do this through a royal decree from Marseille from the same year.[35]

Pharmacy was not a university course like medicine, so Parisian women might, like Adélie l'erbiére in 1292, run an apothecary which dealt in kitchen herbs and herbal medicine without being licensed.[36]

In spite of this, one Agnes Wodekok served a medical apprenticeship under a London barber-surgeon named Nicholas Bradmore. This incidental trace of a woman working in the field comes to us in the record of his will, which was written up in 1417. He leaves a red belt with a silver buckle and cash, six shillings and eight pence, to her, specifically naming her as his apprentice.[37] Agnes was not his daughter or wife and again, the lack of a named familial tie, that of wife or daughter, hints that she was unmarried and learning her trade from him the same way male apprentices would do.

The fine arts were also peppered with women practicing their skills. A set of illuminations from Boccaccio's *Le livre des cleres et nobles femmes* or *Lives of Notable Women* show women sculpting, painting at easels, at desks working on manuscript illustrations, or painting wall murals, and being involved with other crafts.[38] Several manuscripts which show the lives of women include a woman painting a self-portrait using a small hand-held mirror. One of these early fifteenth-century illustrations can be found in the collection of the Bibliothèque Nationale de France in Giovanni Boccaccio's *De Mulieribus Claris*, Fr.12420 101v. The young lady is fashionably dressed in a surcote with hanging sleeves and sits at a purpose-built artist's table with pigments and brushes while she carefully applies paint to the face of her self-portrait.

Widows

Widows perhaps had it best of all when it came to single women working in the Middle Ages. Such a woman could, under the right circumstances, continue her late husband's business by herself or with the assistance of apprentices, which she might have permission to train herself. This was known as trading as a *femme sole*.

Emma Hatfield was an example of this practice. Emma lived in London in the mid-fourteenth century. Her husband William bequeathed his chandler's shop and all the goods pertaining to the making of stock to her upon his death. Chandlery was the practice of making candles, and was a trade usually practiced by women, so Emma would have been well-skilled to take over the business herself. William's will stipulated that she also inherited his apprentice, Roger Gosse, to train, so that shows us that Emma was capable and possessed the skills in the craft to do so. In 1373, her inventory included barrels, grease, vats, lengths of cord for wicks, tallow, salt, and 325 pounds of finished candles.[39] She would have been expected to manage the inventory and pay taxes.

Some women were permitted into guilds, but in many cases, they were excluded completely, because of their gender and not because of lack of experience. Very few women were formally apprenticed, although many were trained by their husbands or fathers in trades informally. Widows of skilled tradesmen often fell into this category. A few records do show that women were admitted, but this should not be thought of as the norm.

Listed in the records of the Company of Soapmakers of Bristol are entries of two widows who did so.

> "The Widdowe Dies took to prentice Michaell Pope the Son Richarde Pope of Bristeltowe for the terme of VII yeares begininge the III of October 1593."[40]

Also among the same records...

> "We reserved into the fellowship of Sopmaken and changleng Richard Lemwell for that he sarved his Apprentisshipe with Alice Lemwell wedow to sopemaken and changlyng."[41]

The late-fourteenth-century Dyer's Ordinances in the city of York list fifty-five male names of masters of the craft but, surprisingly, also four female names, one listed as a widow. While women were overwhelmingly outnumbered in the industry, these women were listed as persons in their own right.[42]

In other wills, a widow was able to continue her husband's business for a certain amount of time before she must remarry. She should make sure that she sought good financial advice and kept her accounts in order. This advice was echoed by the Goodman of Paris himself:

> *"Always bargain ahead of time, and do the accounts and pay often, without allowing long credit to build up."*[43]

This is still solid advice for a small home business operator today. Pay your creditors. Don't let your credit get out of control. Get a quote before you start. Medieval women understood this too.

Further wills gave permission for the widow to run the business on her own, on the strict condition that she kept herself chaste and *did not* remarry. While some historians have seen this as an attempt to control her sexuality after death, it could also be seen as a rather liberating arrangement which the wife may have discussed with the husband prior to his demise and wholeheartedly endorsed.

We know of a number of these now-single women engaged in business from medieval records, including Joan Hille (London foundry with four apprentices), Rose of Burford (London wool trader), Petronilla Balle, widow of Peter the Potter (pottery), Emma Erle (Wakefield cloth trader), Ellen Lynland (York cordwainer), Emma Huntyngton (York apothecary), Isabella Nonhouse (York weaver), Alice Byngley (shearman), Elena Couper (pin maker), Isabella de Copgrave (brick-making), and one unnamed woman who worked as a skinner in London, and another as a butcher.[44]

Seen in a 1379 poll tax from West Riding in Yorkshire, one single woman is listed independently as paying tax for her craft:

> Elizabeth de Snayth, weaver 6d.
> Cecily, her daughter 4d.
> Elizabeth del Chambre, her blood relative 4d.
> Robert, her servant 4d.[45]

The lack of a named husband (where other businesses are listed as "William Hegh and his wife, spicer") indicate that Elizabeth was the principal in the business, without a husband, and that two other single women lived with her, perhaps working as

employees, although this cannot be assumed. It is unclear whether the named Robert is her servant or the servant of her relative, but again that Elizabeth was named in her own right, and not as an appendage to a husband or father, indicated that she too was an independent woman.

Wills from the Diocese of York in 1458 show another widow, Emmot Pannall, who was running her own saddlery business. She left all the tools of her trade and cash to her male servant, Richard.

> "Also I leave Richard Thorpp my servant every single tool of my workshop relating the saddler's craft and 26s 8d in money from selling, discharging and releasing my goods."[46]

Her wording indicates that the workshop and the tools were hers, to dispose of as she felt proper.

Other widows, like the famed writer Christine de Pizan, supported their families in trades which were male-dominated. Widowed at the tender age of twenty-five with three children to support, Christine ably worked at writing what turned out to be one of the most popular books aimed at women, *la Cité des Dames,* or *The City of Women.*

Christine was in the enviable position of having a father who was a member of the court and the foreign affairs advisor to the French king, Charles V.[47] Had she not had this previous connection growing up, becoming a writer to support her family in a male-dominated field certainly would have been more difficult for her. Christine eventually opened her own scriptorium, where she employed calligraphers, copyists, and illuminators. About fifty of

her own manuscripts, which numbered around two hundred, were written and made there.[48] For a single woman and widow, this was an admirable achievement.

Other employment opportunities for widows were few and far between, but that isn't to say there were none at all. A widow might take work as a housekeeper for a clergyman, but only if she were without question of high moral fibre. In spite of this, records of impregnated housekeepers of men of the cloth who were leading supposedly chaste lives pepper the court records over a number of years.

Beggars, Fringe-Dwellers, Poor Women and Prostitutes

Poor women and those without permanent homes did the best they could finding a job, although these were menial and did not pay well. Many we learn of through incidental mentions in contemporary literature.

Glutton, a personified character in William Langland's moral book *Piers the Plowman*,[49] tells how he was lured to a tavern on his way to church, where he met other people who were either itinerant or on the outer fringes of society economically, including Cicely Shoemaker, Tim the Tinker, Clarissa of Cock Lane (no prize for guessing what she did for a living there), Sir Piers Pridie the priest, accompanied by a lady Petronella (perhaps not so much a lady if she was the mistress of a priest who was at the pub), a rat-catcher, a scavenger, an odd-job man, Rose the dish seller, Griffin the Welshman, and a gaggle of old clothes dealers. This list shows poor

women—Cicely, Clarissa, Rose, and Petronella—who were trying to make a living the best they could and were most likely typical of the types of jobs real women might also have.

Single women might also be employed as musicians, *jongleuresses*, and *menestrelles*. Many were itinerant and travelled from town to town and as part of small groups of entertainers, often the wives or daughters of their male counterparts. In a few cases, there are records of women in independent roles. In 1321 in Paris, women were given permission to participate in the Guild of Minstrels. Guild women were more likely to perform more professionally in cities for more upmarket clientele.

Most entertainers that we know of today from this period are male; however, we do know that King Charles V of France's wife had a female jester named Artaude du Puy.[50] Little is known of her other than her name. One other name we have is that of a peasant woman, Guillemette Marighier, whose exceptional beauty and long golden hair got her noticed and subsequently employed by Duke Phillip the Good of Burgundy. By 1430, she was living a pampered life at court and was famed for her acrobatics and athletic prowess.[51] You can read into that what you will, but her life as a single woman provided her with food and lodgings of a good standard.

Single adult women who made their living in the sex industry were as active in the Middle Ages as they are today. Prostitutes were generally looked down upon but deemed a necessary evil, something that society needed but would rather not. The medieval sex industry was fairly regulated and more organised than our own today, with guidelines for the hours worked and wages paid, so that the women might not be taken advantage of or overworked. Some women lived on the premises, but it's noted that others

arrived for work at the appointed time, did their hours, and went home at the end of the day. Southwark, London was the place to go if one was looking for work in a stewe or brothel, as in 1374 there were eighteen known bathhouses there alone. These were all managed by Flemish women and well-patronised by men of religion. Although the brothels were managed by women, many of the properties were rented from the Bishop of Winchester himself.[52]

There were health regulations in place, and many were visited once a week by a doctor for a general check-up and testing for venereal disease.[53] Towns and cities repeatedly tried to regulate the clothing a prostitute could wear, and sumptuary laws tried to curtail extravagant clothes which the lifestyle of a working woman could afford.

The need to find work when one was single and alone and fallen on harder times led women into situations which were unsafe. Prostitutes and whores not protected by the laws of an organised brothel often had an untimely end of life. Capellanus wrote harshly of women who accepted money in return for sexual favours whilst pretending to be women of good repute.

> *"If you are so driven by wantonness of the body*
> *That you want to seek paid women,*
> *It would be better for you to do business*
> *With the women who openly loiter in the brothels*
> *And sell their bodies for a small price*
> *Than to be robbed of your property, under the fiction of love*
> *By some woman who pretends to be a lady*
> *But acts like a strumpet."*[54]

—Andreas Capellanus

In more wholesome employment, poor women or widows might have the opportunity to earn extra money in times of another person's need. Some might, if their own lives had been upright and they had remained continent after their husband's deaths, be paid for praying, for sitting vigil, or for saying masses at a funeral, either at the bequest of the families or of the deceased themselves. Such prayers were, it was thought, to be heard more readily, as poor women of good virtue were closer to heaven than those people who were currently living rich and worldly lives.

In 1274, when Prince Henry was unwell and fears were held for his life, various methods of appeasing God were taken in the hope of heavenly intervention and a cure. This included sending candles to seven churches and paying thirteen poor widows to spend a night in prayer on his behalf. They were paid the sum of a penny each.[55]

Nuns and Cloistered Women

Women who wished to avoid marriage, or were widowed and wished to avoid further marriages, had the opportunity to undertake a life of devoted contemplation. This came in many forms, from lay sisters to anchorites walled into their own little cells, but almost all involved life in a community under the care of an abbess. Work inside a nunnery or religious house varied more than most people suppose. To accompany the daily occupation of prayer, masses, and taking care of the poor and sick, other named positions were given to the women in charge of specific areas.[56]

Seven were needed under the abbess herself for optimal organisational efficiency: portress, cellaress, wardrober,

infirmarian, chantress, sacristan, and deaconess. We shall summarise briefly the duties and responsibilities of each.

Portress

Receiving guests, announcing them, and bringing them to the proper place was the domain of the portress or doorkeeper. It was recommended that she be an older woman, and discreet. She had the power to decide who was or wasn't to be admitted as a visitor. The portress was appointed to regularly see to the poor, and allocate what food and clothing might be spared for them. An older woman was better suited to this position because of her general life experience.

Cellaress

As hinted by the position title, the cellaress had the care of food and drink for the entire establishment in her hands. She oversaw the refectory, kitchen, cellar, mill, bakehouse, and its associated oven. Her duties also included animal husbandry—care of the animals and birds used for food, including poultry and bees.

Wardrober

The wardrober had the responsibility of managing and maintaining the clothing and shoes of the other sisters. She oversaw the shearing of the sheep, the use of hides for shoes, and the wool for cloth production. She took charge of the weaving, and controlled the supply of needles, scissors, and thread for the other women who sewed. As well as clothing, the wardrober

was responsible for the linen, tablecloths, towels, bedding, and any other textile-related items. She was also given the job of supervising the novices until they become full-fledged nuns.

Infirmarian

As the title suggests, the infirmarian was tasked with caring for the sick. She organised the food, baths, or any other thing that their sickness required. She also diligently saw that the spiritual needs of the sick and dying were not forgotten and made arrangements as needed.

Chantress

The job of the chantress was to teach singing, reading, and everything else to do with writing and books. She was in charge of the book cupboard, taking note of books handed out and received back again. It was her duty to oversee the copying and binding of books also, or to delegate this to an appropriate person. The chantress taught the whole choir, organised their seating at services, and arranged the divine offices. After the abbess, the chantress handled discipline among the nuns. This job was only given to a woman with a good knowledge of music and literacy.

Sacristan

The sacristan was also the treasurer who provided for the oratory and kept the keys. She received the offerings and managed the care of the furniture, the vessels, books for the altar, incense, holy relics, and other equipment there. She was also in charge of

the host, which she should personally oversee the making of with other nuns.

Deaconess

The deaconess had the responsibility of overseeing all the other residing women, taking care of their administration, and reporting regularly to the bishop about matters which should be brought to his attention or items which required his guidance. These could range from large issues regarding spiritual matters or rules for the cloister to petty complaints about individual nuns who failed to comply with expected etiquette or sexual misconduct.

Sister

The other nuns were known as cloistral sisters. Beguines were religious women who lived simple lives and were known for their charitable works. These women fell under the direction of the sisters with senior positions of responsibility, and were put to work where the abbess felt they were most suited. This included working in the gardens, copying in the scriptorium, ministering to the sick and the poor in the infirmary, cooking in the kitchen and assisting with meal preparations, and singing psalms and saying prayers for those who had paid for them at funerals. Nuns did not get to choose which area they were employed in, although should one have special abilities in a particular area, this might be accommodated. For example, a woman with a high standard of literacy or artistic ability prior to joining the establishment might be directed to work in the library or scriptorium.

Theodore of Tarsus, the Archbishop of Canterbury, wrote several items pertaining to the duties of holy women in his penitential, *Liber pontificalis*. His concerns lay with whether women should have the authority to teach and the ability to perform other offices.

> *"It is permissible for the women, that is, the handmaidens of Christ, to read the lecterns and to perform the ministries which appertain to the confession of the sacred altar, except those which are the special functions of priests and deacons."*[57]
>
> —Theodore of Tarsus

These female ministers might hear confession but not give out penance, for that was the duty of the priests alone, according to the canon, he said.

Many nuns found employment in their cloisters in the field of book production. By the fifteenth century, the skills which were once the domain of learned and educated nuns became more common in the secular sector, and manuscript and book production within nunneries dwindled, although the bulk of women still involved in the trade were religious ones.

The scriptorium at San Giacomo continued to offer works of outstanding quality which were illustrated and copied in-house. Between 1470 and 1484, their printing press, run by the nuns themselves, produced around seventy books.[58]

Chapter 7
Leisurely Pursuits

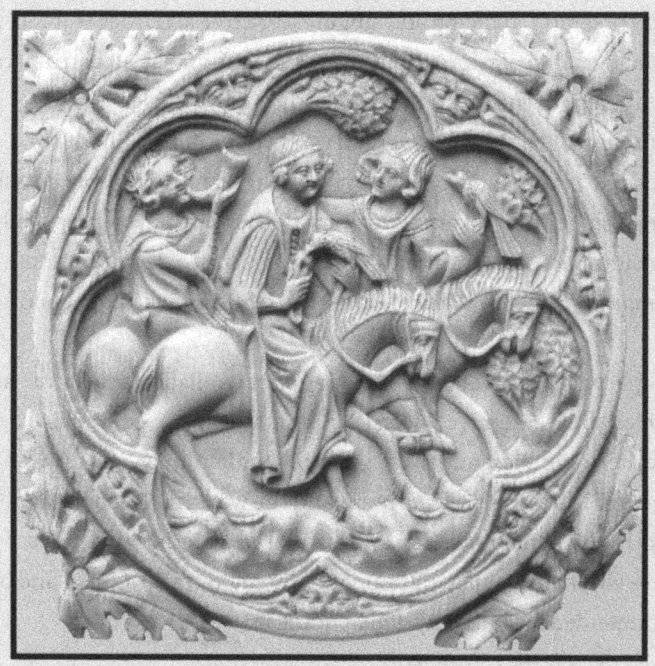

Figure 7. Ivory Mirror Case with a Falconing Party. Dated ca. 1330–60. French. Elephant ivory. Met Museum. Open Access. Accession Number: 17.190.248

Leisurely Pursuits

Medieval women *did* find time for recreational activities. There were many saints' days during the year which provided a break from regular work, as well as Sundays which were, supposedly, a day of rest.

Paintings like *The Garden of Eden* from 1410 show noble women and maidens relaxing in a beautiful garden setting with a variety of cultivated flowers. They are engaged in music, berry-picking, and reading—all genteel pursuits suitable for the single woman of good breeding. Dancing and singing were free activities suitable for women of all social levels, but the playing of a musical instrument required both the funds to buy one and a tutor for lessons, restricting it to the wealthier girls and young ladies. These are shown in contemporary manuscript images. A fashionably dressed fifteenth-century woman wearing a tall hennin plays a harp while her suitor accompanies her on the strings in the detail from the *Annunciation* in the Walters Art Gallery collection, W269, Folio 16r.

Simple pleasures like flower-picking were available to peasants and nobles alike, and travel, both locally and to far-off exotic places in other countries, under the guise of religious pilgrimage, was acceptable for the sick, the poor, and the wealthy. The poor and poorly would not have the wherewithal to make long journeys, but the well-off and upper-class single lady could travel abroad and be commended for her piety whilst doing it.

Other pursuits, like hawking, were available to noble women and noble children only. Not only was it an expensive hobby, but extra staff were required to take care of the bird's special needs: care of the specialist equipment, its hoods and jesses, care of its training, attending to the bird's proper diet, health care in the mews, and bringing it out when required.

Board games were available to most women who lived in a town or city, although elaborate boards and playing pieces were the domain of the wealthy alone. Playing boards could be simple, but most of those which have survived to today show elaborate inlaid panels or painted boards and pieces which were skilfully carved. Four of the most popular board games during the Middle Ages were chess, trictrac (which we now call backgammon), Fox-and-Geese, and Merrils or Nine Man's Morris.[1]

Other medieval games played by ladies and mentioned in manuscripts included dancing, talking, playing at bric (a game with a stick of which no rules are known), hot cockles, pinch-me, blind man's buff, and telling riddles.[2]

Many of the courtly romances of the twelfth, thirteenth, and fourteenth centuries wrote of women who sang and played musical instruments. Instruments played by women included the harp, rebec, shawm, viol, pipes, recorder, psaltery, and hurdy-gurdy. Boccaccio's *Decameron* identifies women who sang and danced along with their male companions. Chaucer also wrote of the types of instruments musicians might play in his *Canterbury Tales*.

> "...many scores of thousands, who made loud minstrelsy with bagpipes and shawms and many other kinds of pipes, and skilfully played both them of clear and them of reedy sound, such as be played at feasts with the roast-meat, ... and many a flute and lilting-horn and pipes make of green stalks..."[3]

While medieval people, especially the working classes, worked extremely hard and had a life harder than ours today, they enjoyed almost sixty holy days annually. Work was not permitted on these days, and specific traditions, foods, and games celebrated them.

Most of these were religious in nature, and perhaps a church service was involved. Many were old pagan feasts which were blended into the Christian calendar. In spite of this, some of the old customs associated with these holidays remained.[4]

A selection of popular feast days and the food and activities associated with them are listed below. This list does not include every known celebration, merely the biggest events of the medieval calendar.

> Feb 2 Candlemas—Feast of the Purification of Mary
>
> Feb 14 St. Valentine's Day
>
> Mar 21 Ostara—Lady Day
>
> Carnival Last before Lent—Shrove Tuesday—Mardi Gras
>
> Mar 22—Apr 25 Easter—Palm Sunday, Maundy Thursday
>
> Apr 30—May 1 Beltane—May Day—Roodmas
>
> Jun 14—21 Midsummer's Eve—Midsummer—Summer Solstice—Feast of St. John the Baptist
>
> July 15 St. Swithin's Day
>
> Jul 31 Lughnasadh—Lammas
>
> Sept 21 Mabon—Autumn Equinox—Second Harvest Festival—Wine Harvest—Feast of Avalon—Equinozio di Autunno (Strega)—Alben Elfed (Caledonii)—Cornucopia—Winter Finding
>
> Sept 29 Michaelmas—Festival of St. Michael the Archangel
>
> Oct 31 All Hallows' Eve—Hallowe'en
>
> Nov 1 All Saints' Day—All Souls' Day—Samhain
>
> Nov 11 Martinmas
>
> Dec 6 St. Nicholas's Day
>
> Dec 21 Yule—Solstice
>
> Dec 25 Christmas Day
>
> Dec 26 St. Stephen's Day

Dancing was a recreational activity enjoyed by women of all walks of life, from the humble farm girl who just swayed, skipped, and performed simple, popular routines, to the formal dances of the ladies of the court. It was recognised that dancing was not only an appropriate activity, but one which also had health-giving benefits.

The fourteenth century health handbook *Tacuinum sanitatus* of Liege commended playing music and dancing as part of a good health regimen. It was beneficial to both the body and the mind for both participants and onlookers alike, unless the musician accidentally hit some wrong notes and spoiled the mood.

> "Nature: To move the feet and the body in rhythm with the music
>
> Optimum: When there is a strict correlation between the music and the movements of the body.
>
> Usefulness: By participating, looking-on, or listening with joy and accord.
>
> Dangers: When the accord among the musical notes is lost.
>
> Neutralisation of the Dangers: When the accord among the musical notes is restored."[5]

Dancing was a normal part of feast days and festivities, although the church frowned on dancing as undignified and taking away the solemnity of Christian observations.

Leisurely Pursuits

Young Girls

Toys for young children were represented in medieval art, and included items of specific interest to girls, baby noisemakers, rattles, dolls, doll clothes, and miniature household items, as well as non-gendered toys including whistles, figurines, hoops, balls, toy horses with knights, and various board games. A young girl might attend public entertainment, like puppet shows, as seen in the lower marginal detail in the fourteenth-century manuscript the *Romance of Alexander*, by Flemish illuminator Jehan de Grise and his workshop, between 1338 and 1344. The manuscript, which is housed in the Bodleian Library at the University of Oxford, is famed for its marginalia showing colourful scenes of real-life activities of regular people alongside fanciful imaginings and deeds of knights jousting and the fair maidens who they hoped to impress.

More energetic recreational activities for a young girl included running, dancing, singing, wrestling, stone-casting, climbing trees, puppet shows, hide-and-seek, balancing on stilts, swings, hobbyhorses, closh (a game similar to croquet), kayles (a game similar to skittles), hunting, catching birds, and shooting at butts (archery).[6] Girls of noble birth may have not joined in the more rough-and-tumble pursuits, their mothers preferring to focus on more ladylike activities.

As with little girls of any time period, dolls remained a popular toy for young girls who wanted to emulate their mothers by mothering their own baby. Medieval dolls were known as *poppets* or *popyns*, and one of the earliest written references to these little dolls made of cloth is an unusual one! In 1396, two French women, one of whom was pregnant, had an actual fight over a little linen doll. This

fight was said to be the cause of the miscarriage of the pregnant woman.[7] Seventeen years later, in 1413, a complaint from a religious writer in England despaired of lazy knights and squires by saying they had:

> "...legs of clouts [cloths],
> as children make poppets for to play with
> while they are young."[8]
>
> —Guillaume de Deguileville

This was intended to make a despairing reference to the uselessness of knights who were lazy, but it incidentally gives us an insight into the construction of a popular girl's plaything—a rag doll.

Fun for the younger medieval girl depended very heavily, like everything else, on what level of society she was born into. Wealthy girls had lessons and music to learn. A peasant girl had a lot of chores and less leisure time to devote to fun than her richer counterparts. In spite of this, a poppet made of cloth was not beyond the ability of the average mother with sewing skills. Scraps could be used with smaller scraps for the filling.

Picking wildflowers—or, in the case of those city girls fortunate enough to have access to walled gardens with cultivated flowers such as roses—and making beautiful, scented chaplets was also seen as a suitable leisure time activity for girls and older young maidens.

Although the fifteen-year-old new wife of the Goodman of Paris was a city girl in France, the advice her much older husband gave her on enjoying the pleasures of youth stand as normal activities

for other young singles. He wrote in his household manual to her about the joys of a young lady growing flowers, singing and dancing, and making flower crowns.

> *"And know that I am pleased rather than displeased*
> *that you tend rose trees, and care for violets,*
> *and make chaplets, and dance, and sing;*
> *nor would I have you cease to do so among our friends and equals,*
> *and it is good and seemly to pass the time of your youth..."*[9]

He was mindful of their social situation, although hers was above his before her marriage, so he was careful to add that his bride shouldn't forget her *new* position and act inappropriately.

> *"So long as you neither seek nor try to go*
> *to the feasts and dances of lords of too high a rank,*
> *for that does not become you..."*[10]

—Goodman of Paris

Have fun, but not too much fun, was the primary message here. His young wife was higher-born than he, but it was not appropriate for her to take up the hobbies unsuited to her new husband's class. It would embarrass him, and he couldn't have that.

Unmarried Maidens and Spinsters

An unmarried maiden might have many leisure options available to her, if her home life permitted. She was young, single, and unwed, the perfect time to enjoy herself on any of the many church

holidays. Singing and dancing, gathering flowers, board games, hawking, and courtly games with members of the opposite sex (under supervision, of course) were encouraged. Needlework was also seen as a suitable pastime for wealthy ladies. Only delicate embroidery or the making of fine pieces were seen as a suitable at-home sewing activity for a noble woman. Making larger garments was a job for tailors or seamstresses.

Manuscripts and carvings on ivory boxes or mirror cases often show two young lovers playing chess or other board games. In the detail of the illumination of the *Annunciation*, manuscript W. 269, folio 16r in the Walters Art Gallery, we see a fashionably dressed fifteenth-century young lady in a gold kirtle and hennin playing tric-trac, or backgammon as we call it today, with a young man whose foot nudges her lower leg suggestively. In a detail from the *Maastricht Book of Hours* in the British Library, Stowe MS17, folio 141r, painted by an unknown miniaturist in the first quarter of the fourteenth century, we find a pair of young lovers engaged in a game of chess under a shady tree.

The Old Woman character who spoke from the pages of the *Romance of the Rose* also had advice about popular entertainment and whether it should be avoided. She felt that it was entirely appropriate for young people to mingle with the opposite sex at public gatherings and festivals.

> *"Attend weddings, processions, games, festivals and dances,*
> *for it is in such places that the God and Goddess of Love*
> *hold their classes and sing Mass to their disciples."*[11]
>
> —Guillaume de Lorris and Jean de Meun

It was, after all, the hope of many young, unmarried maidens to find love.

If love didn't look likely to present itself, an optimistic maiden might try invoking a saint and making a love charm to assist with her predicament. On the eighteenth of October, St. Luke's feast day, a young lady might try the following recipe if she had not yet found love and was eager to know who her future spouse might be.

> "On St Lukes Day, take marigold flowers, a sprig of margoram, thyme, and a little wormwood; dry them before a fire, rub them to a powder; then sift it through a fine piece of lawn, and simmer over a slow fire, adding a small quantity of virgin honey and vinegar. Annoint yourself with this when you go to bed, saying the following lines three times, and you will dream of your partner that is to be: 'St Luke, St. Luke, be kind to me, in dreams let me my true-love see.' "[12]

Whilst it was all very well to tell a girl to go out and attend parties and festivals, it was always a good idea to be cautious when doing so, in case she might encounter men with evil intentions.

Margaret Paston, a fifteenth-century English woman who married well herself, cautioned younger ladies to take good companions with them when they went out.[13] Some more good advice from the Middle Ages which is still relevant today.

Dancing at festivals was an opportunity for the single to mingle. Holidays were the perfect time for dancing and meeting people, and the troubadour songs encouraged this, especially when life was not the happiest. Verse one of "*Ce moys de may* (This Month of May)" by Dufay opens with two lines which capture the very essence of the joyous nature of dance.

> "Let us sing and dance and make merry,
> In defiance of all dismal malcontents!"[14]
>
> —Guillaume Dufay

Well-bred young ladies had music and dance included as part of their education and were expected to attain a reasonable level of accomplishment for recreation and performances at home for guests. Music would often be accompanied with singing, another suitable leisure activity for the noble lady and working-class lady alike, although the songs themselves varied.

The working girl sang of long hours and hard labour and the joy of having a day off when it was permitted, while the upper-class maiden who sang for her guests chose themes of love and longing, especially at the peak of the period of courtly love. One verse in a popular thirteenth-century poem by Renaut, "Galeran de Bretagne," describes the activities in which a rich young lady might indulge.

> "I should do no other work in the day but read my psalter,
> work in gold or silk, hear the story of Thebes or Troy,
> play tunes on my harp, checkmate some one at chess,
> or feed the hawk at my wrist.
> I have often heard my master say
> that such a way of life was gentle."[15]
>
> —Jean Renaut

Hawking was a popular pursuit amongst young noble women who could afford the cost and upkeep of birds and the staff to care for them. Many popular icons of medieval art show a lady with a bird of prey on her wrist, even when not participating in

active sport. Some of these images might represent symbols and signs associated with medieval art allegorically rather than actual activity, although carved ivory mirror cases and small caskets from medieval France often showed ladies actively engaged in the sport.

Perhaps the most well-known image of a lady out with her hawk is from the German manuscript the *Manesse Codex*, dated between 1300 and 1320 CE. It shows a woman on horseback riding with her paramour. She has her bird on her wrist. Her hawking glove is easy to see and protects her hand from the sharp talons of her bird.[16] Another illuminated image of a woman with her bird of prey and hawking glove comes from the *Holkham Bible*[17] of 1325–35 CE. The bird's bell is painted bright gold, and the mistress wears a protective glove.

Additional images in manuscripts show adult women more actively engaged in the sports of hunting and hawking. The *Taymouth Hours*, an English illuminated manuscript dated between 1325 and 1335, displays many images of this. A group of women are actively engaged in a more energetic representation of women, birds, and prey. It was most likely produced in London, but for whom, book historians wonder. While some of these women may have been married, these sports were also seen as appropriate for single, young, high-spirited women.[18]

The types of birds used for hawking include many different types of raptors—falcons, peregrines, etc.—and of these, according to the fourteenth-century falconing manual, the *Boke of St Albans*, the one considered most suitable for a lady to own and use would be a female merlin.[19]

Somewhat akin to the clothing sumptuary laws which regulated who could and couldn't wear which types of fabrics and furs, the

Boke of St Albans provided a list of the falconry Laws of Ownership, which determined who could own what breed of bird. Whether this was adhered to with any kind of obedience or, like the clothing laws, it was roundly ignored, can only be guessed. The *Boke of St Albans* is an English manuscript which dates to 1486 and was printed in the town of St. Albans. It was widely copied and distributed and considered to be the most authoritative text on falconry in the Middle Ages. Much of the information was known before that period, but not compiled and printed.

Widows

What kind of entertainment was best suited specifically for a widow is a subject which has been largely unexplored. One supposes that all of the usual activities of life were still available to her, and that the passing of her husband didn't especially prevent her from doing any of them.

With this in mind, diverse merry things for widows depended, as usual, on what kind of widow one was, and how long it had been since her dearly beloved had departed. For a young widow, it was unseemly to attend parties, games, and celebrations too soon, but it was also considered unhealthy to dwell on her misfortune for too long and close herself off from the world overmuch.

A woman who was now single, but possibly with children in her care, needed to maintain an air of respectability, so as not to ruin the futures of her offspring with her frivolous behaviour. She still desired to maintain good social connections for the benefit of her future in-laws. This extended to her leisure time.

One respectable avenue of entertainment open to the widow was travel. Pilgrimage to shrines or holy sites was absolutely nothing that anyone, especially the church, could find fault with. Journeys could be taken either to pray for a miracle, ask a favour, or give thanks for a blessing already received. Praying for a recently deceased husband's soul at a distant shrine was a legitimate reason to travel.

Many of these trips were overseas to countries like Jerusalem in order to visit a particular saint's relics or atone for a sin or sins. It permitted a woman no longer encumbered with a husband to see a bit more of the world. In some circumstances, the pilgrimage was at the express request of her recently deceased husband, who, having not made a trip personally, needed her to do it for him post mortem.

One fifteenth-century new widow, Ellen Frankyssh from London, found herself in this exact situation when her husband Rowland's will left money and directions for her to make several pilgrimages. These included to Walsingham, York, Canterbury, Beverley, Bridlington, and Guisborough. Rowland was a barber-surgeon and must have been a reasonably well-off one to afford to fund so many excursions up front.

The shrine at Walsingham in South East England and the cathedrals of Canterbury, St. Paul's Cathedral, the basilica of Saint Peter in Rome, the cathedral at Notre Dame in France, and the site of the Holy Sepulchre in Jerusalem[20] were popular destinations, and returning with a pilgrim's badge proved that one had been to a certain place. The badges might have been blessed at the shrine, or in the case of lead ampullae, contained a small amount of blessed water to use later at home as a healing charm in a time of crisis. These often had designs unique to each destination. Ampullae

from the Walsingham shrine featured a crowned W on a cross-hatched background on the front, and the iconic pilgrim's scallop shell design entirely covered the reverse side.

Walsingham in Norfolk was a major drawcard for pilgrims. It featured a replica of the house of the holy family at Nazareth, built by Richeldis de Faverches, a noble woman in the first century who said she had a vision commanding her to do so. Its unlikely relic drawcard was a vial of what the faithful were assured was the Virgin's breast milk.[21] No indication was given as to how this was allegedly collected from the Virgin herself, but as a gift from crusaders in 1300, its authenticity was apparently not questioned.

If roads within the city walls might be perilous to travellers, roads outside them were more so, and it was advised to make long journeys in a group, so many single ladies did exactly that. Poorer pilgrims travelled by foot and slept where they could, but wealthy ladies rode horses and stayed at inns with other travellers. Opportunities like this allowed widows to socialise and travel to exotic locations.

If she was an older widow, she could do whatever she liked, but again, it was prudent to keep a good name. Many widows found themselves embroiled in court cases for fornication, drunkenness, or targeted for unwanted contact by men.

Nuns and Cloistered Women

Fun and frivolity was not seen as an appropriate use of time for medieval nuns. Theirs was supposedly a life of quiet prayer and

religious mindfulness. The fact that there were an extraordinary number of saints' days which were celebrated throughout the year should not lead to undue revelry.

As early as 700 CE, the penitential *Iudicium Clementinis*, attributed to Clement, an Irish missionary, was warning that the church building and its immediate surroundings were not the place for singing songs of love nor for dancing. His direction was clear and his punishment was harsh.

> *"If during any festival anyone coming to church sings outside it*
> *or dances or sings amatory songs,*
> *he shall be excommunicated by the bishop or presbyter or cleric*
> *and shall remain excommunicated*
> *so long as he does not do penance."*[22]
>
> —Willibrord Clement

The ban on the singing of songs was not intended to apply to psalms or hymns. Sacred songs and music were the right way entirely to celebrate holy days. Playing musical instruments was also appropriate, but again, for the correct type of songs: devotional psalms and hymns, not popular secular tunes which spoke of courtly love and desires that a nun ought to have left behind when she followed Christ.

Dancing was completely forbidden to religious women at every level. There was absolutely no excuse for it for any reason whatsoever.

Nuns and cloistered women were encouraged to observe feast days not with feasts, parties, and games, but with prayers to the saints themselves. In spite of this, single women who had no

interest in devotions were repeatedly reprimanded for their lack of observances. The nuns at Godstowe Abbey were once again sternly reminded by the Bishop of Lincoln in 1434 that, as well as dressing in an appropriate manner, they needed to cut down on the late-night entertainment.

> "Also that there be no parties or drinks after compline, but when it is over all the nuns go together to the dormitory and lie there the night..."[23]

This applied to social gatherings, secular visitors, and alcoholic refreshments, rather than prayer groups, dinner beverages, and the companionship of fellow sisters in Christian occupations.

Reading was a pastime both accessible and appropriate for nuns. Secular women often brought books into the nunneries with them, while devotional writings were available within the walls of their own libraries. Books about lives of the saints, psalters, and the Bible were approved. Elaborate Books of Hours, which should be used to guide the devotions of the day, were often extremely ornate, gilded and illuminated manuscripts of great beauty, with humorous marginalia and expensive metalwork clasps.

Deschamps, a fourteenth-century poet from France, wrote about the magnificence of some books from the Middle Ages. Their golden pages, rich illustrations, and floral borders were absolute works of art, passed through the skilled hands of a number of individual artisans and craftsman before completion.

> "A book of hours, too, must be mine,
> Where subtle workmanship will shine,
> of gold and azure, rich and smart,
> Arranged and painted with great art,
> Covered with fine brocade of gold;
> And there must be, so as to hold
> The pages closed, two golden clasps."[24]
>
> —Eustace Deschamps

Travel in the guise of pilgrimage or official duties was a part of the duty of an abbess and some of the officials of the cloister. There were many valid reasons why a woman might leave the gates of her holy home and venture out into the world, but visiting other places of religious significance was certainly the best of them.

Madame Eglentyne, a simple nun for over ten years who rose to a position of higher authority, knew how to take advantage of her situation in regard to seeing more of the outside world than she should have. Her nuns were less than pleased with the number of trips she had taken, and after the nunnery found itself in debt, informed the bishop that this was:

> "...owing to the costly expenses of the prioress, because she frequently rides abroad and pretends that she does so on the common business of the house although it is not so, with a train of attendants much too large and tarries too long abroad and she feasts sumptuously, both when abroad and at home and she is very choice in her dress, so that the fur trimmings of her mantle are worth 100 shillings."[25]

The nuns complained of her excessive lifestyle often, and although dancing and too much celebrating of holidays was not simpatico

with the quiet life nuns hoped for, nevertheless, the accounts of Eglentyne included payments for a variety of entertainment.

> Wassail for Twelfth Night.
> Wassail for New Year.
> Bread and ale on Bonfire nights.
> Games on May Day.
> Players and harpers at Christmas.
> Money for a little girl playing abbess on Holy Innocent's Day.
> Money for a little boy playing at bishop.[26]

It comes as no surprise that the records also include an edict reminding her that dancing, merriment, and minstrels were not really appropriate.

Madame Eglentyne is touted as Chaucer's primary inspiration for the well-dressed, dog-loving, single woman Prioress in his bestselling work, *The Canterbury Tales*.

Notable Medieval Holidays

Many medieval feast days were a blend of pagan traditions and Christian saints' days.[27] Some of the most popular are listed below.

Candlemas—The Feast of the Purification of Mary

February 2

Candlemas was named after a tradition of holding candlelit processions on this day. The priest would also bless candles on this day to be taken home by people in the parish. These special candles would be decorated and kept throughout the year to be burned as protection against storms, and were believed to be helpful in times of illness. This was approximately the halfway mark between the winter solstice and the vernal equinox. Medieval people saw Candlemas as the approach of spring.

In some places, a tradition similar to Groundhog Day was performed, but in this case, a bear came out of his cave. If he turned around and returned to his cave, winter would continue.

St. Valentine's Day

February 14

Traditionally a day to celebrate love, with all the associated activities which we have today. Roses featured as much as today, although red and white roses can be seen in medieval art where maidens make chaplets at every time of the year, not specifically spring or on this day.

Lady Day—Ostara—Spring—The Vernal Equinox

March 21

Ostara is sacred to Eostre, the Saxon lunar goddess of fertility, from whence the word *estrogen* is derived. The theme of the conception of the goddess was adapted as the Feast of the Annunciation, occurring on the alternative fixed calendar date of March 25, old Lady Day, the earlier date of the equinox. Lady Day also referred to other goddesses such as Venus and Aphrodite, many of whom have festivals celebrated around this time.

Traditional foods of the season included leafy green vegetables, dairy foods, nuts such as pine, flower dishes, and sprouts. Herbs and flowers of the season particularly included daffodil, jonquils, woodruff, violet, gorse, olive, peony, iris, narcissus, and other spring flowers.

Fat Tuesday—Shrove Tuesday—Carnival—Mardi Gras

Last days before Lent

Carnival is celebrated on the last day of the year before Lent, and it was celebrated with great enthusiasm. The name derives from *carnelevare*, the Latin word meaning giving up meat. It was also called Fat Tuesday, because all meat and animal products—cheese, milk, bacon and fat—had to be eaten before sundown, since none could be consumed during the forty-day Lenten fast.

This holiday was marked by wild revelling. Masks were worn to protect everyone's identity. The processions and parades often featured male exhibitionism, transvestism, and simulated copulation. These features of Carnival survive today in such traditions as the Mardi Gras in Latin America.

Easter Week—Palm Sunday—Easter Monday—Maundy Thursday

March 22 (the spring equinox) to April 25

Easter week began with Palm Sunday, when the faithful would bring "palm leaves" (usually yew, willow, or box, if not actual palm leaves) or rushes into the church to simulate Christ's procession into Jerusalem. Great acts of charity were often done on Maundy Thursday, and a special mass was held where all the candles were symbolically extinguished one by one during the liturgy to symbolize the coming darkness of the Crucifixion. This concluded

with Easter Monday, celebrating the resurrection of Jesus. The week culminated in Easter, the greatest feast day of the medieval calendar, which fell anywhere from March 22 (the spring equinox) to April 25.

The English name for Easter comes from the Old Norse, *eostur*, meaning the time when the sun began to grow warmer. Eostre was the goddess of fertility, whose two symbols were the egg and the rabbit. A festival at the time of the spring equinox was common to most of Europe, which celebrated new life returning to the earth after the cold winter. The Christian religion adopted these emblems for Easter, which is celebrated on the first Sunday after the first full moon following the vernal equinox.

Though it was not uncommon for tenant farmers to still be required to put in their work on their lord's farm on most feast days, Easter was a notable exception. The feast was taken very seriously, and all work stopped, even that of kings and judicial courts. This was to ensure that attendance in church would be observed, as it was the one time of year when this was absolutely essential.

May Day—Beltane—Roodmas

April 30–May 1

Beltane is now usually celebrated from sundown April 30 to sundown on the first of May. Beltane means *fire of Bel-Belinos*, that being one name for the Sun God, whose coronation feast was celebrated at this time in old Celtic times. It was celebrated by young people who would spend the entire night in the woods a-maying and then dance around the maypole the next morning.

Many people would rise at the first light of dawn to go outdoors and gather flowers and branches to decorate their homes. Women braided flowers into their hair. Men and women alike would decorate their bodies. Breads and cereals were popular, in particular, oatmeal cakes or honey-sweetened cookies.

Older traditions allowed married couples to remove their wedding rings and the restrictions they implied, for this one night. An alternative date is around May 5 (Old Beltane), when the sun reaches fifteen degrees of Taurus. By the time the medieval period proper started, this idea was left behind.

May Day—The Festival of Sts. Philip and Joseph the Apostles

May 1

The celebrations for May Day reflected a theme of fertility on what was considered the first day of summer. As well as maypole dancing, gathering of flowers and forays into the woods, even by town-dwellers, were common. Hawthorn or "may" blossoms were the flowers associated with May Day. Popular games included storytelling tales of Robin Hood (a popular theme), jestering, juggling, Morris-dancing, horseplay, mock-tourney with hobbyhorses, and quintain.

Midsummer's Eve—Midsummer—Summer Solstice—Feast of St. John the Baptist

June 14–21

Midsummer was the culmination of this festive season, as it was the longest day of the year. Popular activities included huge bonfires, staying up the whole night on Midsummer's Eve, parades, and military displays and processions. Jack-in-the-Green was converted to the Feast of St. John the Baptist, often portraying him in rustic clothing, sometimes with cloven feet and horns. The alternative fixed calendar date for this feast was June 25, Old Litha.

Traditional foods served at this time included garden-fresh fruits and vegetables. Decorative herbs and flowers associated with Midsummer included mugwort, wild thyme, vervain, lavender, ivy, yarrow, fern, chamomile, rose, honeysuckle, lily, oak, elder, daisy, and carnation.

St. Swithin's Day

July 15

Legend said that on this day, the holy bones of Saint Swithin were moved from their original resting place to a new shrine, and after the ceremony, it began to rain and continued to do so for forty days, which was a biblically significant number, paralleling the number of days of the Great Flood.

Lammas—Lughnasadh

July 31

Lughnasadh means the funeral games of Lugh (pronounced "loo") and referred to the Irish sun god. The funeral is not his own, however, and the funeral games he hosted honoured his foster mother Tailte. For that reason, the traditional Tailtean craft fairs and Tailtean marriages (which last for a year and a day) are celebrated at this time. This day originally coincided with the first reaping of the harvest. It was known as the time when the plants of spring wither and drop their fruits or seeds for our use, as well as to ensure future crops. Christians adopted this theme and called it "Lammas," meaning loaf-mass, a time when newly baked loaves of bread were placed on the altar. An alternative date around August 5 (Old Lammas) is when the sun reaches fifteen degrees of Leo.

Foods traditionally served at this time included apples, grapes, crab-apples, pears, grains, breads, and berries. Herbs and flowers favoured for the celebration included all grains, heather, blackberries, and sloe.

Feast of Avalon—Cornucopia—Winter Finding—Mabon—Second Harvest Festival—Wine Harvest

September 21

Mabon is the autumn equinox, which divides the day and night equally. The Druids called this celebration *Mea'n Fo'mhair* and honoured the Green Man, the God of the Forest, by offering ciders, wines, herbs, and fertilizer to trees. The Teutonic name, Winter Finding, spanned a period from the Sabbat to October 15, Winter's Night, which is the Norse New Year.

Symbols of Mabon included wine, gourds, pinecones, acorns, grains, corn, apples, pomegranates, ivy vines, dried seeds, tobacco, and horns of plenty. Herbs and foods associated with Mabon include acorns, benzoin, ferns, grains, honeysuckle, marigold, milkweed, myrrh, passionflower, rose, sage, Solomon's seal, thistle, vegetables, breads, nuts, apples, pomegranates, potatoes, carrots, and onions.

Michaelmas—Festival of St. Michael the Archangel

September 29

This feast marked the sowing of wheat, the brewing of ales for winter, and preparations for the winter season. The feast of St. Michael and All Angels, or Michaelmas, fell about the time of the autumnal equinox. St. Michael came to be seen as the protector against the forces of the dark. Many monasteries and churches were dedicated to him, and he is still today ranked the highest of the angels in the host of heaven. His feast was celebrated with a traditional well-fattened goose which had fed on the stubble of the fields after the harvest. In many places, there was also a tradition of special large loaves of bread.

All Hallows' Eve—Hallowe'en

October 31

Hallowe'en, or All Hallows' Eve, is the evening before All Hallows' or All Saints' Day, and was considered a time when the ghosts of the dead walked amongst the living. The Celtic peoples celebrated the festival of Samhain at the beginning of the dark half of the year, about November 1. The Church retained the celebration and the general theme of dead people, but gave it a Christian significance by changing the focus to honour all the saints, both known and unknown. This became known as All Saints' or All Hallows' Day.

At night, lighting bonfires and fortune-telling were popular activities. Mask-wearing was also part of the celebrations. Many medieval people were very superstitious in spite of their professed Christianity, believing in the power of demons, devils, ghosts, and a literal hell. The Church was concerned that dressing up as these figures would give the demons and ghosts extra power, but it was also believed that by making them figures of fun and ridicule, demons and ghosts began to lose their influence over the lives of the people.

All Souls' Day

November 1

All Souls' Day was a day of prayer for those who had died. It followed All Hallows' Eve. It was filled with prayer and thoughts turned to those departed recently and long ago. Masses were said for the souls of those who had already passed, hoping to shorten their stay in purgatory.

Martinmas—Feast of St. Martin of Tours

November 11

Martinmas was immediately followed by the beginning of Advent, forty days of reflection and penance in preparation for the great feast of Christmas. The festivities were similar to those of Carnival, just before Lent, though on a smaller scale. There was much feasting, drinking, and playing of games, storytelling, and sometimes plays. Cock fights, pig-baiting, and sport events such

as racing, leaping, and wrestling were other favourite more-active activities.

Food was plentiful right after the harvest. Meat, from the autumn slaughter of animals that could not be housed and fed over winter, could be salted or smoked for preservation, unlike sausages and other foods made from offal, which would decay quickly. These had to be consumed in a reasonable time frame before they spoiled. Since Advent required some fasting, the feast of St. Martin provided a perfect time to put the abundant meat products to good use.

It also was the day that marked the end of old contracts. Hired help moved on to new positions, and there were farewell and welcoming banquets for them and the new staff.

St. Nicholas's Day

December 6

Traditionally, this was a time for role reversal in the schools, where one of the boys would be elected bishop for the day, presiding over a court of unruly conduct. The festive portion of the season began on Christmas Eve and lasted through to Twelfth Night, the evening before Epiphany on the sixth of January. The feast celebrated the arrival of the three Magi, Caspar, Balthazar, and Melchior, who bore gifts to the stable for the infant Christ. This was still remembered as the first day of the Roman year. The emphasis on light and warmth, embodied in the Yule Log, dates back to the pre-Christian period.

Homes were decorated with evergreens, bay, holly, ivy, and mistletoe, and foods served included pies, nuts, fruits (particularly oranges), and the boar's head. Wassail, a spiced ale served in a brown bowl with great ceremony, was served warm.

Advent

Four weeks before Christmas

From the thirteenth century, the four-week period before Christmas was celebrated as Advent. Since it led up to the day of Christ's birth, it was considered the beginning of the Church year also. The next four weeks were to be ones of preparation, penance, and fasting similar to those of Lent. Fasting was required only three days a week over all four of the weeks of Advent.

Items to be excluded from the diet included meat, cheese, and fat, as well as wine, ale, and honey-beer. The diet was supplemented by fish, often poached, from local rivers or streams. The faithful were also expected to forgo weddings, games, and unnecessary travel. Priests advocated that coitus be avoided for the entire forty-day period of Advent.

Yule—Solstice

December 21

Yule was when the dark half of the year gave way to the light half. Known as Solstice Night, or the longest night of the year, much celebration was had as they awaited the rebirth of the Oak King, the Sun King, the Giver of Life who warmed the earth. Bonfires were lit in the fields, and crops and trees were wassailed with toasts of spiced cider.

Children were escorted from house to house with gifts of clove-spiked apples and oranges, which were laid in baskets of evergreen boughs and wheat stalks dusted with flour. Apples and oranges represented the sun, the boughs were symbolic of immortality, the wheat stalks represented the harvest, and the flour represented light and life. Bitter oranges were imported into England by the royal kitchen from 1390, although it was quite some time later, in the mid-1500s, that orange trees began to be grown themselves. Holly, mistletoe, and ivy decorated the outside and inside of homes. A sprig of holly was kept near the door all year for good fortune.

The ceremonial yule log, usually made from ash, was the highlight of the festival. The log must have been harvested from the owner's land, or given as a gift. It must never have been bought. Once in the fireplace, it was decorated in seasonal greenery, doused with cider or ale, and dusted with flour before being lit with a piece of last year's log, held for this purpose. The log would burn throughout the night, then smoulder for twelve days before being extinguished.

Symbols for solstice included the Yule log, or small yule log with three candles, evergreen boughs, wreaths, holly, mistletoe hung in doorways, gold pillar candles, baskets of clove-studded fruit, wassail, and, in countries where they grew, poinsettias. Herbs associated with Yule included frankincense, holly, mistletoe, evergreen, bayberry, blessed thistle, laurel, oak, pine, sage, and yellow cedar. Foods included nuts, turkey, eggnog, wassail, pork dishes, cookies, caraway cakes soaked in cider, fruits, ginger tea, spiced cider, and an ale made of sugar, nutmeg, and roasted apple.

Christmas

December 25

Christmas had been traditionally celebrated from about the fourth century, at the same time as the winter solstice, which is the shortest day of the year. During the festivities of the twelve days of Christmas, the mighty were displaced and the humble raised. At the Feast of the Ass, a donkey became the focus of the celebrations at the nativity.

While the traditional Christmas wreath we are familiar with today was not a staple of every household in the Middle Ages, we do see one from a single page of a prayer book, illuminated in colour, in Manuscript W.425, folio 26r of the Walters Art Gallery. It is made from green boughs and clusters of red berries tied in a circle, with a sheaf of grain in the centre, and is, for all intents and purposes, a Yuletide wreath.

Another tradition during the twelve days was the Feast of Fools, where a local youth would be elected bishop for the day.

Leisurely Pursuits

St. Stephen's Day

December 26

On this day, lords and servants reversed roles, and those in service received their yearly gift of a set of clothes or livery. After Twelfth Night, the populace got back down to business, and the yearly calendar began. Farmers began to plan for spring by performing maintenance work around the home and farm.

Chapter 8
Animal Companions

Figure 8. Squirrel and squirrel house. Antiphonary ca. 1350–75. Bruges Public Library. Manuscript Stichting van Caloen 010a folio 7r. Creative Commons 4.0.

When we think of medieval animals, or more specifically medieval pets, dogs and the like, we usually think first and foremost of large hunting dogs—great, sturdy beasts capable of bringing down a deer or taking on a wild boar.

Our first thoughts are unlikely to be kittens, songbirds, or fluffy white lapdogs who sleep on the bed, yet we know from medieval records, both written and as illustrations, that single women were presented with these as gifts of love or acquired them as companions. Medieval women, like women today, were avid pet-keepers. Pets were defined as those animals kept in the inner chambers of a woman's home or personal space which have no other practical purpose than that of companionship.

In contemporary artworks—manuscripts, effigies, and paintings—we find a variety of fluffy white dogs, cats, birds in beautiful cages, and even red squirrels, each with their own special custom-made housing, which show that these were not working animals, but pets. Dogs and squirrels can be seen wearing little red collars with bells attached, especially made for them.

Cats

This riddle was posed by Aldhelm, abbot of Malmesbury, in seventh-century England.

> "Who am I? I am a most faithful watchwoman, ever-vigilant in guarding the halls; in the dark nights I make my rounds of the shadowy corners—my eyes' light is not lost even in black caverns. For unseen thieves, who ravage the heaped-up grain, I silently lay snares as fatal obstacles. Though I am a roving huntress and will pry open the dens of beasts, I refuse to pursue the fleeing herds with dogs, who,

> yapping at me, instigate cruel battles. I take my name from a race that is hateful to me."[1]

The answer, of course, is a cat.

A very early record about the nature of cats in medieval literature comes from a twelfth-century bestiary:

> "The vulgar call her *Catus the Cat* because she catches things (*acaptura*) while others say that it is because she lies in wait (*captat*) i.e., Because she 'watches.' "[2]

References to cats as playful household pets favoured by girls and ladies alike are not to be found at this time.

Cats are often seen in manuscript marginalia and fall into two distinct categories: those which are pets and those which are household cats for catching mice. Household cats were usually tabby—that is, striped (hence tabby weave) and usually grey, but the pet was usually a different colour, something less mundane.

The most favoured by noble ladies were specially imported Syrian cats,[3] ginger or ginger-and-white in colour. These were mentioned in correspondence many times over—the wish to acquire them, the happiness and love that the kitten had brought, and the overwhelming sadness at their passing. Poets composed elegies for the death of a noble woman's beloved cat, and it was noted that mourning for such an animal was quite normal. That several women had even constructed small tombs for their cats was also noted in personal letters.

The musical song of a kitten was sure to bring delight to any lady, according to one thirteenth-century writer, Thomas de Cantimpré. He noted that cats had their own form of feline song, which could be brought about with petting.

> "They delight in being stroked by the hand of a person and they express their joy with their own form of singing."[4]
>
> —Thomas de Cantimpré

Bartholomew the Englishman had less charitable things to say about the kind of noises cats made.

> "When a cat is in heat, it fights to attract its mate, screeching and howling horribly."[5]
>
> —Bartholomew the Englishman

Cats were also considered carefully by Hildegard von Bingen in her works *Liber Simplicis Medicinae* and *Physica*. She was not entirely enthusiastic about their properties and suitability as pets, noting that a cat's loyalties lay with whosoever gave it food.

> "The cat is not willingly with a person,
> except the one who feeds it...
> When it carries its young within,
> its heat stirs up lust in a person;
> at other times, its heat is not harmful for a healthy person."[6]
>
> —Hildegard von Bingen

It's true that a modern cat is extremely fond of whoever turns up at feeding time, but while some cats are aloof and standoffish,

many are close companions to the point of annoyance; sitting on laptops, sleeping on crafting supplies (while they're in use) and laundry piles, intruding in book reading, and generally trying to sleep in places as close as possible to their human, or actually on their human.

Dogs

Hildegard had significantly more charitable thoughts on canines as suitable companions. She wrote warmly of their affectionate nature, companionship, and value as a protector.

> "The dog...has a natural affinity with human ways.
> It senses and understands the human being,
> loves him, willingly dwells with him, and is faithful...
> If there is a thief in the house, or someone who wants to steal,
> it growls and gnashes its teeth.
> It will go after him, testing his odour with its nose and stalking him.
> In this way the thief can be recognised."[7]
>
> —Hildegard von Bingen

Dogs were often seen as playful creatures, and it comes as no surprise to see them illuminated in marginalia in books of hours or psalters. We find a bagpipe-playing dog in the book of hours in the Walters Art Museum, item W120, folio 75v., dated from around 1300 in England. Canines might be given human qualities in these books, like the ability to stand upright, wear clothes, and engage in humorous activities.

Although dogs represented fidelity and could be included in paintings in an allegorical sense, several household accounts list

expenses for food for companion dogs, rather than those used for hunting or hawking. A small dog was seen as an acceptable companion for a lady, as long as she did not lavish food on it which was good enough to feed the poor.[8] Although he wasn't talking about inside dogs, Sir Guy de Montigny wrote that, as far as he was concerned, one should put the care of one's hounds and falcons before personal comfort.[9]

The knight of la Tour-Landry, in 1371, counselled his daughters against overfeeding a pet dog, reminding them that the needy should be administered to before mere animals. He told them a story of a woman who refused to do so, with dreadful consequences.

> "There was a lady that had two little dogs, and she loved them so that she took great pleasure in the sight and of feeding them. And she made every day, ... dishes of sops of milk and after gave them flesh. But there was once a Friar that said to her that it was not well done that the dogs were fed and made so fat, and the poor people so lean and famished for hunger. And the Lady for his saying was wroth with him, but she would not amend her it."[10]

The story continued with the swift death of the lady and some unreal black death hounds visiting her bed. The moral was to be interpreted that a girl should get her priorities right and feed the poor, not her pampered pets.

Most artworks help distinguish lapdogs from hunting dogs by a red leather collar with several brass bells attached. Collars like this can also be seen on images of pet squirrels. Working dogs often had sturdier collars, without bells, so as not to frighten prey away. One fifteenth-century image from *The Garden of Love*, in the Reaud de

Montauban cycle, *Der höfische Garten*. Ms 5072. folio 71v., shows a pair of lovers in a fenced garden with a medium-sized white dog wearing the traditional belled collar. Both are fashionably and expensively dressed, and while their hands do not quite touch, the young woman's knees press up against the suitor's shapely legs.

Red Squirrels

Hildegard continued her assessment of animals and their properties in *Physica* with her thoughts about squirrels, but at this point in history, it seemed that keeping one for a pet was not encouraged. Her thoughts centred entirely on eating them and using their pelts for clothing.[11]

By the thirteenth and fourteenth centuries, this opinion changed, as women discovered the delightfully playful nature of squirrels and started keeping them for amusement. There are several medieval manuscripts which show women with pet squirrels, the red squirrel being the overwhelming favourite. Like dogs, they are often shown wearing a red collar and small bells.

Squirrels might live in a purpose-built squirrel house, much like a wooden bird house, only larger. There are several lovely examples of these seen in marginalia from medieval manuscripts in the fourteenth and fifteenth centuries.[12] A mid-fourteenth century depiction of a pet squirrel, complete with a red collar and leash and a feeder or house, comes to us from an antiphony, the *Stichting van Caloen*, 010a folio 7r. dated ca. 1350–75, from Bruges. The house has an arched doorway, round windows, and a roof which features little trefoil gold knops. This isn't merely a utilitarian pet house; it is a purpose-built pretty little house, which shows us that the squirrel was beloved.

Another such manuscript which shows squirrels as pets comes from England in the fourteenth century. The *Luttrell Psalter* shows an image of a lady out in a covered carriage with her pet squirrel on her shoulder,[13] and further in the manuscript, of the little squirrel with collar and bell sitting playfully near her while she holds her hands to her lap, perhaps to encourage it to climb up. Yet another image of squirrel ownership can be seen in the detail of a medieval floor tile which shows a noble woman wearing a coronet with her pet squirrel on her hand.

Songbirds

Songbirds were also fashionable pets, and pet shops listed an extensive variety of birds which were available. These included parrots, thrushes, sparrows, nightingales, starlings, doves, finches, skylarks, and surprisingly, magpies.[14] Parrots were the most exotic of these, but can be found in several manuscripts.

A person could purchase a bird through specialist sellers in the Middle Ages, and a thirteenth-century Parisian dictionary of Jean de Garlande notes bird sellers who sold birds to eat, but also songbirds in cages for amusement.[15] Makers of birdcages, which could be quite ornate, appear as early as 1292 in tax records from Paris.

The Goodman of Paris gives quite a lot of advice to his bride for the care of pet birds, indicating that birds, whether caged or in an aviary, were suitable pets for a young lady. The foods he advised as the most suitable were moistened hempseed, which was broken up with shells removed and mashed; chickweed and groundsel, both green and with their stems in water; and sowthistles, which were

kept with their stems in water. He recommended that live food should be added to the diet.

> "You should also give them caterpillars, worms,
> flies, spiders, grasshoppers, butterflies,
> fresh hemp in leaf, moistened and soaked.
> Spiders and caterpillars and such like things
> which be soft to the little bird's beak, which is tender."[16]
>
> —Goodman of Paris

The water should be changed three times a day. For breeding birds such as goldfinches, turtle-doves, and linnets, he instructed what he considered to be the best bedding materials to nest in. Feathers and carded wool were his recommendations.[17]

In practice, these responsibilities would most likely have been attended to by a household servant, rather than a young lady herself, but as with many other aspects of running a household, she should know the procedure herself, should she need to correct her staff.

Young Girls

Kittens have always brought happiness to single girls as charming play companions because of their exceeding cuteness, but this appears not to have been the case in the Middle Ages. In a rural environment of less wealthy households, cats were likely household animals which doubled as pets and mouse-catchers. Any other pets were likely to be household animals which actually served a purpose, rather than those bought for the specific task of companionship.

This seems to be supported by imagery in medieval art. There are numerous marginalia of children being entertained and numerous images of pets, but extremely rarely of the two together. One might expect that if children had puppies or kittens as general playmates, these might be represented pictorially.

One contemporary illumination of the fifteenth century shows a group of women with two younger girls sitting in a group, with a small white cat or dog sprawled across the lap of one of the young ladies.[18] This particular picture is one of four from a surviving copy of Christine de Pizan's *Livre des trois vertus* or *Book of Three Virtues*, which was completed around 1408 and is now housed in the Beinecke Rare Book and Manuscript Library. It is interesting to note that the older of the two girls is dressed the same as the adult women around her, whilst the smaller child is dressed in a simpler outfit with her sleeves removed and the long sleeves of her undersmock showing.

Unmarried Maidens and Spinsters

Although many unmarried women had household cats which were also pets, kittens with unusual colours became a much treasured, and rarer, gift of love to rich, single maidens. If a suitor wished to make an impression, he might import one of exotic colouring to England at great effort and expense.

Complaints about cats being overly spoiled are nothing new. The cat seen in the Book of Hours of Charles the Noble, King of Navarre, sits happily on a green cushion of patterned fabric which has red tassels on each corner, and it is immediately obvious that

this was an animal which was loved. Pet cats *were* pampered in comparison to the kitchen cats, who slept nowhere special and caught their own food. Chaucer himself wrote in his *Canterbury Tales* about well-fed cats having milk, tender flesh, and a couch of silk.[19]

In 1510, printer Wynkyn de Worde's English translation of a 1480 French text, the *Dystaff Gospelles*, assured young men that they ought not be jealous of the attention young ladies gave to their little cats. Although de Worde was a popular Tudor publisher, his sentiments applied to the medieval lover and indeed apply to modern men equally.

> *"Young men should not hate cats*
> *because they are a great cause of happiness*
> *and can assist with achieving success in matters of love*
> *with young and charming ladies."*[20]

—Old woman, *Dystaff Gospelles*

Once a young lady had a kitty companion, she was advised by the women in the *Gospelles* to keep it at home with this method:

> *"If a woman has a good cat and wants to keep it,*
> *she must rub its four legs with butter for three nights,*
> *and then the cat will never leave the house."*[21]

—Gomberde la Faee

A version of this is a folk remedy many people swear by today, although the modern version requires buttering the paw pads only once when the animal is moved to a new house. The reasoning is this: by the time the cat licked all of the butter off, the unfamiliar

environment's smells are more familiar and less upsetting. It seems that medieval women also had this idea.

Many manuscripts also show romantic scenes of courtly love with young ladies with small white dogs at their feet. Dogs were often a sign of fidelity, but as we have seen, many household accounts show that these were kept as pets also. The lady pictured in a fifteenth-century image of a courting couple in the Garden of Love, from Renaud de Montauban cycle, is fashionably but modestly dressed with expensive jewellery and a flamboyant but stylish padded headdress. Her knees and lower legs are pressed up against her suitor, while his leg rests between her knees. The small whippet-like dog with a red collar and gold bells sits off to the side. The image is almost identical to *The Garden of Love*, from the Reaud de Montauban cycle, *Der höfische Garten*, with only the position of the lovers reversed.

While many young, unmarried ladies were dog-keepers themselves, some helpful advice on how to stop a dog from barking can be found in the Chantilly manuscript version of the *Distaff Gospels*.

> *"If you don't want to be attacked*
> *or barked at by dogs, by day or night,*
> *you should have a piece of good roasted cheese*
> *and give it to them while saying:*
> *'In camo et freno, et cetera' and they will not disturb you.*
> *Lovers should be aware of this trick."*[22]

—Sebille des Mares

The full phrase *"In camo et freno maxillas eorum constringe qui non approximant ad te"* is from Psalm 31:9, and translates as "with bit and bridle bind fast their jaws who come not near to thee." In

other words, stop barking and don't bite me! This was especially useful for lovers, the book says, who don't want their secret trysts discovered. Rowdy animals might draw unwanted attention in their direction while they conducted their clandestine meetings.

As we have previously learned, red squirrels could be seen in artworks and carvings as companions to young ladies. A beautiful ivory mirror case from France, dated at the mid-fourteenth century and in the collection of the Walters Art Gallery, again demonstrates a young maiden's fondness for her little pet.[23] She holds her squirrel at chest level while a young man tries to embrace her. As it depicted a modestly attired, mid-fourteenth century young lady being wooed by a hopeful suitor, we can accept that the maiden is single. The little squirrel sits on her wrist the same way a hunting bird might.

These types of mirror cases were reasonably large for the period, with an average size of 9.5 cm x 9.5 cm x 0.5 cm. They were made from elephant ivory, with silvered glass set into a recess on one side. Their size and texture made them suitable for carving with intricate and detailed scenes of love.

Caged birds were also suitable gifts of love, with songbirds especially treasured.

Widows

Very little is recorded about widows specifically keeping pets, but it is assumed that household animals they had before they were widowed followed them into their solo lives. Companionship after bereavement may have been of some comfort to widows, even if it was small and furry.

Exactly how much widows loved their pets is apparent in the real-life story of a gentleman who tried to make a certain one give hers up. The quest of Tolommeo Spagnolo started in 1496, when he fruitlessly searched to find and acquire a Syrian cat for Isabella d'Estre, a wealthy lady and the Marchesa of Mantua. Isabella already had several cats but wanted another three or four felines to add to her personal chamber, and the unfortunate Tolommeo was tasked with finding the prettiest he possibly could and bringing them back for her. His search took him to many places, until one day, travelling in Venice he saw, in his own words, "a most beautiful Syrian cat" wearing a little red collar with bells attached. It was sitting in the window of a house, and he boldly sought out the owner in the hope of obtaining it.

Unfortunately for him, the widow who possessed it, unkindly described by him as "the oldest woman I have ever seen" absolutely refused to hand her beloved cat to him. Tolommeo attempted speaking to her son, offering large amounts of cash and explaining who the cat was for, but with no success. The widow refused to part with it, and he had to continue his search elsewhere.[24]

Another widow we also know of who was a devoted pet keeper is our lady writer Christine de Pizan, who is almost always illuminated with her little white dog by her side.[25] We don't know the name of her little companion, which is surprising, as she seemed fond enough of it to include it in her pictures. Christine herself complained that women spent too much time on their pets, so it was very much a case of "do as I say, not as I do."

Nuns and Cloistered Women

Nunneries were a hotbed of complaints when it came to the residents keeping illegal and distracting pets, especially, as we see again and again in records of visiting diocese, when they were brought into sacred spaces, hampered divine services, and disrupted the devotions of the nuns.[26] The main offender was the small dog. In one of his visits, the fourteenth-century archbishop of York unhappily noted that they "were a great hinderance." Nuns were not to have little dogs, and they certainly weren't permitted to bring them to service, or take them into the cloister for any reason.

In spite of this, we find pictorial evidence of this rule being ignored in the manuscript Stowe MS 17, folio 100r, which shows a nun happily snuggling her little white dog to her chest while it gazes up with adoration at her, and another from the first quarter of the fourteenth century in the *Maastricht Book of Hours*, BL Stowe MS17, folio 034r, by an unknown miniaturist from the Liège-Maastricht area. There a nun sits spinning with her distaff while a gray and white striped tabby cat plays with the wool on her drop spindle.

In a guide for English anchoresses, *The Ancrene Riewle*, written in 1205 by an anonymous author, religious women were permitted one animal companion, a cat.[27] They were also enjoined not to have flocks of birds, pigs, cattle, or other domestic animals. A nun who had cattle was thought better suited to be a housewife than a nun.

Animal Companions

Complaints from church records indicating that cats originally intended simply to catch mice were actually spoiled and beloved pets were not uncommon. Pampered pet kitties were very much not encouraged and pets generally were frowned upon, as these were a distraction from God and their daily duties. In spite of this, many nuns and cloistered women refused to do as ordered, and kept a wide array of small animals as pets anyway.

One Jane Scrope, who was cloistered in a Benedictine nunnery near Norwich, had a little pet sparrow which she named Phylyp. Unfortunately, he was killed by Gyb, the cat, and Jane's distress was so great that an elegy was written for it by John Skelton, renowned fifteenth-century poet. In two of the verses, we see an uncommon attachment to such a common bird.

"...*I wept and I wailed,*
The tears down hailed,
but nothing it availed,
To call Phillip again,
Whom Gib, our cat, hath slain...
Was never bird in cage
More gentle of courage,
In doing his homage
Unto his sovereign,
Alas! I say again,
Death hath parted us twain,
The false cat hath thee slain.
Farewell Phillip, adieu!
Our Lord, thy soul rescue!
Farewell without restore,
Farewell for evermore."[28]

—John Skelton

It is very clear from this that Jane had more than a passing attachment to her little bird.

Still, further examples of illicit pet-keeping can be seen from when the archbishop of Rouen, Eudes Rigaud, visited the nuns at Saint Evreux in 1250. He was so annoyed at the number of animals which distracted the nuns from their prayers that he, like the archbishop of York who came after him, wrote a proclamation ordering the women to get rid of their pet dogs, birds, and squirrels. He also insisted that the larks and other caged birds which were being kept as pets were to go, but alas, they were still there at his next visit.

Several years later, he reproachfully and disapprovingly noted a further three squirrels were kept as pets at Saint-Leger des Preaux, along with several small dogs.[29]

Cloistered women who weren't nuns also contributed to the complaints about pets. A certain Lady Audley, who was staying in the diocese of Lincoln, aroused the ire of the nuns there. It was written into the ledger that:

> "Lady Audley, who boards there, has a great abundance of dogs, insomuch that whenever she comes to church there follow her twelve dogs, who make a great uproar in the church, hindering the nuns in their psalmody and the nuns are thereby terrified!"[30]

Even the most lenient of abbesses might find it hard to cast her eye aside from twelve dogs running amok in the chapel. Lady Audley may have been just a boarder and not a woman of the cloth, but she

gave the impression of wanting to make an entrance, rather than meekly and quietly fitting in.

In 1387, Romsey Abbey was similarly afflicted with a large number of pets being brough to sacred areas, including rabbits and birds, as well as little dogs. When William of Wykeham visited, he was firm that the abbess should not just keep the hounds out of the church building itself, but disallow them within the abbey altogether. From the complaints that followed in future years, it seemed that any removal of animals was somewhat half-hearted and entirely temporary.

Chapter 9
In Sickness and in Health

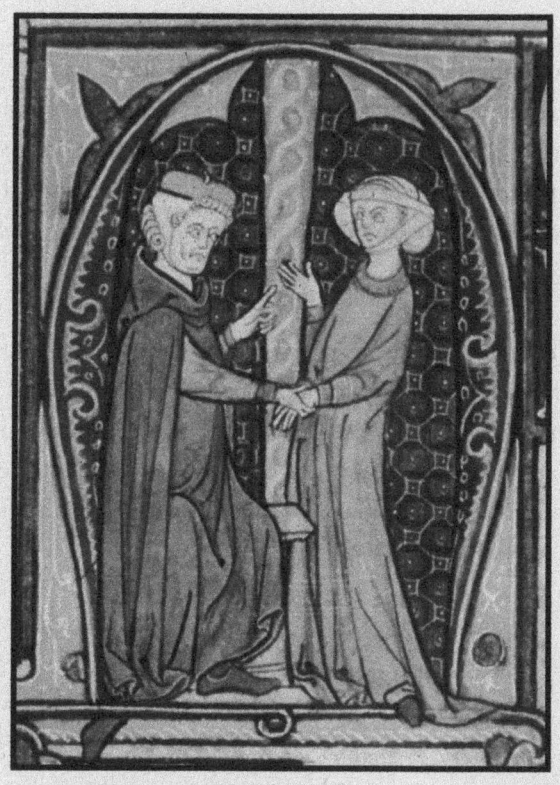

Figure 9. The physician Galen takes a woman's pulse.
Galen-Tegni-Vienna. ÖNB 2315, folio 147r. Dated 1260.
The MacKinney Collection of Medieval Medical Illustration. Austrian National Library, Vienna.

Thanks to a plethora of medieval movies showing people with rotting teeth and poor hygiene, this aspect of the Middle Ages is full of more misconceptions than any other. Bathing and handwashing were more frequent than imagined. Public baths, and even public toilets, were an actuality in many towns. Hair was brushed, cleaned, and styled, and efforts were made to keep lice under control. Perfumes and scented waters were used. Teeth were cleaned. Cupping and urology were also important branches of medical care, which can be seen in numerous manuscripts and treatises.[1]

The information we have today about the bathing habits of medieval people is enough to fill an entire volume on its own, so for the sake of brevity, we shall acknowledge that medieval women *did* bathe—whether in a wooden tub or with a jug of hot water and bowl—and cared whether they smelled, and focus more on other facets of health care.

Herbal remedies were utilised throughout the Middle Ages, some of which persist today. Taking honey for a sore throat in modern times does not raise an eyebrow and was a common medieval remedy. Care needed to be taken, however, that herbal preparations were not linked to pagan charms. On this matter, priests advised caution.

> "But people who seek for forbidden remedies for their illness by means of soothsaying and forbidden charms... they will justly be punished more grievously for these acts..."[2]
>
> —*Fasciculus Morum*

The more acceptable way to combine herbal medicine with godliness was to adopt a two-fold strategy. The Paris manuscript

version of a late fourteenth-century text, the *Distaff Gospels* offered advice in this manner.

> *"To be cured of continuous fever,*
> *you must write the first three words of the 'Our Father,'*
> *on a sage leaf, locally grown,*
> *and eat it in the morning.*
> *Do this for three days and then you will be cured."*[3]

—Berthe de Corne

Sage has anti-inflammatory properties and antioxidants which may have been beneficial when it came to fever or the cause of it, so the treatment may have had some value. Sage was also used in many medieval recipes, both culinary and medical.

Only a few textbooks survive from the Middle Ages which specifically deal with women's health, although medieval women faced the same kinds of daily complaints as the modern woman. Contemporary health care practitioners were working from manuscripts which were hundreds of years old: the compendium of texts today known as the *Trotula*, advice from Hildegard von Bingen in *Physica*, Bartholomew the Englishman, Gilbert the Englishman, and the writings of Claudius Galen.

Galen lived around 129–216 CE and was a believer in and promoter of the four humours theory of physiology. At the age of sixteen, he started his medical training in Alexandria. His four humours theory was echoed by those who followed for the next few centuries. Belief that people were governed by phlegm, bile, blood, and black bile, and the balance of these within the body, shaped the diets of the sick and recommended treatments for diseases and other bodily maladies. Elements of these were incorporated into

newer works like the *Tacuinim Sanitatus* and the *Compendium of Medicine*.[4]

Hildegard von Bingen, our twelfth-century German physician, wrote on women's health, as did the Franciscan Bartholomew the Englishman in 1230 and Gilbert the Englishman (also in the early thirteenth century), but perhaps the best-known medieval health care journal is the set of texts attributed to a female doctor, possibly Trota, and several other unknown writers, which is known collectively as the *Trotula*.[5]

Copies of the late fourteenth-century *Tacuinum Sanitatis*, a codex with almost full-page colour illuminations, were also widely distributed. There are several existing copies of this book which vary slightly, but contain, for the most part, the same information. The preface of these manuscripts introduced Ibn Botlan, the Doctor from Baghdad, who first ascribed the properties of things in eleventh century. Some of the manuscripts re-transcribed in the fourteenth century have additional notes for the items which were known to Ibn Botlan, but not to the population locally, such as bananas.

The *Tacuinum Sanitatis* dealt with many aspects of health care—herbs, plants, foods, substances, emotions, and types of fabrics, each of which were able to affect the body in some way. It wrote of the benefits and dangers of each item and what to do about them. Much of what we know today about medieval health care comes from these manuscripts. One extant copy was written and illuminated for the Cerruti Family and was probably made in Verona.

Other contemporary writings, like the *Romance of the Rose*, gave advice on both care of the body and morals through the speech of characters.

Minor ailments like headaches, ringworm, and warts might be seen as blights from a displeased God, but remedies were plentiful and went hand in hand with prayers. Bloodletting was believed to release vile humours from the body through the wound site and was practiced on both men and women. The current time of day, sign of the zodiac rising, and initial time of the patient's sickness or injury might be considered as part of whether the treatment was expected to work. Most medical remedies were dispensed on a need basis, to be used when needed and not as preventatives.

Other, more intimate areas of health care dealt with personal issues: body odour, sexual health, and dental care. Women of all classes and states were concerned with keeping themselves clean and in good health. The texts known as the *Trotula* offer a deodorant for women who are struggling with bodily freshness.

> *"There are some women who have sweat*
> *that stinks beyond measure.*
> *For these we prepare a cloth dipped in wine*
> *in which there have been boiled leaves of bilberry,*
> *or the herb itself or the bilberries themselves."*[6]
>
> —the *Trotula*

Dental care was also not as primitive as many modern people suppose. Gilbert the Englishman wrote his *Compendium of Medicine* around 1400 CE, and included some good advice on keeping the teeth clean and ensuring no food was stuck.

> *"...it is important to rub your teeth and gums*
> *with a cloth after eating,*
> *because it is important to ensure*
> *that no corrupt matter abides among the teeth."*[7]

—Gilbert the Englishman

Another of Gilbert's recipes for a clean mouth after eating included cleaning with a clean, linen cloth and added herbal components, including mint, the flavour of which we use today as a breath freshener in both toothpaste and chewing gum.

> *"Let the mouth be washed with wine*
> *that birch or mint has simmered in.*
> *And let the gums be well rubbed*
> *with a sharp linen cloth until they bleed.*
> *And let him eat marjoram, mint, and*
> *pellitory, til they are well chewed.*
> *And let him rub well his teeth with*
> *the chewed herbs and also his gums."*[8]

—Gilbert the Englishman

His advice about rubbing the teeth to ensure no food debris remained on the surface and between the teeth themselves was great advice. A toothpick might also assist with this. The wine and simmering mint is the precursor to our modern mouthwash. Hildegard von Bingen suggested a similar wine mouthwash, with sage replacing the mint.[9]

Extant recipes to make sweet-smelling herbal water for washing hands at the table are included in several manuscripts. Each includes freshly gathered herbs and warm water, and were to

have been used at the table or before and after meals, or in the household lavabo.

> "To make water for washing hands at table: Boil sage, then strain the water and let it cool until it is a little more than lukewarm. Or use chamomile, marjoram or rosemary boiled with orange peel. Bay leaves are also good."[10]

The idea that medieval people were continually grubby and had poor hygiene is a myth. It is generally accepted that soap was known in England by the tenth century. A record from Richard of Devizes, a monk from the twelfth century, makes remark about the number of soapmakers in Bristol and the smelly nature of their profession. Records also show a "sopehouse" at Bishopsgate in London in the fifteenth century.[11] The *Trotula* texts mention the use of soap even earlier.

Handwashing was a common occurrence in the Middle Ages. Cleanliness was, after all, next to Godliness. People would wash their hands and faces upon rising, before meals, at the end of the day, and upon arriving at a house after a long journey. This might be achieved with a simple jug and bowl of water, or an aquamanile, which was a type of jug similar to a teapot. Aquamaniles were popular for washing hands at the table for the upper classes and were made in the shape of animals, deer, griffins, dragons, and knights on horseback. These were either ceramic or brass for the wealthy.

Two beautiful green-glazed ceramic rams survive, both of which were made in England. One is housed in the Metropolitan Museum of Art and another resides in the collection of the Scarborough

Museums and Galleries. The style of pottery is known as Scarborough ware.

Lavabos (from the Latin, *I shall wash*) were also handwashing stations, sometimes set recessed into the wall itself, or on a stand which could be moved. The primary vessel used to contain the water for the lavabo was a double-spouted round pot which hung on a chain suspended from the top of the stand. If it was used on a free-standing bracket, a large, deep brass dish was used to catch the water which fell from the spout as it was poured. Originally, these were used in sacred spaces, but they became popular with the nobility. These can be seen in contemporary art with fringed towels hanging nearby.

Religious items were genuinely believed to aid with many aspects of health care—whether for relief for a woman in labour or for assistance with plague. Looking at an image of Saint Christopher was devoutly believed to give protection from sudden death for the next twenty-four hours.

Reliquaries, which held a small piece of religious artifact, were a guaranteed recipe for good health and protection from sickness. These might be smallish containers with mottos or images relating to saints, Jesus, or Mary, and would have held a small piece of a holy artifact or a small item blessed with holy water. Pregnant women sometimes wore such pendants for protection. Shell-shaped ampoules called *ampullae*[12] might have holy water in them, collected from shrines visited on pilgrimage, to use in times of unwellness.

The Pierpont Morgan Collection houses one extant fourteenth-century French locket, made of silver gilt and enamel, which once contained a small disk of wax, blessed by the pope during the

Easter season and worn as a kind of amulet. The back shows a lamb, a symbol of Jesus, and is surrounded by a Latin inscription that translates, "Lamb of God, who takes away the sins of the world, have mercy upon us." It is a beautiful example of the craftsmanship which went into these kinds of protective amulets.

Wearing a ring or brooch with the names of the three wise men, Caspar (or Jaspar), Melchior, and Balthazar, was also a good epilepsy preventative.[13] Thirteenth- and fourteenth-century rings were also inscribed with the letters A.G.L.A., *Atha Gebri Lielan Adonai*, which stood for "Thou, O Lord, art mighty forever"; they were intended to protect the wearer against fevers. Others simply had *Ave Maria* or *Lamb of God* engraved in the hope that it would provide general immunity from bodily harm or disease.

Not all personal items were religious, with the general items used for a woman's personal hygiene routine much like our own: mirrors, tweezers, nail cleaners, and tooth powders. Small cosmetic mirrors made of brass and decorated with delicate zigzags of rocker-work designs[14] have been found in England from the late thirteenth century onwards. Mirrors like this had silvered glass inside and were hinged to fold closed, and are a tiny 3 cm across each half.

Young Girls

The care of an infant child, both boys and girls alike, fell to the mother or to the wet nurse, if the family had one. Health books agreed that only milk and food that was fresh was suitable for a very young child who was still nursing at the breast. Should the babe be unwell, medicine might be administered, but it needed to

be given is a very specific way by the nurse. This was described in *De Proprietatibus Rerum* in the thirteenth century.

> "And when the child is sick it should be given medicine, but it should be given to the wet nurse, not to the child..."[15]
>
> —Bartholomew the Englishman

The reasoning behind this is that the diet of the woman nursing the child directly influenced the milk being produced. With this in mind, any medicine the child needed would pass through the nurse's body into the milk, and then safely into the body of the sick child.

Children of both sexes fell to the usual childhood illnesses, and the recorded care of their health isn't specifically gendered. In one particular instance, we see a doting father send his four-year-old little girl, Agnes, from her home in Coventry to stay with her uncle Thomas in Bristol in the hope that she would avoid catching the plague in 1386. While Adam, her father, died of the great pestilence, Agnes, who was safely couriered one hundred and twenty miles away, lived.[16]

Toddlers, being the curious creatures they are, were no different to our own, putting small items they found lying around the house unattended into their mouths. These included a ring, a silver groat, a badge, a brass pin, and an ear of wheat.[17] We also read of the deaths of young girls from court records by either infanticide or, more usually, misadventure rather than lack of suitable health care.

A quote from *L'ornement des Dames* or *Ornatus Mulierum*, an Anglo-Norman text from the thirteenth century, shared with readers

what a pretty girl should look like, but that she was destined to lose her looks as she got older.

> "Some, for example, when they are young girls,
> are pink, white and lovely.
> As soon as they are married, their colours vanish.
> Others were never beautiful; at any time in their lives."[18]
>
> —the *Trotula*

An herbal recipe to deal with eruptions of the face may have been of great interest to preadolescent girls who were reaching the early stages of puberty and finding the first few pimples on their faces. The *Four Seasons of the House of Cerruti*, or the *Tacuinum Sanitatis in Medcina* (*Table of Health in Accordance to Medical Science*), as it is also known, recommends using a decoction of sage and rosemary in wine for washing the face.[19] This manuscript from Italy is dated to the fourteenth century, but was originally written by Ibn Botlan, the Doctor from Baghdad, as he was known, in the eleventh century. Rosemary was a very common herb, easy to grow, and a staple of kitchen gardens for both medicinal and cosmetic recipes alike.

On the whole, the health of a girl child was the responsibility of her mother or her nurse, unless she had an accident or serious illness, when a physic may have been called.

Unmarried Maidens and Spinsters

Medical care by a qualified professional was available to those who could afford it, or those who sought it at a hospital or hospice. Limited beds at these institutions meant that not everyone who arrived was guaranteed treatment.

As with every other aspect of her life, the health of a maiden or spinster also depended on who she was and what she did for a living. Rural women working on their own properties had less food, but access to kitchen gardens and home-grown herbs and foods and a lot of exercise. Pottage, literally cooked in a pot, was one of the easiest and healthiest dishes to make, being mostly made of leafy greens. A modest version might have not much more than greens and bread, but meats and more exotic ingredients were added for persons of better means. Plain pottages were seen as being very suitable for those who were unwell, and being blander than other types of rich, spiced foods, were easily digested.

The name given to a certain type of pottage, which required very little in the way of ingredients but was nourishing and delicious, was Jouts, and it was essentially a thickened soup. One recipe given for Jouts[20] is this one below.

Jouts.

8–12 oz of mixed herbs

Soft white breadcrumbs

Stock

Almond milk

> Boil the herbs in plenty of water for ten minutes, drain, press dry, chop and grind to a smooth paste. For meat-days grind four ounces soft, white breadcrumbs with the herbs and a little stock, stir into two pints of beef stock, and simmer until thickened.
>
> For fish-days, replace the beef stock with salmon or eel stock.
>
> For jouts with almond milk, add the ground herbs to two pints almond milk and stew until the herbs are tender.

While the plain version of herbs and stock was quite flavoursome, the almond milk version would have been a sweeter and richer delight for those who could afford almond milk. This was true for many medieval recipes. Most have a plain version and a fancier one with more exotic elements added, like saffron, raisins, almonds, sugar, ginger, or rarer spices. Spices, being expensive, were used by wealthy households as exciting extras and not, as some historians have suggested, to hide the taste of rotten or spoiled meat.[21] Basically, if you could afford spices, you certainly could afford clean meat.

The diet of poor peasants can be deduced by reading contemporary literature, like "Piers the Plowman," a fourteenth-century poem by William Langland, which is filled with allegorical characters who talk about their lives. There are several translations of this book, but the first given here is from 1888, from *The Vision of William concerning Piers the Plowman by William Langland*, according to the version revised and enlarged by the author about 1377 CE. This transcription comes from the Reverend Walter Skeat, a professor of Anglo-Saxon at Cambridge University.

In one section, Hunger arrived and wished to be given food, but sadly, Piers reminded him that there was little to eat at that time of year. The conversation illustrates that food, and therefore health, depended on the weather and crops for a lot of rural population.

> " 'I haue no peny,' quod Peres poletes forto bigge;
> Ne neyther gees ne grys, but two grene cheses,
> A fewe cruddes and creem and a hauer cake,
> And two loues of benes and bran, y-bake for my fauntis.
> And yet I sey, by my soule, I have no salt bacoun,
> Ne no kokeney, bi cryst, collops forto maken.
> Ac I haue percil and porettes and many kole plantes,
> And eke a cow and a kalf, and a cart-mare
> to Drawe a-felde my donge the while the drought lasteth.
> And bi this lyflode we mot lyue til lammasse tyme.
> And bi that I hope to haue heruest in my croft;'..."[22]

In more modern language, in *A New Translation of the B Text* by A. V. C. Schmidt, it reads:

> " 'I've no money,' said Piers, 'for chickens or geese or pork,
> All I've got is a couple of fresh cheeses,
> a tiny amount of curds and cream, an oat cake
> and a couple of loaves for my children, baked from bean flour and bran.
> I give you my solemn word, moreover,
> that I don't have the ingredients to fry you a platter of bacon and eggs.
> All I've got is parsley, leeks and a huge supply of greens,
> as well as a cow, a calf and a mare
> that pulls my dung cart in the dry season.
> You see, that's the sort of food we've got to live on til Lammastide comes by which time I hope the fields will be ready for harvest...' "[23]

Whilst there are differences between the texts, most of the foods mentioned remain the same, and while Piers isn't a single, peasant woman, he shows us what kind of foods his family is eating and

what kind of foodstuffs he might usually have. Bacon and eggs aren't the first thing we think of today when we consider medieval peasant food, yet the combination was a staple for many people.

Household accounts are helpful for gauging what other levels of society were eating when we look at preparations of feasts and banquets—what food is to be slaughtered or obtained fresh and in what quantity. Foods which were not used at the time of killing were pickled or salted to preserve them. Food wasn't left to be eaten half-spoiled. This is another myth from historians past which has been repeatedly debunked.

The wealthy spinster waiting for marriage concerned herself with genteel activities which were less physically strenuous, and ate more exotic foods, many of which were higher in calories than those of her counterpart on the farm. Young ladies were warned, in this particular case, by the Archpriest of Talara, on the matter of overeating.

> "Avoid eating and drinking excessively of rich and precious dishes."[24]
>
> —Alfonso Martínez de Toledo

Even in the Middle Ages, overeating was known to affect the health of the body negatively.

Unmarried women cared as much for the health of their skin as anyone else. Whether of marriageable age or widowed, women used herbal concoctions to keep their complexion healthy and pleasing to look at. Smooth, clear skin was highly regarded in the medieval period as the most beautiful of all kinds. Paleness indicated a woman of superior breeding and the tanned look that

many associate with health today was associated with outdoor work and therefore a low birth.

Women were called "fair" for their smooth, unblemished appearance, not the colour palette of their skin: thus a woman with olive Italian heritage and a woman of pale English heritage could both accurately be described as fair, although their skin tones were not similar in the least.

Unmarked skin was held in particularly high esteem because frequent smallpox epidemics left much of the population with unattractive pockmarks. Smallpox arrived in Europe between the fifth and seventh centuries,[25] and its ongoing reappearance ruined many complexions. Some treatments involved blocking the light or wrapping the skin with red fabric in an effort to reduce the scarring left by burst pustules. A treatise of medicine called *Rosa Medicinae*, written by John Gaddesden in the fourteenth century, gives precise instructions on how this should occur.

> *"Then take a scarlet or other red cloth*
> *and wrap the smallpox patient completely in it,*
> *as I did with the most noble King of England's son*
> *when this disease had seized him,*
> *and I permitted only red things to be about his bed,*
> *by the which I cured him,*
> *without leaving a trace of the smallpox pustules on him."*[26]
>
> —John Gaddesden

Gaddeson's smallpox treatment is a medieval stratagem called the *Doctrine of Signatures*, in that if something looked like a part of the body, it should be used to treat it. For example, walnuts looked like little brains, so were good to treat disorders of the brain. Beans are

kidney-shaped, therefore they were good for urinary infections. The red pustules of smallpox suggested that red things should be used to treat it. Red cloth and foods for red spots.

Whilst preserving her health, cleanliness, and general appearance, a woman might commit the sin of vanity, so it was important for her to find that fine line between enough care and too much. According to several sources, it was also reasonable for a lady to take extra care of her looks if she had been unwell or was ugly. This was echoed from Galen, whose primary interest was medical, but who admitted that some medicines might be used for cosmetic reasons, of which he thoroughly disapproved.

> "The object of the cosmetic part of medicine
> is to produce an enhancement of beauty,
> while the object of the decorative part is to preserve
> everything natural
> in the body that is naturally accompanied by beauty.
> The appearance of the head suffering from alopecia is ugly,
> as it is with the eyes when the eyelashes and the hairs of the
> eyebrows fall out;
> and these hairs contribute not only to beauty
> but much more to health of the parts...
> But to make the colour of the face whiter by means of drugs,
> or redder, or the hair of the head curly, or yellow, or black,
> or to make it much longer, as women do,
> and the operations like these belong to the
> depravity of cosmetics and not to the healing art."[27]

—Claudius Galen

The Old Woman from the manuscript the *Roman de la Rose* was far more straightforward about improving one's looks by artificial enhancement when she also offered advice on skincare:

> "If her complexion loses colour
> and her heart is tormented as a result,
> she should arrange always to have aqueous ointments
> hidden in boxes in her chamber, for the purpose of painting her face.
> But she must take care that none of her guests can smell or see them:
> otherwise she could be in great trouble…
> If her hands are not fair and unblemished
> but marred by spots and pimples,
> she ought not to leave these alone but use a needle to remove them;
> or else she should hide her hand in her gloves
> so that the spots and scabs are not visible."[28]
>
> —Guillaume de Lorris and Jean de Meun

Although her key concern was health generally and not the enhancement of beauty, Hildegard von Bingen understood that many women wished to avoid a blemished complexion. One herbal remedy she recommended utilised ginger, vinegar, and wine.

> "Pulverize ginger with twice as much galingale
> and a half portion of zedoary.
> Place in a tied cloth in vinegar and then in wine
> so it doesn't become too dark.
> Smear the skin where eruptions are, and he will be cured."[29]
>
> —Hildegard von Bingen

Bathing was one way for a medieval woman to keep herself clean, and bathtubs can be seen in manuscripts throughout the entire medieval period, notably illustrating the tale of Bathsheba or warnings around the perils of mixed bathing at stewes. In an image

from the *Extrait du Livre de Gerard de Nevers*, by Lyoset Liedet and Guyot d'Augerans, we see a young lady spied on in her bathing chamber whilst she is naked and attending to herself. The image is dated to the early fifteenth century and is in the collection of the Bibliothèque Nationale de France.

Recipes for scented waters were also recommended to assist with other ailments. If bath tubs or access to a bath house were not readily available, women made use of a bowl and ewer with warm water to provide their daily toilette. Not having daily access to a bath did not mean that a young lady chose to be dirty instead. It was recognised that not being clean did led to health problems, not the least of which were bad smells and skin eruptions.

Gemstones were also used to make potions and unguents for promoting fair skin and removing pimples. Amethyst was the gem of choice in this matter. An afflicted person was directed to dampen an amethyst with saliva and rub it over the spots.[30] Also, one might try to heat water over a fire and hold the stone until it sweats, then use the sweat from the amethyst mixed with water and wash the face. How effective the gemstone remedies were is anyone's guess, although it is unlikely that they were of any real medicinal value, especially when rubbed on the surface as described.

Whilst food and drink were the cornerstones of medieval writers' advice in health handbooks, the well-being of an unmarried, single woman in the Middle Ages had a bit of a recurring theme. Keep yourself clean and keep yourself *nice*. Liaisons with young men of dubious character, drinking, partying, and immoderate anything-at-all would ruin your health and leave you deeply regretful, if not pregnant, with a venereal disease, or a combination of all three. It

can be summed up by the literary character Piers Plowman's advice to single women in a mere thirteen words.

"She must be a good girl and keep her Chamber of Venus clean."[31]

—William Langland

Single women who had reached puberty, and therefore adulthood, were generally in charge of their own daily health. The medical writings attributed to Albertus Magnus, *de Secretis Mulierum*, or *The Secrets of Women*,[32] composed in the late thirteenth or early fourteenth century, was aimed at this target group—fertile women who regularly had periods. Chapter after chapter speaks on the state of the menses, generating a foetus, the birth of a baby, too much menstrual flow, what to do when it stopped, how to tell if a woman was no longer a virgin, defects of the womb, and generally everything pertaining to gynaecological issues. Even if a maiden had yet to experience many of these things, she might learn some of them from her mother or female relatives in readiness for her future role as a wife and mother. There is a question over its entire authorship, and over eighty copies still exist today.

Concerning sexual health, maidens and spinsters were not always as well-behaved as they were told to be. Some were chaste, while others were sexually active outside of marriage, and had the risks of an unwanted pregnancy to consider. Here we shall concern ourselves with contraceptives for the medieval woman. Not being pregnant was of great interest to many women, but especially to those who were not married.

Medieval women did know about and use rudimentary birth control. Charms and talismans were employed rather hopefully with absolutely no protective power whatsoever. Other forms

were basic herbal concoctions which were unlikely to work as a preventative. Abortifacients concocted from plants may have been effective with "bringing about a late period," a euphemism for what to do if an early pregnancy was suspected. At one time, German women were said to have used a contraceptive block made from what was essentially a tampon with a coating to help seal it in place, which was to be inserted prior to coitus and removed afterwards. Many other writings on sexual health fail to mention this option, so it may have been a localised phenomenon and not widely spread to other countries.

Since childbirth was so perilous, many women desired contraception. This was condemned by the church. St. Augustine declared that any woman, whether she was married or otherwise, became a whore in the eyes of God if she used contraceptives, as the only reason for sexual intercourse was procreation. On the whole, the church agreed with him. Intercourse was for the continuation of species, not a titillating pastime.

> "Sometimes... resorts to such extravagant methods
> as to use poisonous drugs to secure barrenness;
> or else, if unsuccessful in this, to destroy the conceived seed
> by some means previous to birth,
> preferring that its offspring should rather perish than
> receive vitality;
> or if it was advancing to life within the womb,
> should be slain before it was born.
> Well, if both parties alike are so flagitious, they are not
> husband and wife;
> and if such were their character from the beginning,
> they have not come together by wedlock but by debauchery.
> But if the two are not alike in such sin,
> I boldly declare either that the woman is, so to say,

the husband's harlot; or the man the wife's adulterer."[33]

—Aurelius Augustin

This was not a popular opinion with women who enjoyed sex and wanted to be having it, single or not.

Single Mothers

Should an unwed woman fall pregnant, her life options became severely limited. If this news became public knowledge, she would be shamed and shunned, often by her own family and friends. She had only a few options: terminate the pregnancy or continue with the birth and make arrangements afterwards.

The health of a single, expectant woman in the Middle Ages might be largely the woman's own problem for much of the gestation, but as the time of confinement drew near, charitable institutions provided not only a place to stay, but health care for the mother-to-be and her newborn. Not all places offered this service, and the number of women who could be assisted was limited.

In 1352, the hospice at St. Bartholomew in London was granted a tax reprieve because of its charitable work in this field. The hospital at Southwark, run by St. Thomas in London, was noted for its discretion, lest the mother's sin be known and prevent a future good marriage. This also indicated that the babies born there were not kept by the mothers but fostered into other families or the church.

A London citizen wrote that St. Bartholomew's was indeed a great comfort to the poor, fallen women they cared for there.

> "...and in specialty unto young women that have misdone, that are with child. There they are delivered, and unto the time of purification they have meat and drink at the place's cost and full honestly guided and kept. And in much as the place may, they keep their council and worship."[34]

This too, indicated that the hospital did their best to keep the births private.

An unmarried mother who had hidden her pregnancy and gave birth to it secretly, not attending a hospital or charitable place, had few options once she had given birth: leave it at an orphanage to be raised by nuns, abandon it somewhere, or secretly dispose of it. Abandonment was technically not murder if the baby was alive at the time of desertion, as there was always the chance that the infant would be found by a passer-by and saved. Should the baby be found dead, and the mother traced, she would be charged with the death.

Unfortunately, the fifteenth-century records from Newton Blossomville in England show that the child might not always be found until after its life had expired.

> "Alice Mortyn gave birth to a child in the house of a rector there, but the father of the child is not known and, it is said, immediately after the birth the said Alice hid the child in the bog where the child died for want."[35]

Women were held responsible in a court of law if they were caught. Alice's story didn't explicitly say, but hinted that she was not a servant in the regular employ of the rector, but sought

him out at the time of her labour and absconded without much delay afterwards. Court records where a servant of a household became with child usually mention that the girl was a part of the household, and in Alice's case, it did not.

Widows

According to the Four Humours school of medical belief, old people were susceptible to many maladies as their bodies slowed down and decayed. As we have seen, a widow might not always be an older lady, so for the purposes of medicine, young widows should take their health care advice the same as spinsters and maidens. It is with older women who were single and elderly that we will now concern ourselves.

The health handbooks we learned of earlier included helpful and specific instructions for the older and infirm person. Hildegard's work, *Causau et Curae, part 2—Liber Compositae Medicinae*, advised that breakfast, whilst not of great importance to healthy young individuals, was of benefit to the frailer, more feeble kind of person.

> *"For the sick, frail and physically run down,*
> *it is good and healthy to breakfast in the mornings*
> *in order at least to gain some strength from nourishment,*
> *which one might not have had otherwise."*[36]
>
> —Hildegard von Bingen

The *Tacuinum Sanitatus* of the House of Cerruti, the late-fourteenth-century Viennese copy of the manuscript, had thoughts about what was most appropriate to drink. *The Table*

of Health in Accordance to Medical Science's recommendation was robust red wine, but only for a certain demographic.

> "Robust Red Wine.
>
> Most gentle liquor, genuine sustainer of life, regenerator of the spirits, wine is more suitable for old people than anyone else, because it tempers the frigidity they have accumulated over the years."[37]

Red wine is known to be a warming beverage and is indeed more suited for older people. It has been known to temper frigidness also, so in this case, good advice to follow, especially in cold weather.

The set of manuscripts known as the *Trotula* took time to consider the health of celibate older and single women. The concern was that bad humours would build up inside a woman, causing illness if not dealt with in an appropriate and timely manner. A lady who was single might have desires, which needed to be tended to without committing the carnal sin of fornication. The advice to both nuns and widows, whom she felt ought to be chaste, was as follows:

> "On the Preservation of Celibate Women and Widows.
>
> There are some women to whom carnal intercourse is not permitted, sometimes because they are bound by a vow, sometimes because they are bound by religion, sometimes because they are widows... These women, when they have a desire to copulate and do not do so, incur grave illness. For such women, therefore, let this remedy be made. Take some cotton and musk or pennyroyal oil and anoint it and put it in

> the vagina. And if you do not have such an oil, take trifera magna and dissolve it in a little warm wine, and with cotton or damp wool place it in the vagina. This both dissipates the desire and dulls the pain."[38]

Pennyroyal, according to Hildegard von Bingen's treatise *Physica*, was good for a number of ailments, including afflictions of the brain and poor sight in a middle-aged person, and purged a poison-filled stomach, all of which are of benefit to older women in this situation.[39] Dealing with the brain would take away the desire for amorous encounters, and purging the poisons from the body would help restore the balance of humours.

For less intimate care of age-related ailments, an elderly widow might resort to an herbal remedy recommended by Hildegard for the discomfort we associate with minor aches and pains, or perhaps rheumatism, today. She advises:

> *"But let whoever is worn out by stiffness*
> *cook sage in water and drink it...and it checks the stiffness.*
> *For if it is given with wine,*
> *the wine makes the stiffening humours pass by in some way."*[40]
>
> —Hildegard von Bingen

Sage was a particularly helpful plant when it came to relieving ailments and was a favourite of Hildegard's. She also recommended it as a cure for halitosis, advising that anyone who had stinking breath should cook sage with wine instead of water, before straining it through a cloth and drinking it often.[41] This recipe was tested in 2024, in the spirit of experimental archaeology, by the author and a group of game volunteers, and surprisingly, the results were favourably agreeable with the original advice. Whilst some participants felt it was not a particularly *pleasant*

beverage, all involved in the trial agreed that the taste of the sage *did* overpower all else, including the smell of anything else on the breath. One participant reported a sage taste in the mouth which lingered for almost a full twenty-four hours, even after drinking and eating meals.

Warm herbal baths were recommended by most health books for the relief of muscular aches, and sage is often mentioned as one of the herbs suited to this purpose also.

Beggars and Fringe-Dwellers

The health care and diet of a beggar was extremely frugal. She managed on whatever she could.

Should a poor single woman contract leprosy, she was ousted from the municipality and forcefully pushed to live beyond the walls of the town, along with those accused of prostitution. The borough ordinances of Bristol in 1344 encouraged this by making her home unliveable, giving the woman no alternative but to leave or live in a home which was not secure or weatherproof.

> "And if such a woman should be found so living that then the doors and windows of their houses be taken down and carried off by the mayor's servants as far as the constable of the peace of that ward's house and kept there, and such women be entirely removed."[42]

Single women in poor circumstance might find temporary respite in alms houses, obtaining at least a place to sleep and simple nourishment. Since many were unwell from lack of adequate nourishment and protection from the elements, they were taken is as an act of charity, made warm, and fed simple food.

A recipe given for sick people is Flemish broth, which is made thus:

> "Boil a pot of water. Then for each bowl beat four yolks with white wine. Pour this in a thin stream into your water, stirring well. Add salt to taste. When it is well boiled, take it off the fire. When making one bowl for one sick person, use five eggs."[43]

This recipe, using five eggs for one person, is clearly not something a poor woman could cook at home, but more of the type of meal she might receive in the care of a charitable house. A recipe for sweet barley water used mostly more accessible ingredients, including barley and figs. To this was added the slightly more exotic licorice and a healthy dose of sugar.[44]

> "To make sweet barley water, take some water and boil it. Then for each *sextier* of water, add an ample bowl of barley, with or without the hulls, two *parisis* worth of licorice, and some figs, and let it boil until the barley bursts. Strain it in two or three cloths. Put a lot of crystalised sugar in each cup. Afterward, this barley is good to give to chickens to fatten them up. Note that the good licorice is the youngest, and when cut it is bright green; the old is colourless, dead, and dry."

Interestingly, it was advised not to feed the barley itself to the patient, but to fatten the poultry, although why it might not have

done likewise for the person who was unwell is a mystery. As with many medieval recipes, exact quantities are not given for all of the ingredients.

Nuns and Cloistered Women

The standard of health care for women in nunneries was significantly better than for the lay population. Their living conditions were clean and they received adequate sustenance, making the nuns less likely to suffer from diseases associated with malnutrition or squalid living. Many people relied on the infirmaries in charitable houses to meet their medical needs, especially when they were very ill and could not afford a private physician to attend them. The infirmarian had some specific medical knowledge and, although not a university doctor, was able to provide medical care to other women. She was responsible for special dietary requirements of the sick within the cloister and supervised extra baths if they were thought to be medically beneficial.

Cloisters had gardens with many herbs, both medicinal and culinary, so using herbal remedies in a religious setting was an entirely normal occurrence. Many plants have been proven today to have properties which would do the jobs medieval healers hoped of them. God had created plants for humans to use and were part of his divine plan.

Always mindful of working in God's grace, herbal medicine needed to be approached in the correct way. Many doctors consulted the patient on their date and time of birth, as it was believed that the

position in the zodiac would either help or hinder recovery, and knowing the position would give clues to the type of treatment most likely to produce the best results. An image of the zodiac which was created for use by monastics can be found in the manuscript *Cosmography*, W73, folio 1r in the Walters Art Gallery. Created in England in the late twelfth century, it demonstrated that using the stars to guide medical treatments was an acceptable practice and not regarded as pagan or un-Christian.

Fasciculus Morum, the preacher's handbook from the fourteenth century, warned nuns that to use herbs was permissible, as these things had been provided for use by God, but it should be noted that paganism and superstition must be avoided.

> "To this kind, belong witches, in English 'tilsters,' who carry out their craft…healing with charms and other retched contrivances. Often this does more harm than good, especially in spiritual terms, because skills of this sort are forbidden. Therefore in such cases one must inquire whether or not such effects may be caused naturally.
>
> But Raymundus says on this issue that if a man or woman gathers medicinal herbs or something of this kind and does so reciting the Creed or the Lord's Prayer or writes these on a piece of paper which he places on a sick person, so that by doing this he only honours God, the Creator of all things, there is no reproach in this as long as nothing else of a superstitious character gets mixed with it."[45]

Replacing pagan charms and chants with religious ones made herbal medicine acceptable. Should the person not recover using natural preparations, it was certainly the will of God and not the fault of the treating clinician. Nevertheless, doctors were advised to be mindful not to accept patients who were so unwell that they were unlikely to recover, because it made them look less successful.

Diets were strictly controlled in religious houses under the guidance of an abbess, who may or may not have been taking her personal duty regarding fasting and the kinds of food she should be having, seriously. Again, visiting clergy were appalled at infractions witnessed and made stern notes as to what *should* be going on instead of what they could see with their own eyes.

When Richard, the Bishop of Lincoln, visited Elstow Abbey in 1421, he advised the proper portions of meat and drink the nuns ought to have, and made particular mention of the quality of the bread.

> "Likewise, we direct that every nun of the said convent have one dish of meat or of fish appropriate to the season each Monday, Wednesday, and Saturday, each dish worth a penny. Also that each nun have five measures of superior ale every week, and that there be no distinction between the bread of the Abbess and the bread of the convent, and that bread is to be sixty shillings' worth in weight."[46]

We read in other visiting diocese records that sisters often complained about the special food that found its way onto the table of the abbess and wasn't shared amongst them all.

On the question of sexual health, we already know that a woman's humours would not be balanced without the input of intercourse, and a religious woman with no husband was in danger of her emotional and physical well-being suffering. What was she to do? Popular medical belief taught that the humours would build up inside her if she was denied sexual release, leading to convulsions, madness, fainting fits, suffocation of the womb, and hysteria. Doctors advised that women who remained chaste, like nuns, although admired for purity, needed an action plan.

In the fourteenth century, this came in the form of learned advice from John Gaddesden of the medical faculty at Oxford University. He was certain that the female seed which wasn't being brought forward during intercourse was of great detriment to single and sexually virtuous women, and he had a remedy to combat this.

> *"If she does not or cannot do this,*
> *because she is a nun and it is forbidden by her monastic vow...*
> *she should travel overseas, take frequent exercise*
> *and use medicine which will dry up the sperm...*
> *If she has a fainting fit, the midwife should*
> *insert a finger covered with oil of lily, laurel or spikenard*
> *into her womb*
> *and move it vigorously about."*[47]
>
> —John Gaddesden

The was essentially the same advice given by the *Trotula* to chaste women and widows, but using an herbal vaginal pessary to dull the desire, without the recommendation for overseas holidays or cardio.

Chapter 10
Death, Funerals, and Beyond

Figure 10. *The Throne of Charity* from the *Psalter of Bonne de Luxembourg*, circa 1349. Unknown author. MET open access.

The afterlife and the soul of the deceased was a very serious business to those who lived and died in the Middle Ages, and great consideration was given to preparation for the soul's eternal life. This was as true for single woman as for all others. The medieval person's idea of death was terrifying, and the thought of being forgotten or trapped in purgatory or hell an ever-present concern.

> "When the head trembles,
> And the lips grow black,
> The nose sharpens,
> And the sinews stiffen,
> The breast pants,
> And breath is wanting,
> The teeth clatter,
> And the throat rattles,
> The soul has left,
> And the body holds nothing but a clout—
> Then will the body be thrown in a hole,
> And no-one will remember your soul."[1]
>
> —Fasciculus Morum

Life on earth was just a stepping stone to a forever after in heaven, so a good death was as important as, or *more* important than, a good life.

The struggle for the soul was a recurring theme in medieval art, and in the *Hours of Philip the Good*, made in Bruges between 1455 and 1460 by Getijdenboek van Philips van Bourgondië, we can see a devil and an angel battle for a woman's immortal soul above her head. The angel lights a taper representing everlasting life, while the devil uses a pair of hand-held bellows to attempt to extinguish it.

Repenting of one's sins on the deathbed could erase the corrupt deeds of a lifetime, it was hoped. Two thirteenth-century icons, one from an altar in Catalan and the other a sculpture from Bourges, show the archangel St. Michael weighing the soul of the departed on a set of hand-held scales while the devil tries to tip the balance in his favour.² This was a real concern to those who had led worldly lives.

Resurrection was a certainty for all, and even those who had been eaten by animals or were mangled in an accident, were assured that they would rise in perfect form to face judgement.³ All would be judged on the day of judgement, and Nicholas Bozon, an English friar in Anglo-Norman times, made a clothing analogy so simple people would be sure to understand his point.

> "At the day of judgement, the simple folk will be exalted
> for their good deeds and the haughty abased for their pride.
> Then God will do as the mender of old clothes,
> who turns the lappet to the front,
> and what was uppermost downwards."⁴
>
> —Nicholas Bozon

Images like the *Dance of Death* by Talin vividly depicted the mortality of man and the inability of even the upper classes and kings to escape death's clutches. The Dance of Death was a popular theme in contemporary artwork, especially since the Great Pestilence touched almost every family, village, town, and city on and off sporadically for most of the medieval period. Grinning skeletons danced between men and women, took the hands of the wealthy and poor alike, and reached into cradles with no regard for the living around them.

While death came to all, its financial repercussions varied depending on the position of the deceased. In the early medieval period, when an unfree tenant passed away, a heriot or fine was paid to the Lord, usually the best beast. It was written in the Cuxham court roll that if a man had only one beast, the Lord should have it,[5] via his representatives on earth, the church. The parish church claimed the second-best beast as a mortuary fine. If a family was of modest standing, it was quite possible to lose all the livestock it possessed, especially if illness claimed more than one family member within a short space of time. Later in the medieval period, the fine was the donation of the winding sheet which the corpse was wrapped in before burial.

Much expense was spent by the upper classes on candles, masses, and donations to the church. Funerals were not only to mark the passing of a loved one, but for the nobility or very wealthy townsfolk, it was another opportunity for a showy display of wealth. By the fourteenth century, black had once again become the popular colour for mourning. In the very late fifteenth century, English sumptuary laws specified the length of trains and tippets on hoods to be worn by mourners.[6] As usual, the higher social strata had the longest of these, down to chambermaids who were to have none.

Wills leaving charitable bequests were a way of easing the soul through purgatory by helping the needy as an act of charity. Many images of funerals can be seen in fourteenth-century art with women present who are mourning. These might be family members, hired clergy who said masses for the souls of the departed, or paid mourners, like poor widows and poor women earning extra money. The prayers of the poor who suffered in this world were believed to carry more weight with God. Employing

poor women was also an act of charity, so this practice of having strangers pray for the dead was not discouraged.

Common people sat vigil with the deceased, often singing, playing games, and dicing. In an effort to curtail these kinds of activities which, in 1284, were felt by the Ludlow church to be not particularly solemn, merchants' guilds forbade games and the attendance of women who were not direct family members.[7] This was reiterated by the preacher Burchard of Worms in his *Corrector*.

> *"Hast thou observed funeral wakes, that is,*
> *been present at the watch over the corpses of the dead*
> *when the bodies of Christians are guarded by a ritual of pagans;*
> *and hast thou sung diabolical songs there and performed dances*
> *which the pagans invented by the teaching of the devil;*
> *and hast thou drunk there*
> *and relaxed thy countenance with laughter,*
> *and setting aside all compassion and emotion of charity,*
> *hast thou appeared as if rejoicing over a brother's death?*
> *If thou hast, though shall do penance*
> *for thirty days on bread and water."*[8]

—Burchard of Worms

In spite of this, many images of funerals can be seen in fourteenth-century art with women present.

An elaborate funeral pall of costly material can be seen in a finely and richly illuminated thirteenth-century book of hours held by the Walters Art Gallery; W102, folio 55r. These types of coffin covers were often donated to the church to be made into vestments or altar cloths after the funeral, and great sums of money or lands donated to the church ensured prayers were said

for the soul of the departed by monks or nuns long after the initial service was over.

The final preparation of the physical body for burial was considered as important as the life of the person who lived it. For the bulk of the middle and later part of the medieval period, the body of the deceased was prepared for a proper burial the same way.

Firstly, the body was taken to its own home, where it was carefully washed with water and then wrapped in a white winding sheet or shroud in preparation for burial. Later, it would be transported to the church for the funeral proper. Should it be necessary to leave the body at home overnight, a night watch, or wake, would be organised, perhaps with candles around the body.[9] The funeral procession might be led by a person with a bell followed by monks, then men, the deceased, and finally by women. The funeral pall covered the coffin.

Other illuminations show scenes from simpler burials, with the deceased already wrapped in his winding sheet and being lowered into a long, rectangular box while prayers are being read from a book. Illustrations of plague burials may not involve a casket.

Burials were considered the proper way to dispose of a body in the Middle Ages. Although burning alive was a severe form of punishment meted out to the particularly ungodly, cremations were not considered conducive to resurrection, so were not the usual method of corpse disposal.

In the section on abominations in the illuminated German manuscript *Der Naturen Bloeme*, by Jacob van Maerlant, a picture is included of those who burn their dead along with

other abominations: giants, dwarves, people born with their hands back to front, people born with grey hair, naked savages, people who kill their old parents, people who live on raw meat and honey, and people who bear quintuplets. It is slightly ironic that the punishment for those who sin by burning their dead is for them themselves to be cast into the fiery pits of Hell, usually horrifyingly illustrated as burning its inhabitants in a hellmouth run by torturous demons. This rather fantastic late thirteenth-century manuscript can be found in the *Koninklijke Bibliotheek*, the National Library of the Netherlands, KB KA 16.

Young Girls

> "Little Infant, that were but late born,
> Shaped in this world to have no pleasance,
> Thou must with other that go here before,
> be led in haste, by fatal ordinance.
> Learn of new to go on my dance;
> There may none age escape in sooth therefrom."[10]
>
> —John Lydgate

So wrote the poet-monk John Lydgate of Bury, who lived in England in the fourteenth and the first half of the fifteenth centuries. It is the first stanza of his poem about the Dance of Death, a popular medieval theme which extolled that death came for everyone, even the young. In the following verse, a small child replies that they were born but the day before, but will go with him anyway.

Infant mortality in the Middle Ages was often caused by accidents, either in the domestic setting or surround. As babies became

toddlers and toddlers became young children, their home environment became more dangerous. As any mother knows, a toddler is quick, loves to explore, and is curious, and the hazards in a household, especially one with an open fire for cooking, are many. The *Bedfordshire Coroner's Rolls* in 1274 list a heartbreaking entry where a small girl is drowned.

> "About Prime... Joan, a small child of five, went through Risely to beg for bread. She came to a bridge called Fordebrugge and, as she tried to cross it, fell into the water and drowned by misadventure. Her mother, Alice, daughter of Bicke first found her..."[11]

The entry read that her mother had found her, so it appeared that her mother wasn't with her at the time of the accident, and that little five-year-old Joan was crossing the bridge alone without adult supervision. Where her mother was, we don't know, and why her daughter was begging without her at that age, we don't know.

A similar fate befell nine-year-old London girl Mary de Billingesgate in 1340. Although she was a little older and could be trusted with running errands alone, unfortunately, in this instance, it didn't go well for her.

> "Tuesday before the feast of St George... Mary, daughter of Agnes de Billingesgate, aged nine years, lay dead of a death other than her rightful death under the wharf of Thomas de Porkele in the parish of All Hallows, in the ward of Dowgate. ... having summoned the good men of that ward and the ward of Langbourn where the said Mary lived with her mother, they diligently enquired how it happened. The jurors...say that on the preceding Sunday after the hours of vespers, the aforesaid Mary filled an earthen pot with water on the aforesaid

> wharf, the Thames being in flood, when she fell into the water and was drowned."[12]

Both girls were the victims of accidental death involving falling into rivers while unsupervised when their deaths could have been prevented by the presence of a second person.

Children of these ages were to have been baptised, and should have been buried in accordance with their parent's beliefs, although what kind of funeral Joan would have had if she was the daughter of a beggar can only be speculated upon. Her mother would not have had the wherewithal for masses, candles, and a tomb with a statue, so it is likely she was buried charitably by nuns who ran an alms-house or hospital for the poor.

The proper minimum age for a mass and religious burial was a question of concern to some early priests, who felt that babies, toddlers, and infants were too young for a full mass, because, although they might be baptised, they were not old enough to fully comprehend the doctrine behind the practice. The writer of the *Penitential of Theodore* gave his thoughts on that particular aspect of a child's funeral. He stated his disagreement that infants, those not yet considered children, were too young for a proper mass.

> "Many say that it is not permissible to celebrate masses for infants of less than seven years; but it is permitted nevertheless."[13]

—*Fasciculus Morum*

Whilst the ceremonies for adult funerals were heavily ritualised, burials for children were plain. The body was wrapped in a winding sheet and placed in the casket without further adornment.

Surprisingly, according to a study of medieval cemeteries in Britain, children's graves sometimes included small goods.[14] These included crosses, coins, dress items, beads, and, in the case of a boy aged between seven and ten at St. Augustine's Abbey, Canterbury, a pilgrim badge. These may have been personal items or protective amulets placed in the grave by the family.

Children of wealthy parents were mourned in a more elaborate way. The little three-year-old Katherine, the daughter of Eleanor of Provence and King Henry III, died on the third of May in 1257 and was buried in Westminster Abbey in a magnificent tomb complete with a silver-plated effigy.[15]

In a beautiful set of verses, one anonymous writer, only known as the Gawain Poet, wrote a poem about a heartbroken father whose daughter passed away whilst still an infant. The poem, "Perle,"[16] is the best-known example of a parent mourning their child. True to other late fourteenth-century Middle English literature, the verses themselves are filled with imagery and allegory.

In the opening verses, the bereft father who had lost his child fell asleep in a garden and there encountered a heavenly lady dressed in white. He questioned her about her current situation and she replied gently with Christian teachings. He realised that this woman in white was his infant daughter, grown to maidenhood, but he awoke from his dream when he tried to cross a river to reach her. A small excerpt demonstrates a father's love for his daughter who was taken before her time:

> *"...Alas, I lost her in a garden;*
> *she went from me through the grass to the earth.*
> *I pine away, wounded by love's power,*
> *for the Pearl of mine that was without flaw..."*

> *...Before that spot I clenched my hands*
> *because of the cold sorrow that seized me.*
> *A desolate grief lay hid in my heart,*
> *though reason calmed me..."*
>
> —the Gawain Poet

This outpouring of grief shows that fathers, too, could be emotionally attached to their female children.

Unmarried Maidens and Spinsters

There are a plethora of coroner's records listing single women who died as a result of grievous bodily harm. In these circumstances, these women would not have had a chance to make a will or bequeath their goods to anyone. As an unmarried woman, any goods or personal belongings she had at the time of her demise were the property of her father, so individual wills distributing property or goods are not to be found. Single spinsters and maidens relied on their families to make their funerary arrangements and organise masses and candles for their souls. Widows and women trading *femme sole* made other arrangements, as we shall see shortly.

An unmarried woman who was employed in service in another household may, in some circumstances, have had her funeral arranged by her employer, as was the case of an unnamed maid of Mistress Halhede in 1505. She was buried in the Pardon churchyard for the sum of two shillings.

When attending a funeral, a woman's behaviour was still on display and she was warned in etiquette books how she should approach the business of mourning. Weeping, for example, should not be ugly crying, no matter how sad one was. Guillaume de Lorris, who wrote the bulk of *The Romance of the Rose* in the fourteenth century, gave helpful advice on the proper way to cry, so a woman wouldn't embarrass herself by crying in the wrong way in public. He omitted to actually say what the proper way *was*, but continued his observations on mourning when he said that women really cry most to get attention and it was no more than emotional entrapment for men who saw them.

> *"There is also a proper way to weep,*
> *but every woman has the skill to weep properly*
> *wherever she may be...*[17]
> *No man should be moved by it,*
> *not if he sees the tears flowing as fast as rain,*
> *for a woman only sheds such tears and suffers such sorrow*
> *and affliction in order to make a fool of him.*
> *A woman's tears are nothing but a trap..."*[18]
>
> —Guillaume de Lorris

A fourteenth-century text by John Bromyard, the *Summa Predecantium*, painted a vivid picture of what lay in store in hell for wealthy single women, especially those fond of unnecessary trinkets and fine luxuries.

> *"Their soul shall have, instead of palace and hall and chamber,*
> *the deep lake of hell...*
> *In place of scented baths, their body shall have*
> *a narrow pit in the earth,*

> *and there they have a bath more foul than any bath*
> *of pitch and sulphur.*
> *In place of a soft couch, they shall have a bed more grievous*
> *and hard than all the nails and spikes in the world...*
> *instead of gluttony and drunkenness, hunger and thirst without end;*
> *instead of gaming and dice and the like, grief."*[19]
>
> —John Bromyard

These imaginings were illustrated in bibles and manuscripts in bold colours, which hoped to inspire better behaviour from those who saw them.

Widows

Death came for everyone in the medieval world, as shown in skeletal artworks like the National Gallery of Slovenia's fresco *The Dance of Death*. Murals and images like this one showed that no matter how wealthy one might be currently, the result would be the same. Death would come. Whether one was a rich or poor woman, a noble or a humble one, a young or an old one, only death was a certainty. The message was that one needed to be spiritually prepared to face it.

There are many examples of single women planning their own funerals and making arrangements for their own lives in the hereafter, those of widows who had property and goods worthy of distribution.

Funeral arrangements and bequests from women depended on a number of variables. What did she own? What should she leave to the church, family, and friends? Did she have a business to make

arrangements for? Was her soul in need of extra salvation? Had she led a worldly life and developed concerns about not making it to heaven? Should she leave money for others to pray for her to lessen her time in purgatory?

All of these depended on what kind of widow she was.

Poor widows might have a simple burial funded by a religious organisation with the absolute least observances possible. Wealthy widows were able to afford a funeral of great sumptuousness, including all the trappings of an impressive death.

Business women who were trade members might be afforded some assistance from their guild members. Many trade guilds provided for their own members, even at the time of death, with donations of masses, tapers, and burial costs. It was standard practice in some guilds that the deceased, had they died whilst out of town, would be afforded the same courtesies as if they had died in their home parish.

The question of what a widow should leave to others in her own will depended entirely on what disposable assets she had, and whether she had children who were to inherit any of it. Definitely, there were donations to religious establishments. Wealthy widows often left money for the preservation of town infrastructure, such as the repair of roads or bridges. In 1485, Katherine Mason left instructions for the upkeep of a little bridge in Shoreham and fifty-three shillings eight pence to pay for it.[20]

The Throne of Charity from the *Psalter of Bonne de Luxembourg*, dated around 1349, vividly illustrates how each single act of charity increases a woman's proximity to heaven. The image shows a woman on a staircase ascending to heaven, each good deed a

further step toward everlasting life in heaven, and this was a message which religion imparted to both sexes, single and married alike. Every act of charity counted.

Even poor widows left as much to the church as they could, even if it were a token gesture. Wills also directed household goods to other women, including beds, mattresses, sheets, cookware, clothing, jewellery and money. Leaving alms or clothes to the poor was a form of charity which not only physically helped other women of little means, but pleased the church at the same time.

The will of Cecily Giry, who was named as a widow in the wills in the diocese of York, made her bequest almost to that end in 1388:

> "And I will that the three feather beds with the sheets pertaining to them in the guest chamber remain there to serve as a hospice for the poor."[21]

Cecily wasn't donating the goods to the church for *their* hospice, but was stipulating that the guest chamber of her own place be turned into a hospice for the needy. This hints that the dwelling itself was to remain in the hands of someone who already lived there, perhaps her son, who would become the owner after her passing. This also left the burden of serving the patients at her future in-house hospice to someone other than herself.

Other widows left vestments, cloths, and candles or wax to the church directly. Agnes Umfrey, who wrote her will in 1484, donated a number of items to multiple churches for the betterment of her soul, before distributing her goods and chattels to friends and family. Agnes was very precise in her wishes as to

which churches were to receive what goods, and especially where funds for lighting specific chapels were to be spent.²²

For the church at Edlesborough:

> "Also, I leave to the high altar of the same [church], two measures of wheat. Also to the light of the crucifix 4d, Also to the eight great lights of the same, 8d. Also, to light the image of the Blessed Mary of Pity, 1d. Also for the repair of the torches, 4d. Also I leave for the maintenance of a priest...in the church of Edlesborough..."

and for the church at Dagnall:

> "Also I leave for the chapel of Dagnall, a measure of wheat. Also for the purchase of vestments for the church of Edlesborough, if such happen to be bought..."

And for two churches of Gaddeston:

> "Also to the church of Little Gaddesden, 12d. To the fraternity of the church of Great Gaddesdon, 20d..."

She moved on to further personal bequests of household goods, including one Agnes Merston, who was to receive an acre of wheat, a brass pot, and a pair of sheets. Her relationship to Agnes isn't noted, so we are unable to tell if she is a family member, friend, or servant.

Wills of wealthy widows also permitted them to control the distribution of their personal items, many of great value. The will of Elizabeth Speke bequeathed a number of expensive possessions.[23] Family members, sons, and cousins were left silverware, seven ladies were left items of clothing, and one of her cousins-in-law was left some very beautiful and expensive things.

> "...my lytull rope of perells with the bedstone of gold. Also to hir, my litull paire of beides of gold, and my best purfle for a bonet sett with perells and my best pyncasse, also a cross of gold that hyng aboute my necke usually, my second best frontlet and a demy girdell of coorse of venys gold."

which in modern English reads:

> "...my little rope of pearls with the bead stone of gold. Also to her, my little pair of beads of gold, and my best purfle for a bonnet set with pearls and my best pin case, also a cross that hung about my neck usually, my second best frontlet and a demi-girdle of course of Venice gold."

Many pin cases were made from metals, highly decorative and very expensive, so its inclusion amongst jewellery of great value was not surprising.

A widow at Oxford in 1282 left her female relatives regular household goods which they would find useful for their own homes. These ranged from brass pots, pans, and pitchers to hangings and sheets, along with a mazer cup with foot to her daughter, and a small pillow, silver spoon, and a mazer cup without a foot to her niece.[24]

A detail from the manuscript of the *Hours of Charles the Noble, King of Navarre* by the Master of the Brussels Initials and Associates, dated 1361–1425, shows a funeral with mourners, an expensive funeral pall, and lit candles around the coffin. These are all trapping of an expensive funeral, something a rich widow might aspire to in order to give herself a magnificent sendoff.

Wealthy widows sometimes chose to ape the affluent funerals of the upper nobility in an effort to make a good sendoff from the mortal world. A widow might leave instructions for masses to be said after her death, which were paid in advance. We have a number of surviving examples of these wills which specifically earmark funds to churches for masses and prayers. These might be for a specific number of prayers or masses, or those said for a requested number of days, months, or years. Other requests were more modest and related to trappings more than prayers. Three examples of these can be seen from the first half of the fifteenth century.

In 1429, Amice Gregory assigned eight silver marks for a priest to say mass for an entire year for her soul.[25] Elizabeth Stafford, on the other hand, made instructions in 1405 for when her time came. She requested, and paid for in advance, one thousand masses for her soul and the souls of her children at the multiple churches of St. Giles, Dorchester, Yevelchester, and Abbotsbury.[26] Margaret Ashcombe's more modest will of 1434 in London directed that two tapers should stand at her head while her body still rested at her house before being taken to the church.[27]

Memorial brasses were another way for the wealthy to be remembered after death. The brasses were made from a combination of copper, zinc, lead, and tin, which was beaten into thick plates of various sizes and engraved by skilled artisans.

Although principally manufactured at Cologne, England was the largest consumer of brass for use in brass memorials.[28]

Persons commemorated with brasses were usually engraved on the plates life-sized by deeply incised lines. Brass plates also offered the ability to record greater detail in clothing and accessories than stone or marble. The earliest existing dated examples of memorial brasses are from the thirteenth century. In some cases, black and red plain enamels were used to enhance the brass, while other brasses were further adorned with Limoges enamels, which could be many varied colours. Brasses were at their greatest artistic excellence in the fourteenth century, slowly deteriorating in the following centuries.[29]

One example of this style of marker is the memorial brass of Juliana Anyell at St. Margaret's parish church in Witton by Norwich. Juliana wears a pleated veil under her chin and her disproportionately large hands are devoutly posed in prayer. Her brass is dated to around 1500. Another extant English brass is of Elizabeth de Northwood, which is dated at 1335. She is engraved modestly wearing a wimple over her plaited hair, which is resting on an elaborate pillow.

The most popular pose for women shown on brasses was with palms pressed together in devotional prayer. Often a couple were shown on one plate, and sometimes a beloved pet dog was included at the feet, as is the case with Sir John Casey's wife in Deerhurst, Glos. The dog has a collar with little bells around its neck, and its name, Terri, is written underneath.[30]

Some widows were paid to sing at the funerals of others. Their widowhood made them respectable matrons in the eyes of society, and in many cases, it was a good source of extra income.

In 1346, widows were left six shillings and eight pence for singing psalms and watching over the body of William de Huntyngton, an apothecary from York.³¹

Not all widows were well-off or well-behaved, which resulted in untimely deaths. Some retained their homes but had little in the way of income, and others were single but living a lifestyle which did not fit the expected picture of a modest and chaste woman by going to taverns and seeking the company of men. Neither of these bode particularly well for women wishing a long life. The *Coroners' Rolls of Bedford* in 1270 show how Lucy Pofort met her untimely end.

> "Towards vespers… Lucy Pofort, formerly the wife of Thomas of Houghton, came from the tavern in the house of John of Cranfield of Aspley Guise in Aspley Guise and went to her house. A lewd stranger came and asked for entertainment and Lucy entertained him. At dawn the next day Andrew, son of Simon of Houghton Regis, servant, came to draw water at a well called 'Swetewell,' came to Lucy's house, saw her dead with five wounds to her heart apparently made with a knife…"³²

This record brings a lot of unanswered questions to the fore about the widow Pofort, but illustrates the dangers of a widow behaving in a manner which medieval society thought was not proper.

Other widows drew censure to themselves by not grieving for their husbands properly. Preachers complained that women were only *appearing* to mourn because it was expected of them, that the feeling wasn't genuine, and the new widows were more concerned with how the death of the head of the household would affect their own livelihood.

> "After their death, they hardly follow them to the cemetery, which they cannot avoid, wailing and in the eyes of society as it were tearing themselves; but then, when the corpse has been buried, their grief abates and they quickly return home without tears, saying: 'Alas, alas, we have lost our support. What shall we do now?' but they do not say: 'Ah, Lord, how can I help his soul free from its pain?' "[33]

This demonstrated the high value put upon a good death over concerning oneself with the trials of the mortal body, at least by priests. That a widow may have had a genuine and valid concern about how to support herself, and her family, if she had one, was of secondary importance.

Poor Women, Beggars and Fringe-Dwellers

Single women who had fallen down the social scale were the most likely to die sad deaths. They were unable to pay for masses and candles or make bequests to benefit themselves in the afterlife. They had no husband to make arrangements and no children to take care of their affairs. In spite of this, writer Christine de Pizan advised old, poor women to take heart by telling them they were likely to die soon, which ought to be to a comfort to them. Christine was neither old nor poor, but her message was well-meant.

> *"The older the better,*
> *for you are nearer the end of your voyage and closer to God."*[34]
>
> —Christine de Pizan

Feelings toward those who suffered and were ill are not in line with today's views. The medieval perspective was that those who suffered on earth would be rewarded in the future. The worse the suffering, the bigger the reward. Little comfort to those affected by suffering.

Religious women, like Teresa de Cartagena, also shared the view that sickness and suffering brought a person much closer to God, and therefore was a good thing.[35] In her *Grove of the Infirm*, a treatise she wrote in the fifteenth century, she assured the poorly that they should be thankful.

> *"I address and admonish only the sick, sad and sorrowful*
> *with their ailments and suffering, so that, indeed,*
> *we may all use our tribulation and human sadness*
> *to procure spiritual joy with devout and healthy intention,*
> *and may we say with the Apostle:*
> *Gladly therefore, will I glory in my infirmities."*
>
> —Teresa de Cartagena

Whilst charity was to be encouraged, she personally felt that relieving the situation too much was removing the future closeness to God, thereby a spiritual disservice. There was a balance to maintain.

Poor women who were either single or widowed, and with little income, often turned to lives of unwholesomeness, theft, or prostitution, which often ended in death by misadventure or murder. Coroners' rolls document these with details given to them by those who found the bodies.

Art, too, visualised a poor woman's demise. An image of Death stepping across a woman's body can be seen in Guillaume de Deguileville's *Le pèlerinage de la vie humaine*. This allegorical text written in vernacular verse was inspired by Guillaume de Lorris and Jean de Meun's *Roman de la Rose*, although its theme was concerned with morality instead of the acquisition of love. Composed between 1330 and 1332 CE in northeast Flanders, it can be seen in the Walters Ex Libris, W141. Folio 92v.

Christine de Menstre's death is recorded in the 1301 London Coroner's rolls after she was murdered in the churchyard of St. Mary at Woolchurch. The witness accounts were given by three men, although it is not clear whether they found her body. They seemed to know who the perpetrator was and why he had killed her, but they did nothing to prevent it.

> "...She lay dead other than her rightful death ... three good men of the ward say on their oath that the preceding Sunday evening a certain William le Sawiere met the said Christina in the churchyard and asked her to spend the night with him and she refused and endeavoured to escape from his hands.
>
> The said William, moved with anger, drew a certain Irish knife and struck the said Christina under the right shoulder blade, causing a wound an inch broad and six inches deep, of which she then and there died."[36]

As Christine is not listed as a widow or as anyone's daughter or wife, it is likely that she had left her familial home and was living independently with no family connections. The Coroners' Rolls from Bedfordshire list several of these types of stray women.

Some were poor women, like Beatrice Bone of Turvey, who begged for food and lodgings in 1273.

> "...Beatrice Bone, a poor woman, went from door to door in Turvey begging for food. She came to Alice Mordant's house in 'Arneburwey,' fell down because she was so weak and infirm and died there by misadventure between prime and terce."[37]

Emma of Hatch died of exposure whilst out begging for food in the cold of January in Beeston. Her death is also noted in the Bedford Coroners' Rolls of 1273.

> "Emma of Hatch came from Beeston, where she had been begging for bread from door to door, and towards vespers, she returned to Beeston to seek lodging. She came to a piece of cultivated land called 'Pokebrokforlong' in Northill, was overcome by cold, and died by misadventure..."[38]

Poor single women such as these had no family to support them, a home of their own, or the means to support themselves other than relying on charity, and their burials would have been unremarkable pauper's graves without the benefits of extra masses, candles, and paid mourners which accompanied the funerals of wealthy widows.

Bequests from other widows might benefit them in life, like the will of Agnes Poost from Doncaster.

> "Also I bequeath all my wood and coals to be divided among the poor people hastely after my death."[39]

The Norwich Guild of St. Katherine made sure that, should a sister fall into poverty, a farthing from every brother and sister in the entire guild should be given as financial aid[40] to provide a little food and basic necessities.

Nuns and Cloistered Women

Death for a nun, that is, a woman who entered the walls of holy life with a true calling, was seen as a celebration rather than a tragedy. The holy woman was finally to meet her heavenly bridegroom, there to spend the rest of eternity with him and be rewarded for her years of prayer and absolute devotion. All her suffering and sacrifice were about to be rewarded many times over, it was believed. Her funeral rites would be taken care of by her fellow sisters.

Canon Peter Abelard gave specific instruction for the care of the body of the deceased:

> "The body of the dead woman must then be washed at once by the sisters, clad in some cheap but clean garment and stockings, and laid on a bier, the head covered by a veil. These coverings must be firmly stitched or bound to the body and not afterwards removed."

The death of an abbess was to be treated the same, but with an additional addendum of a hair shirt.

> "...her entire body shall be wrapped only in a hair shirt and sewn up in this as a sack."[41]

Following the washing and clothing of the body, Peter gave further instruction for the final stages of her burial and at the church.

> "The body shall be carried into the church by the sisters for the monks to give it proper burial, and the sisters meanwhile shall devote themselves to psalm-singing and prayer in the oratory."[42]

The Guild had a set of items drawn up in 1389 which instructed the brothers and sisters in how to perform various services and observations. These included the death of a sister within the community. What kind of mass was to be held was covered in their guild ordinances.

> "...it is ordained that whenever a brother or sister has died, every brother and sister shall come to the dirige and mass, and at the mass everyone shall offer a halfpenny and give a halfpenny for alms, and for a mass to be sung for the soul of the dead person, a penny.
>
> And at the dirige, every brother and sister that is lettered shall say the placebo and dirige for the soul of the dead in the place where they shall come together, and every brother and sister that are unlettered shall say twenty times for the soul of the dead person, the Paternoster with the Ave Maria, and there shall be of the goods of the guild two candles of wax of sixteen pounds weight around the body of the dead person."[43]

These rules were given for a death within the city of Norwich itself, but further instructions to retrieve the body if it was further afield were also given. It was important to bring the person to come home, as it were. Should this not be possible, other arrangements for an appropriate funeral should be made.

> "...if any brother or sister dies within eight miles outside the city, that six of the brothers that has the goods of the guild in their care shall go to the brother or sister that is dead, and if it is lawful he should be carried to Norwich and in other wise be buried there.
>
> And if the body is buried outside Norwich, all the brothers and sisters shall be notified to come to the aforesaid church of saints Simon and Jude, and there shall be done for the soul of the dead person all services, lights, and offerings as if the body were present there."

The manuscript image of nuns and monks attending a funeral by Jean De Wavrin, dated to 1470, was typical of the period. The pall covering the coffin is made of expensive brocade and is emblazoned with four small coats of arms. Tall wax tapers stand at the head, foot, and both sides, and the priest rings a bell while the clergy refer to their books. This was the kind of funeral a wealthy widow might expect, and the kind nuns might be paid to attend to provide either prayers or psalms, or both. The image can be found in the Walters Art Gallery. W267, folio 86r.

Although not a nun for most of her life, Eleanor de Bohun, Duchess of Gloucester, died like one. After a very rich life of secular and worldly pursuits and all its trappings—fine clothing, good foods, entertainment, and living the life of almost royalty—Eleanor became a vowess and chose to devote herself to the salvation of her soul. She entered a nunnery in 1397, after the death of her

husband, and resided there until her own death two years later in 1399. She has a beautiful memorial brass in Westminster Abbey.[44]

While her stay at Barking, Essex was very short, she is shown on her brass in sombre clothing. A widow's pleated veil is underneath her chin, showing that she took her vows seriously and wished to die in the best possible way she could.

This was, in essence, the goal of a single medieval woman.

Conclusion

The lives of single women in medieval society were as varied as ours today. Young, unmarried girls grew to be maidens or spinsters. Some married and became wives and then widows. Others turned to religion or had it thrust upon them, unwished for.

At each step of the way, unique challenges and rules applied to her. What she should or shouldn't wear, or how she might spend her leisure time if she had any, was the subject of authors, poets, and priests. A single girl might get an education of some sort or take part in a trade, or become a business owner and operator herself, with staff under her supervision and training.

Single women went to festivals and courted husbands, kept pets for companionship, and were concerned for their own health and well-being. They might have pretty trinkets and expensive clothing, or just a few household goods to their name.

They took care of their health as best they were able and planned their funerals if they could.

In short, like single women today, they did the very best they could.

Selected Bibliography

A History of Private Life, Volume II: Revelations of the Medieval World. Edited by Philippe Ariès and Georges Duby, translated by Arthur Goldhammer. Harvard University Press, Belknap Press, 1987.

Aldhelm: The Prose Works. Translated by Michael Lapidge and Michael Herren. D. S. Brewer, 1979.

A Medieval Garner: Human Documents from the Four Centuries Preceding the Reformation. Edited and translated by G. G. Coulton. Constable, 1910.

A Medieval Home Companion: Housekeeping in the Fourteenth Century. Edited and translated by Tania Bayard. HarperCollins, 1991.

A Medieval Woman's Mirror of Honor: A Treasury of the City of Ladies. Christine de Pizan. Edited by Madeleine Pelner Cosman, translated by Charity Cannon Willard. Bard Hall Press, Persea Books, 1989.

"An English Translation of *Le Chastoiement des Dames* by Robert de Blois: Courtly Conduct Books and What They Assume About Medieval Women." Jaidyn Williams. Honors Thesis, Ball State University, 2023.

Bedfordshire Coroners' Rolls. Edited and translated by R. F. Hunnisett. Bedfordshire Historical Record Society 41, 1961.

Between Pit and Pedestal: Women in the Middle Ages. Marty Williams and Anne Echols. Markus Weiner Publishers, 1994.

Between Text and Patient: The Medical Enterprise in Medieval and Early Modern Europe. Edited by Florence Eliza Glaze and Brian Nance. Sismel Edizioni del Galluzzo, 2011.

Brasses. J. S. M. Ward. Cambridge University Press, 1912.

Calendar of Coroners Rolls of the City of London: A.D. 1300–1378. Edited and translated by R. R. Sharpe. Richard Clay and Sons, 1913.

Calendar of the Patent Rolls Preserved in the Public Record Office: Edward III, Volume IX, A.D. 1350–1354. Mackie & Co., 1907.

Codex Manesse (Große Heidelberger Liederhandschrift). Heidelberg University Library, Cod. Pal. germ. 848.

Cooking and Dining in Medieval England. Peter Brears. Prospect Books, 2012.

Court Rolls of the Manor of Hales 1272–1307. Translated and edited by John Amphlett, Sidney Graves Hamilton, and Rowland Alwyn Wilson. Worcestershire Historical Society, 1910.

Death in Medieval Europe: Death Scripted and Death Choreographed. Edited by Jöelle Rollo-Koster. Taylor & Francis, 2016.

Death in the Middle Ages: Mortality, Judgment and Remembrance. T. S. R. Boase. Thames & Hudson, 1972.

De Grace Especial: Crime, État et Société en France à la Fin du Moyen Âge. Claude Gauvard. Éditions de la Sorbonne, 1991.

Die Lieder Walters von Chatillon in der Handschrift 351 von St Omer. Edited by K. Strecker. Wiedmannsche Buchhandlung, 1925.

Early English Poetry. Edited by H. Macualay Fitzgibbon. Walter Scott, 1887.

Early Modern Women: An Interdisciplinary Journal. The Nun's Crown. Julie Hotchin. The Australian National University, 2009.

Edward Jenner and the History of Smallpox and Vaccination. Dr. Stefan Riedel. National Library of Medicine, 2005.

English Wayfaring Life in the Middle Ages (XIVth Century). J. J. Jusserand. Translated by Lucy Smith. Putnam's Sons, 1931.

Everyday Life in Medieval London: From the Saxons to the Tudors. Toni Mount. Amberley, 2014.

Fasciculus Morum: A Fourteenth-Century Preacher's Handbook. Edited and translated by Siegfried Wenzel. Pennsylvania State University Press, 1989.

Fashion in the Age of the Black Prince: A Study of the Years 1340–1365. Stella Mary Newton. Boydell & Brewer, 1980.

Gilbertus Anglicus: Medicine of the Thirteenth Century. Henry E. Handerson. CreateSpace, 2014.

Growing Up in Medieval London: The Experience of Childhood in History. Barbara Hanawalt. Oxford University Press, 1993.

Guild of St. Katherine, Norwich. English Guilds, 1389. Edited and translated by J. Toulmin Smith. Oxford University Press for Early English Text Society, original series 40, 1870.

Guillaume Dufay, "Le belle se siet," on *The Art of Courtly Love*, Early Music Consort of London, Seraphim, 1973.

Hildegard of Bingen's Medicine. Translated by Drs. Wighard Strehlow and Gottfried Hertzka. Bear & Company, 1987.

Hildegard von Bingen's Physica: The Complete English Translation of Her Classic Work on Health and Healing. Translated by Priscilla Throop. Healing Arts Press, 1998.

How the Good Wife Taught her Daughter. Lambeth Palace Library, MS 853.

Leben und Visionen der Alpais von Cudot (1150–1211). Edited by Elizabeth Stein. Gunter Narr Verlag, 1995.

Le Livre des Cleres et Nobles Femmes. Giovanni Boccaccio. Royal MS 16 G V.

Le Menagier de Paris (The Goodman of Paris): A Treatise on Moral and Domestic Economy by a Citizen of Paris, c. 1393. Translated by Eileen Power. Folio Society, 1992.

Le Petit Jehan de Saintré (L'Hystoyre et Plaisante Cronicque du Petit Jehan de Saintré et de la Jeune Dame es Belles Cousines Sans Autre Nom Nommer). Antoine de la Salle. 1456.

L'Espinette Amoureuse. Jean Froissart. Edited by Anthime Fourrier. Librairie Klincksieck, 2002.

Selected Bibliography

Le Testament Villon. Edited by Jean Rychner and Albert Henry. Librairie Droz, 1974.

Life in Medieval France. Joan Evans. Phaidon Press, 1925.

Lincoln Diocese Documents: 1450–1544. Edited by Andrew Clark. Kegan Paul, Trench, Trübner & Co., 1914.

Little Sermons on Sin: The Archpriest of Talavera. Alfonso Martínez de Toledo. Translated by Lesley Byrd Simpson. University of California Press, 1959.

Livre des Trois Vertus. Christine de Pizan. Yale University Beinecke Rare Book and Manuscript Library, Beinecke MS 427, folio 72r.

L'Ornement des Dames (Ornatus Mulierum): Texte Anglo-Normand du XIIIe Siècle. Edited by Pierre Ruelle, translated by Madeleine Jeay and Kathleen Garay. Presses de l'Université de Bruxelles, 1964.

Love and Power in the Peasant Family. Martine Segalen. Wiley-Blackwell, 1983.

Love Locked Out: A Survey of Love Licence and Restriction in the Middle Ages. James Cleugh. Spring Books, Hamlyn Publishing Group, 1963.

Making Women's Medicine Masculine: The Rise of Male Authority in Pre-Modern Gynaecology. Monica H. Green. Oxford University Press, 2008.

Manor Court, Wellington. Materials for the History of the Town and Parish of Wellington in the County of Somerset. Translated by A. L. Humphries. H. Gray, London, 1910.

Medieval Children. Nicholas Orme. Yale University Press, 2001.

Medieval Folklore: A Guide to Myths, Legends, Tales, Beliefs, and Customs. Edited by Carl Lindahl, John McNamara, and John Lindow. Oxford University Press, 2002.

Medieval Handbooks of Penance: A Translation of the Principal Libri Poenitentiales. John T. McNeill and Helen M. Gamer. Columbia University Press, 1938.

Medieval Jewellery in Europe 1100–1500. Marian Campbell. V&A Publishing, 2009.

Medieval Monastic Cemeteries of Britain (1050–1600): A Digital Resource and Database of Excavated Samples. Roberta Gilchrist and Barney Sloane. Museum of London Archaeology Service, 2005.

Medieval People. Eileen Power. Folio Society, 1999.

Medieval Pets. Kathleen Walker-Meikle. Boydell & Brewer, 2012.

Medieval Women and the Law. Edited by Nöel James Menuge. Boydell & Brewer, 2000.

Medieval Women: A Social History of Women in England 450–1500. Henrietta Leyser. Weidenfeld & Nicolson, 1995.

Medieval Writings on Secular Women. Translated by Patricia Skinner and Elisabeth van Houts. Penguin Classics, 2011.

Memorials of London and London Life, in the XIIIth, XIVth, and XVth Centuries: Being a Series of Extracts, Local, Social, and Political, from the Early Archives of London. A.D. 1276–1419. Edited and translated

by Henry Thomas Riley. City of London, 1868; Kessinger Legacy Reprints, 2010.

Mistress, Maids and Men: Baronial Life in the Thirteenth Century. Margaret Wade Labarge. Phoenix, 1965.

Montaillou: Cathars and Catholics in a French Village 1294–1324. Emmanuel Le Roy Ladurie. Translated by Barbara Bray. Penguin Books, 1978.

"Nuns in Medieval England." Michael Carter. English Heritage. english-heritage.org.uk/learn/histories/abbeys-and-priories/medieval-nuns

On the Properties of Things: John Trevisa's Translation of De Proprietatibus Rerum. Bartholomew the Englishman. Translated by Madeleine Jeay and Kathleen Garay. Clarendon Press, 1975.

Piers Plowman: A New Translation of the B-Text. William Langland and A. V. C. Schmidt. Oxford University Press, 1992.

Pilgrim Souvenirs and Secular Badges: Medieval Finds from Excavations in London. Brian Spencer. Museum of London, 1998.

Rolls of the Collectors in the West Riding of the Lay-Subsidy (Poll Tax), 2 Richard II. Yorkshire Archaeological and Topographical Journal, Volume 7. 1882.

Secular Lyrics of the XIVth and XVth Centuries. Edited and translated by R. H. Robbins. Clarendon Press, 1955.

Select Cases of Trespass from the King's Courts 1307–1399 Volume 1. Translated by Morris S. Arnold. Seldon Society, ca. 1985.

Some Sessions of the Peace in Lincolnshire 1381–1396. Edited by Elizabeth G. Kimball. Hereford Times for the Lincoln Record Society, 1955.

Summa Confessorum. Thomas of Chobham. Ca. 1216.

The Agonizing Choice: Birth Control, Religion, and the Law. Norman St. John-Stevas. Indiana University Press, 1971.

The Art of Courtly Love. Andreas Capellanus. Translated by John Jay Parry. Columbia University Press, 1960.

The Boke of Saint Albans. Dame Juliana Berners. Project Gutenberg eBook #71266. 2023.

The Book of the Courtier. Baldesar Castiglione. Translated by George Bull. Penguin Books, 1976.

The Book of the Knight of La Tour-Landry Compiled for the Instruction of his Daughter. Thomas Wright. Alpha Editions, 2020.

The Booke of the Pylgremage of the Sowle. Guillaume de Deguileville. Edited and translated by Katherine Isabella Cust. Basil Montagu Pickering's Publications, 1859.

The Courts of the Archdeaconry of Buckingham. Translated by E. M. Elvey. Buckingham Record Society, 1975.

The Decameron. Giovanni Boccaccio. Translated by John Payne. Project Gutenberg eBook #23700. 2007.

The Distaff Gospels: A First Modern English Edition of Les Évangiles des Quenouilles. Edited by Madeleine Jeay and Kathleen Garay. Broadview Press, 2006.

The English Register of Godstow Nunnery, Near Oxford. Edited and translated by Andrew Clark. Kegan Paul, Trench, Trübner & Co. for the Early English Text Society, 1911.

The Everlasting Cat. Mildred Kirk. Faber & Faber, 1977.

The Four Seasons of the House of Cerruti. Ibn Butlān. Translated by Judith Spencer. Facts On File Publications, 1983.

"The Habit of the Order of St Birgitta of Sweden." Uller Sander Olsen. Birgittiana Journal, Volume 9, 2000.

The History of English Law Before the Time of Edward I. Frederic William Maitland and Sir Frederick Pollock. University of Cambridge, 1895.

The Holkham Bible Picture Book. British Library, Add. 47682. Ca. 1330.

The JPS Guide to Jewish Women: 600 B.C.E.–1900 C.E. Emily Taitz, Sondra Henry, Cheryl Tallan. Jewish Publication Society, 2003.

The Lady in Medieval England 1000–1500. Peter Coss. Sutton Publishing, 1989.

The Letters of Abelard and Heloise. Translated by Betty Radice. Penguin Classics, 1974.

The Letters of Hildegard of Bingen: Volume 1. Translated by Joseph L. Baird and Radd K. Ehrman. Oxford University Press, 1994.

The Luttrell Psalter. British Library, Add. MS 42130. Ca. 1330.

The Medieval Art of Love: Objects and Subjects of Desire. Michael Camille. Laurence King Publishing, 1998.

The Medieval Housewife & Other Women of the Middle Ages. Toni Mount. Amberley, 2014.

The Medieval Tailor's Assistant: Common Garments 1100–1480. Sarah Thursfield. Crowood Press, 2015.

The Middle Ages: Facts and Fictions. Winston Black. ABC-CLIO, 2019.

The Natural History of Cats. Claire Necker. Dell Publishing Co., 1970.

The New Oxford Companion to Literature in French. Edited by Peter France. Oxford University Press, 1995.

The Oxford Book of Medieval English Verse. Edited by Kenneth and Celia Sisam. Clarenden Press, 1970.

The Oxford Book of Medieval Latin Verse. Edited by Stephen Gaselee. Clarendon Press, 1928.

The Paston Women: Selected Letters. Edited by Diane Watt. D. S. Brewer, 2004.

"The Poll-Tax of 1377 for Carlisle." Translated by J. L. Kirby and A. D. Kirby. Transactions of the Cumberland and Westmorland Antiquarian and Archaeological Society, Volume 58, 1959.

The Romance of the Rose. Guillaume de Lorris and Jean de Meun. Translated by Frances Horgan. Oxford University Press, 1994.

The Statute of Cambridge 1388. 12 Ric. 2. c. 7.

The Taymouth Hours. British Library Yates Thompson MS 13. Ca. 1325–1350.

The Time Traveller's Guide to Medieval England: A Handbook for Visitors to the Fourteenth Century. Ian Mortimer. The Bodley Head, 2008.

The Trotula: An English Translation of the Medieval Compendium of Women's Medicine. Edited and translated by Monica H. Green. University of Pennsylvania Press, 2002.

The Vision of William Concerning Piers the Plowman. William Langland. Edited by Rev. Walter W. Skeat. Clarendon Press, 1881.

The Writings of Teresa de Cartagena. Dayle Seidenspinner-Nunez. University of Notre Dame, 1998.

The Wyvern Collection: Medieval and Later Ivory Carvings and Small Sculpture. Paul Williamson. Thames & Hudson, 2019.

"Thomas de Chobham, Sermones." Edited by F. Morenzoni. Corpus Christianorum Continuatio Mediaevalis Volume 82A. Brepols, 1993.

Through the Glass Window Shines the Sun: An Anthology of Medieval Poetry and Prose. Edited by Pamela Norris. Tiger Books International, 1998.

"Tombs of Royal Babies in Westminster Abbey." Joan Tanner. Journal of the British Archaeological Association Volume 16, 1953.

Trades and Crafts in Medieval Manuscripts. Patricia Basing. British Library and New Amsterdam Books, 1990.

Visitations in the Diocese of Lincoln, 1517–1531: Volume II. Edited and translated by A. Hamilton Thompson. Boydell & Brewer, 1970.

Visitations of Religious Houses in the Diocese of Lincoln A.D. 1420–1436. Edited and translated by A. Hamilton Thompson. Boydell & Brewer, 1915.

Visualizing Household Health: Medieval Women, Art, and Knowledge in the Régime du Corps. Jennifer Borland. Pennsylvania State University Press, 2022.

Walter of Henley's Husbandry: Together with an Anonymous Husbandry, Seneschaucie, and Robert Grosseteste's Rules. Walter of Henley. Translated by Elizabeth Lamond. Longmans, Green, and Co., 1890.

What Life Was Like in the Age of Chivalry: Medieval Europe, A.D. 800–1500. Denise Dersin. Time Life Books, 1997.

Women and Gender in Medieval Europe: An Encyclopedia. Edited by Margaret C. Schaus. Routeledge, Taylor & Francis Group, 2006.

Women and the Book: Assessing the Visual Evidence. Edited by Lesley Smith and Jane H. M. Taylor. University of Toronto Press, 1997.

Women in England c. 1275–1525. Edited and translated by P. J. P. Goldberg. Manchester University Press, 1993.

Women in the Medieval English Countryside: Gender and Household in Brigstock Before the Plague. Judith Bennett. Oxford University Press, 1987.

Women's Lives in Medieval Europe: A Sourcebook. Edited by Emilie Amt. Routledge, 1993.

Women's Secrets: A Translation of Pseudo-Albertus Magnus' De Secretis Mulierum with Commentaries. Helen Rodnite Lemay. State University of New York Press, 1992.

York City Chamberlain's Account Rolls 1396–1500. Edited by R. B. Dodson. Northumberland Press for the Surtees Society, 1980.

Yorkshire Sessions of the Peace, 1361–1364. Edited by Bertha Haven Putnam. Yorkshire Archaeological Society, 1939.

Source Notes

You'll have noticed many source number markers in each chapter throughout this book. In an effort to save a bunch of pages and put more information in, you can access them online; download the PDF file for free here:

rosaliegilbert.com/secretlivesofsinglemedievalwomen_sources.html

or scan the QR code:

Bonus feature!

Visit the gallery of images mentioned in this book

rosaliegilbert.com/secretlivesofsinglemedievalwomen_gallery.html

or scan the QR code:

Heartfelt Thanks

There are a number of people who really made this happen and to whom I feel a great debt of gratitude. I'd like to thank them, if I may.

Much love and gratitude to everyone who supported my first book, *The Very Secret Sex Lives of Medieval Women*. Your interest and support have been incredibly encouraging.

A huge thanks, as always, goes to Jenny, my long-suffering boss, who has given me the flexibility to do what I love doing, writing and spending time doing bookish, author things—often on short notice. I would not be writing this without you. A special thank you to author Toni Mount for her willingness to help a fellow history lover and for her wonderful foreword. I really appreciate it. Also to Angela, Chris, and Az, who offered help and encouragement—you guys rock.

Thanks also to the team at Mango Publishing, headed by Brenda. I wouldn't be doing this without you too.

About the Author

Rosalie Gilbert is passionate about living history, experimental archaeology, and women in the Middle Ages, particularly England, where her family origins are. She is a lifetime member of the Friends of the Abbey Museum of Art & Archaeology and a member of the Queensland Living History Federation.

Rosalie has been a guest speaker on *Medieval Feminine Hygiene* and *The Very Secret Sex Lives of Medieval Women* at the Abbey Museum of Art and Archaeology, the Queensland Museum's *After Dark* Program for the British Museum's *Medieval Power: Symbols & Splendour Exhibition*, the University of the Third Age's Winterschool Program, the University Pavilion at the Abbey

Medieval Festival, a lecture series throughout Brisbane City Council libraries, and various women's social groups. She has a strong focus on education and especially on revealing the truths behind the lives of medieval women.

She is committed to busting the myths that medieval women were dirty, smelly, always sexually repressed, and had no idea about hygiene, with her accessible and engaging living history displays, talks, and presentations, through the media and in person at public events.

Rosalie is the voice behind *Rosalie's Medieval Woman*, an online presence on many platforms focusing on fourteenth-century women's lives, including historical tailoring tutorials and experimental archaeology trials, and is the owner and curator of *The Gilbert Collection*, a medieval antiquities study collection which is available online with free access.

Her first nonfiction book, *The Very Secret Sex Lives of Medieval Women*, was an international bestseller for Mango Publishing in 2020; has been translated into Russian, Polish, and Japanese; and is available through the Braille Library of Australia.

Mango Publishing, established in 2014, publishes an eclectic list of books by diverse authors—both new and established voices—on topics ranging from business, personal growth, women's empowerment, LGBTQ studies, health, and spirituality to history, popular culture, time management, decluttering, lifestyle, mental wellness, aging, and sustainable living. We were named 2019 *and* 2020's #1 fastest growing independent publisher by *Publishers Weekly*. Our success is driven by our main goal, which is to publish high-quality books that will entertain readers as well as make a positive difference in their lives.

Our readers are our most important resource; we value your input, suggestions, and ideas. We'd love to hear from you—after all, we are publishing books for you!

Please stay in touch with us and follow us at:

Facebook: Mango Publishing
Twitter: @MangoPublishing
Instagram: @MangoPublishing
LinkedIn: Mango Publishing
Pinterest: Mango Publishing
Newsletter: mangopublishinggroup.com/newsletter

Join us on Mango's journey to reinvent publishing, one book at a time.

www.ingramcontent.com/pod-product-compliance
Lightning Source LLC
Jackson TN
JSHW032107050425
81405JS00001B/1